AUSTRALIAN NATURE
from the heart

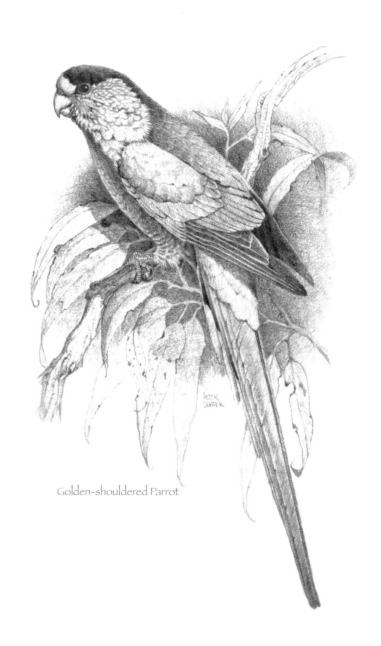

Golden-shouldered Parrot

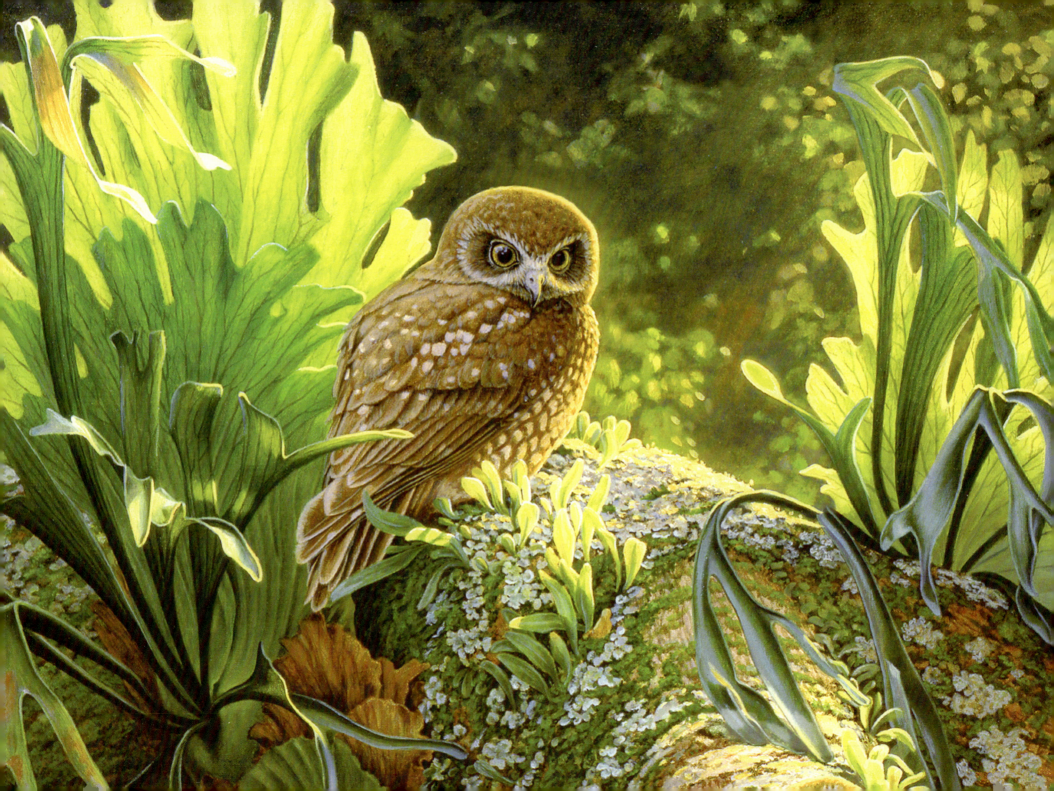

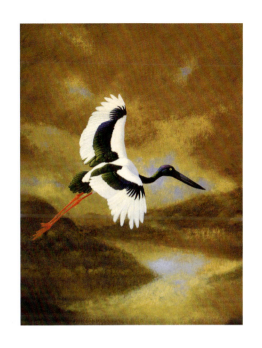

AUSTRALIAN NATURE

from the heart

The Paintings of
SALLY ELMER & PETER SLATER

First published in 2021 by Reed New Holland Publishers
Sydney • Auckland

Level 1, 178 Fox Valley Road, Wahroonga, NSW 2076, Australia
5/39 Woodside Avenue, Northcote, Auckland 0627, New Zealand

newhollandpublishers.com

Copyright © 2021 Reed New Holland Publishers
Copyright © 2021 in text and images: Peter Slater and Sally Elmer

All rights reserved. No part of this publication may be reproduced, stored in a retrieval system or transmitted, in any form or by any means, electronic, mechanical, photocopying, recording or otherwise, without the prior written permission of the publishers and copyright holders.

A record of this book is held at the National Library of Australia.

ISBN 978 1 92554 668 2

Managing Director: Fiona Schultz
Publisher and Project Editor: Simon Papps
Designer: Andrew Davies
Production Director: Arlene Gippert

Printed in China

Artwork by Peter Slater: pages 1, 3, 5, 7, 8, 11, 16–25, 36 (left), 37, 38, 40, 42–4, 48–51, 53–9, 60 (right), 62–70, 78–83, 85 (right), 86–9, 92–7, 103–4, 108, 110–7, 122–134, 136–143, 145–153, 155, 157, 159, 174–5, 189, 190, 199–204, 209, 218–9, 222, 224

Artwork by Sally Elmer: pages 2, 4, 6, 9, 10, 12–5, 26–35, 36 (right), 39, 41, 45–7, 52, 60, 61, 71–7, 84, 85 (left), 90–1, 98–102, 105–7, 109, 118–121, 135, 144, 154, 156, 158, 160–173, 176–188, 191–8, 205–8, 210–7, 220–1, 223

Haikus by Peter Slater: pages 173, 199

10 9 8 7 6 5 4 3 2 1

Keep up with Reed New Holland
and New Holland Publishers
ReedNewHolland
@NewHollandPublishers and @ReedNewHolland

Other titles by Reed New Holland include:

The Slater Field Guide to Australian Birds (2nd Ed)
by Peter Slater, Pat Slater and Raoul Slater (978 1 87706 963 5)

Glimpses of Australian Birdlife
by Peter Slater, Sally Elmer and Raoul Slater (978 1 92554 633 0)

Field Guide to Birds of North Queensland
by Phil Gregory and Jun Matsui (978 1 92554 625 5)

See newhollandpublishers.com for details

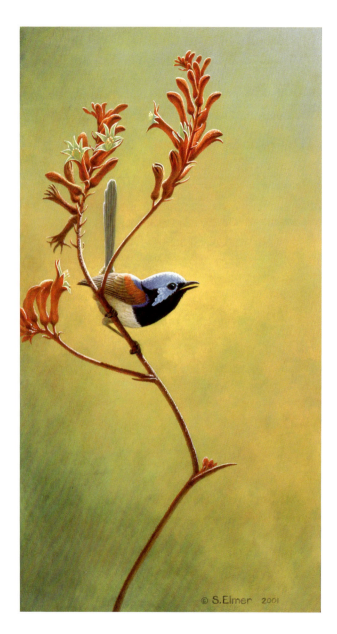

Dedicated to:

Pat Slater 1937–2003
Sam and Naomi
and those who influenced my life
Mildred Manning, Olive Seymour,
Eric Lindgren, John Warham,
David Ride, Roy Wheeler,
Brigadier Hugh Officer, Laurie Muller.
Peter

Babette Elmer, who always
supported my artistic endeavours.
Sally

Acknowledgments

Peter Slater, 17.10.1932–28.5.2020,
had a long and happy association with
New Holland Publishers,
beginning with his
The Slater Field Guide to Australian Birds
which has been in continuous print since 1986

CONTENTS

Foreword	7
Introduction	10
Painting the Background – Sally	12
Painting the Background – Peter	16
Eastern Grey Kangaroo	28
Red-necked Pademelon	30
Tasmanian Pademelon	33
Whip-tailed Wallaby	34
Tasmanian Emu	36
Southern Cassowary	37
Musk Lorikeet	38
Rainbow Lorikeet	39
Swift Parrot	40
Australian Ringneck	42
Elegant Parrot	42
Red-winged Parrot	43
Adelaide Rosella	44
Eastern Rosella	45
Crimson Rosella	46
Paradise Parrot	48
Golden-shouldered Parrot	48
Hooded Parrot	49
Paradise Parrot	50
Mulga Parrot	52
Eastern Ground Parrot	54
Western Ground Parrot	55
Night Parrot	56
Double-eyed Fig-Parrot	58
Coxen's Fig-Parrot	59
Princess Parrot	62
Regent Parrot	64
Red-tailed Black-Cockatoo	66
Major Mitchell's Cockatoo	68
Galah	70
Laughing Kookaburra	72
Blue-winged Kookaburra	77
Yellow-billed Kingfisher	78
Buff-breasted Paradise-Kingfisher	79
Red-backed Kingfisher	80
Rainbow Bee-eater	82
Southern Boobook	84
Eastern Barn Owl	86
Rufous Owl	87
White-throated Nightjar	88
Spotted Nightjar	89
Wedge-tailed Eagle	90
Black Falcon	94
White Goshawk	95
Peregrine Falcon	96
Australian Brush-turkey	98
Rock Dove	100
Rose-crowned Fruit-Dove	102
Crested Pigeon	106
Peaceful Dove	107
Partridge Pigeon	108
Squatter Pigeon	108
Spinifex Pigeon	109
Australian Pratincole	110
Inland Dotterel	111
Nullarbor Quail-thrush	112
Rufous Fieldwren	113
Eyrean Grasswren	114
Sandhill Grasswren	115
White-throated Grasswren	116
Black Grasswren	117
Variegated Fairy-wren	118
Superb Fairy-wren	120
Variegated Fairy-wren	121
Red-backed Fairy-wren	122
White-winged Fairy-wren	124
Lilac-crowned Fairy-wren	125
Pacific Robin	126
Scarlet Robin	127
Red-capped Robin	128
Flame Robin	129
Red-capped Robin	130
Rose Robin	132
Eastern Yellow Robin	134
Pale-yellow Robin	136
Fairy Gerygone	137
Olive-backed Sunbird	138
Lemon-breasted Boatbill	139
Crimson Chat	140
Yellow Chat	140
Orange Chat	141
Northern Shrike-tit	142
Western Whipbird	143
Diamond Firetail	144
Painted Finch	145
Red-browed Finch	146
Plum-headed Finch	146
Long-tailed Finch	147
Scarlet Honeyeater	148
White-browed Woodswallow	150
Paradise Riflebird	152
Victoria's Riflebird	153
Willy Wagtail	154
Pied Butcherbird	155
Grey Butcherbird	156
Silver-backed Butcherbird	157
Welcome Swallow	158
Silver Gull	160
Australian Pelican	162
Herald Petrel	174
Soft-plumaged Petrel	175
Australasian Grebe	176
Black Swan	180
Pacific Black Duck	182
Australasian Shoveler	188
Plumed Whistling Duck	190
Australian Wood-Duck	191
Dusky Moorhen	192
Cattle Egret	196
Little Egret	197
Intermediate Egret	200
Eastern Great Egret	201
Yellow-billed Spoonbill	204
Royal Spoonbill	205
Straw-necked Ibis	206
Australian White Ibis	207
Jabiru	208
Green Tree-Frog	210
Red-eyed Tree-Frog	213
Carpet Python	214
Southern Angle-headed Dragon	216
Eastern Water Dragon	217
Blue-tailed Ctenotus	218
Kakadu Ctenotus	219
Richmond Birdwing	220
Caper White	222

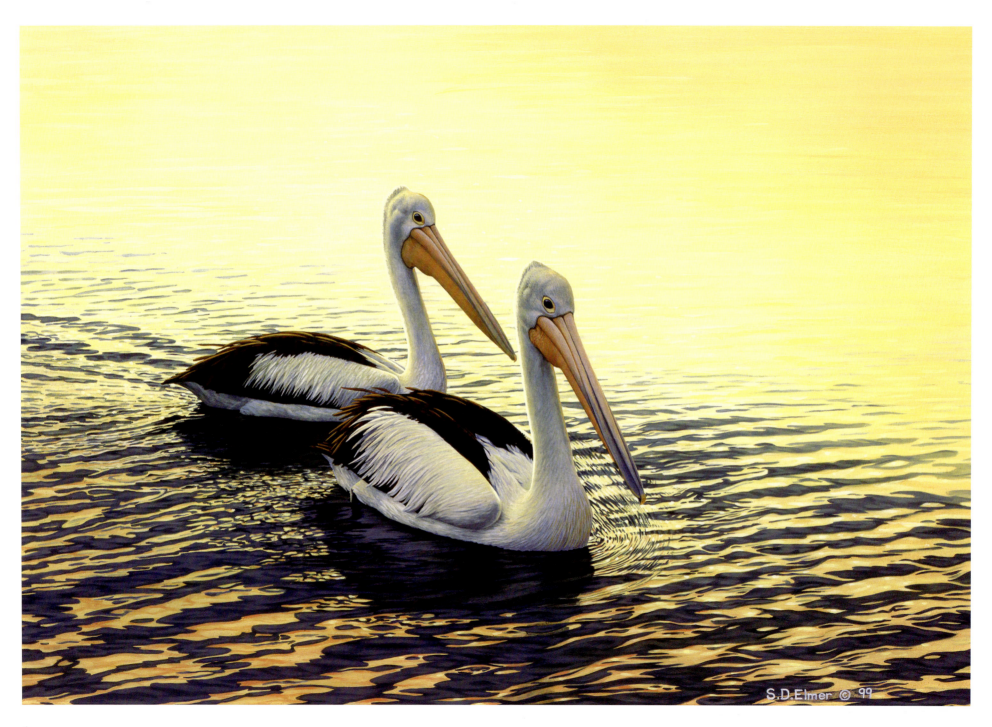

FOREWORD

'How did you become interested in wildlife, and especially in birds?' often has been asked of me, and I suspect that at times Peter Slater and Sally Elmer were called upon to answer the same question. My father was a railwayman in New South Wales, so my childhood was spent in country towns, mainly on the mid north coast and in the central west, during the somewhat carefree times of the late 1940s to mid 1950s, when the rural landscape was less impacted by urbanisation and agricultural development. For me and some of my school friends, out-of-class days were spent 'in the bush', where we chased rabbits down burrows, caught yabbies in farm dams, brought home pet cicadas, looked out for the first Christmas beetle or spring-flowering wattles and watched birds. Because they were always present and highly visible, birds attracted our attention and soon became the focus of our interest. Not surprisingly, we wanted to know more about the different birds that we were seeing, so with saved pocket money I purchased my first copy of *What Bird Is That?* at a newsagency in Dubbo, then my home town, and I still have that copy. As with so many of my generation, Cayley's book generated a stronger, more serious interest in birds, which eventually determined for me a career in ornithological research and wildlife conservation.

What Peter told me of his background parallels to some extent my own story. His father was a clergyman ministering to parishioners in country towns in Western Australia, and Peter's earliest recollection of an encounter with birds was as a small child watching crows in the backyard of his home. After qualifying as a school teacher, he deliberately sought appointment to remote centres, from the Kimberley division of Western Australia to far northern Queensland, so that he could continue his field encounters with wildlife. These field encounters always were Peter's 'stock-in-trade', and were meticulously recorded in photographs, sketches or paintings. I had the pleasure of accompanying Peter in the field on a few occasions, and was impressed by the intensity of his observations as he took in the whole scene before him, registering the birds in their natural surrounds, often commenting on the presence of particular plants. It is this same totality of birds and habitat that is a feature of his paintings.

My first association with Peter dates from the late 1960s, when I was a technical officer in the then Division of Wildlife Research at the Commonwealth Scientific and Industrial Research Organisation (CSIRO) in Canberra. Peter had prepared colour plates, drawings and some text for a proposed field guide to Australian birds, and Dr H J (Harry) Frith, Chief of the Division, offered to facilitate prompt publication of the non-passerines part by providing additional text prepared by officers of the Division. I was asked to contribute the text on parrots, and the non-passerines volume was published in 1970. Peter produced the passerines volume, which was published in 1974. Looking back, we can acknowledge that this field guide had some shortcomings, not least being its publication in two volumes, but it was welcomed enthusiastically because it was a major advance on books being used as field guides and, for the first time, there was a guide that really did aid in identification. In collaboration with wife Pat and son Raoul, Peter produced *The Slater Field Guide to Australian Birds*, a single volume guide published in 1986 and incorporating many new features. Of the Australian bird guides it was then and, and in my opinion, still is the most suited to use in the field.

It has been particularly fascinating and pleasing to witness stages in the development of Peter's artistic skills, so manifest over the years in editions of the Field Guide, in the numerous publications that he has illustrated, sometimes produced in collaboration with Pat, and in the large spectacular paintings prepared for exhibitions or as commissions. Possibly with birds of prey, a particularly favoured group, has this development in his skills been most evident. Pat authored numerous books on Australian wildlife, and I was well aware of her close partnership with Peter, having little doubt that her support, companionship and encouragement was a key to his achieving the goals that he set for himself. Her death in 2003 was a devastating loss for Peter.

I very much regret that my collaboration with Peter for a planned book on grassfinches did not eventuate. It was proposed that I would co-author with Richard Zann a book on grassfinches, and I asked William Cooper if he would illustrate the book. From Bill I received a prompt, emphatic response when he replied "No, you need Peter Slater because nobody paints finches as well as Peter." Richard and I subsequently met with Peter to discuss the project and all seemed set to proceed. Peter prepared some coloured plates and preliminary behavioural

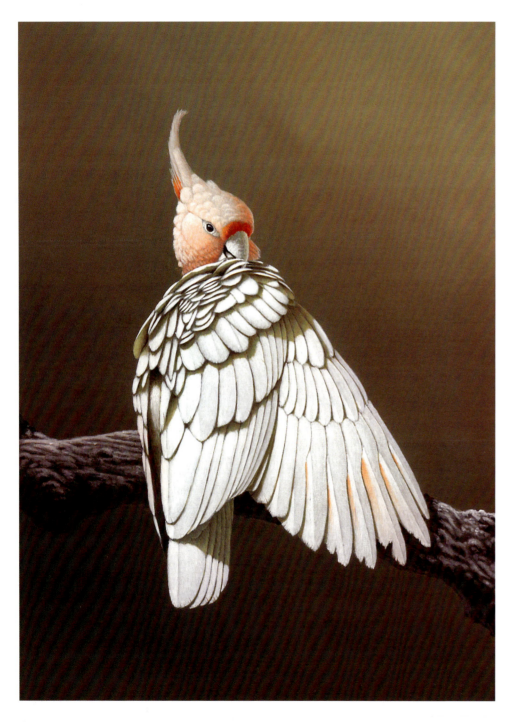

drawings based on Richard's studies. Our plans came to an end with the tragic death of Richard in the catastrophic Victorian bushfires of February 2009. A year or so later I resumed work on the grassfinches book, but at that time Peter could not be involved because of other commitments.

Peter was privileged to have experienced two creative partnerships in his lifetime. His partnership with Pat was manifested mostly as an author and illustrator collaboration, though I know that Pat supported and assisted in many other ways. When Sally Elmer partnered with Peter there came together two highly gifted wildlife artists whose works are so strongly complementary. When asked to contribute the Foreword to this book, there was one potential difficulty that caused some hesitancy on my part. While my association and friendship with Peter was longstanding, I knew very little of Sally and her artwork. I had met Sally on only one occasion, but was fully aware of how much her companionship and collaboration meant to Peter. Consequently it has been particularly satisfying to see her superb paintings reproduced in this book and to learn from reading her biographical text that she also traces her interest in wildlife to a childhood spent 'exploring the bush' in the Adelaide Hills and during family weekends in the natural environment of Brisbane suburbia.

Sally mentions creating an atmosphere when composing a picture, and that is an aspect of her paintings that impressed me. The rather 'quizzical look' of a standing pelican, a Whiptail Wallaby turning its head to watch three intruding fairy-wrens, the furtive emergence of pademelons from safety of the underbrush, and what might have been an 'afternoon nap' by a pair of Diamond Firetails on a barbed-wire fence are paintings that for me have so much atmosphere. Another aspect of Sally's paintings that I find particularly appealing is what I would term 'the complete picture' that comes when depicting an animal or animals in a habitat setting to produce a painting that can be enjoyed. I did enjoy looking at Eastern Rosellas feeding near the ruins of an old wagon.

Although Sally had met Peter at meetings and exhibitions of the Queensland Wildlife Artists Society and they had worked together producing prints of Sally's paintings, the partnership came about in 2007 when Sally assisted Peter in updating and revising the field guide for publication of the second edition in 2009. Also in 2007, Sally

accompanied Peter on the first many extended field trips to various desert national parks and to locations as distant as Alice Springs, Tasmania and Kangaroo Island. Sally fondly recalls that in addition to providing opportunities for photography and the compilation of field data, these trips enabled them to enjoy being with nature and to become very close friends, 'each understanding and appreciating the other'. Obviously, it was a blending of kindred spirits able to share numerous common interests. Sally has undertaken to revise and update the field guide, a task that will ensure continuation of the partnership.

It has been with a mix of gratitude and a sense of loss that I have prepared this Foreword. I am grateful for the opportunity to contribute in a small way to this book as a tribute to the life and work of Peter, but there is a void in knowing that I have lost a very talented friend and colleague. I know that Peter Slater and William Cooper were friends who held each other in high esteem, and always I have credited them as being largely responsible for bringing about the international recognition and acclaim now experienced by wildlife artists in this country.

Thank you Peter for contributing so much to an understanding and appreciation of our wonderful wildlife and the need to protect it.

I have mentioned my enjoying 'the complete picture' aspect of Sally's paintings, and indeed this is a book to enjoy. I know that I shall come back to it time and time again because looking at the stunning artwork reminds me so forcefully that a love of the Australian bush and its inhabitants, formed during childhood times, stays with me and has been the motivation for a lifelong involvement with wildlife research and conservation. I trust that all readers will gain from this collection of works from two highly talented artists a strong appreciation of the need to safeguard the beauty and diversity of Australia's unique wildlife.

Joseph M Forshaw AM
Canberra, 1 July 2020

Left: A preliminary study for a larger painting of Major Mitchell's Cockatoo. Right: Richmond Birdwing.

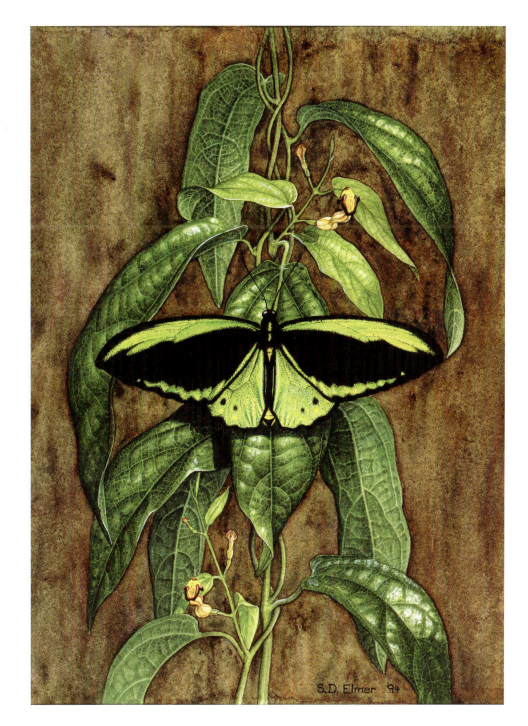

INTRODUCTION

Australian wildlife has inspired artists since the first humans arrived sometime within the past 65,000 years. The first 'canvases' were smooth rock faces and the artists pursued one of two methods. The first was to engrave images into the rock itself. As well as realistic or symbolic representations, mammal and bird footprints were common subjects. In some areas, such as the Burrup Peninsula and Dampier Archipelago in north-west Western Australia, hundreds of thousands of engravings may still be found in a relatively small area, a site of immense international significance, basically the world's largest art gallery. A considerable number of these petroglyphs depict animals still common in the area as well as some that no longer occur. In general the engraved rock art varies from simple scratchings to quite sophisticated peckings not too unlike similar art in Africa. The other method used ochres, charcoal and haematite to draw and paint on sheltered rock walls. There is an abundance of styles and some particularly fine examples should be considered masterpieces of World Art, among them the 'Bradshaw' paintings of the north-west Kimberley. There is considerable difficulty in dating works, but some estimates suggest at least 30,000 years for older existing images. Among the wildlife depicted are creatures such as the Thylacine, which have since ceased to exist the vicinity of the artworks. At least one image appears to represent an extinct Mihirung, the giant 'thunderbird' that died out about 10,000 years ago. As well as on rock faces, many paintings were done on bark. They were generally more intricate than rock paintings.

Many contemporary aboriginal artists use modern materials such as acrylic paints and canvas to produce traditional images. I don't think it matters, but one feels that traditional methods of bark and ochres are in some ways preferable. I suppose it is the image that matters, not the materials used to produce it.

The age of exploration by Europeans ultimately led to the colonisation of Australia and its disastrous effect on both the original inhabitants and the wildlife. But in the early years there was wonder at the unfamiliar creatures, and many artists sought to portray them, from those who sailed with Captain Cook, including Sydney Parkinson, Georg Forster and William Wade Ellis, to officers and convicts of the First Fleet, George Raper and Thomas Watling among them; Ferdinand Bauer sailed with Matthew Flinders and left an incredible collection of paintings, including plants and birds. John Lewin arrived in the colony in 1800 and produced illustrated books of birds and butterflies. John and Elizabeth Gould visited Australia in 1839 and returned to England inspired to produce great works on birds and kangaroos. Sadly Elizabeth, who was responsible for the art work, died after finishing about a hundred lithographs, and her place was taken by Henry Constantine Richter. Gracius Broinowski and Silvester Diggles produced illustrated bird books, inferior to Gould's but interesting

nonetheless. Neville Cayley and his son, Neville W, between them painted all the birds of Australia, some of them, like the Laughing Kookaburra, many times. *What Bird is That?* by the younger Cayley is a classic, still in the bookshops 90 years after its first publication. He also illustrated a guide to butterflies, works on parrots, finches and budgerigars and a beautiful book of fairy-wrens. The American artist Roger Tory Peterson is widely regarded as 'the father of the field guide' but Neville Cayley predated him and merits at least equal billing.

Many contemporary artists have painted wildlife including John Olsen, Clifton Pugh and Glenys Buzza (my favourite). There are many who paint more traditionally, specialising in wildlife, from Robin Hill, who now lives in America, to Peter Trusler, Greg Postle and Tony Pridham. One cannot list them all, although they merit recognition, but I would like to mention a few in particular: William T Cooper brought the vignette style of illustration, first employed in lithographs by Edward Lear, to its ultimate degree of perfection; his images may be equalled but will never be exceeded. Bill also produced edge-to-edge paintings of immense power, with masterful handling of light. He also documented rainforest fruits with beautiful watercolours. Ray Harris Ching, a New Zealander, lived in Australia for a while and produced incredible paintings of kangaroos. To my mind, these, like William Cooper's paintings, should be in public galleries. Few wildlife painters seem to favour kangaroos. One exception is Rosemary Woodford Ganf, who painted all of the macropod species, a truly dedicated project rivalled only by Bill Cooper's cockatoos and Celia Rosser's banksias.

I don't know what compels these artists to paint wild things, any more than I know why I paint birds. But paint them we must.

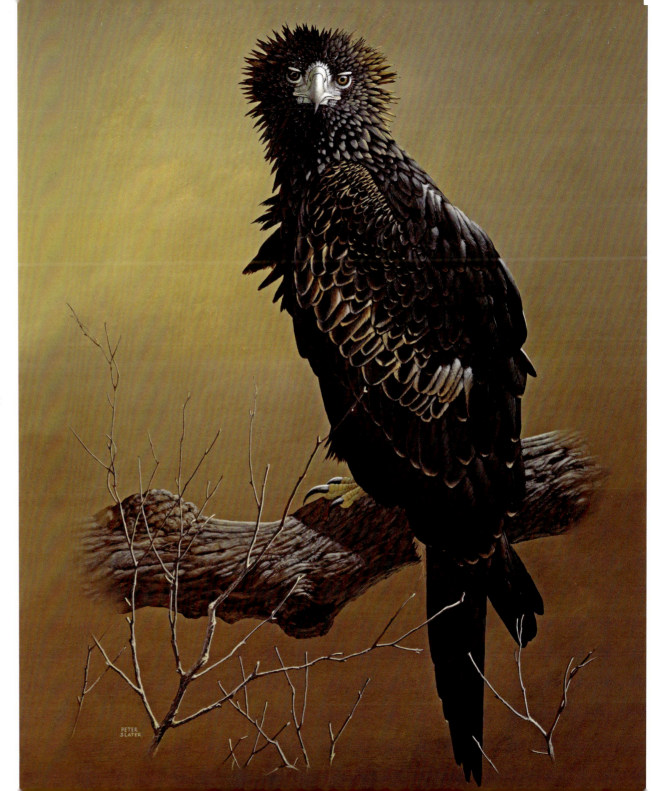

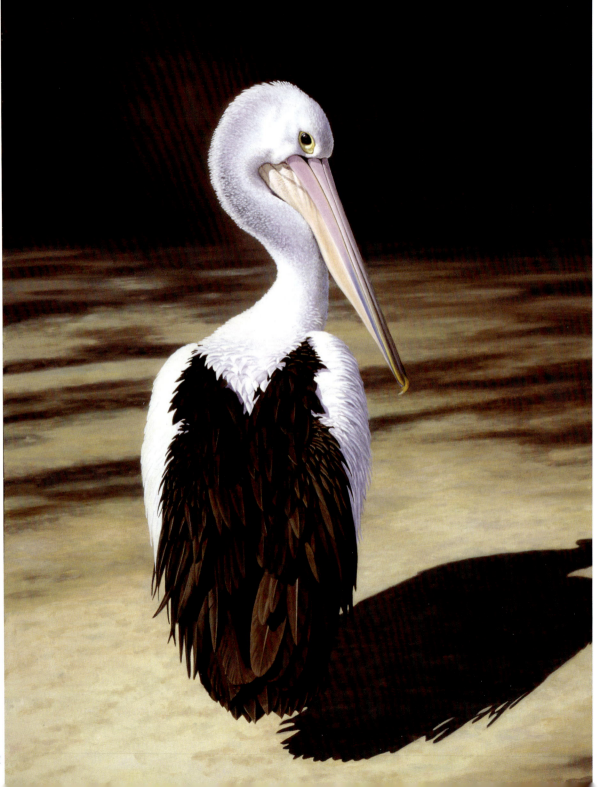

PAINTING THE BACKGROUND

Sally Elmer

As a child I was a daydreamer; I saw birds, animals and wonderful/fantastic beasts in the clouds, I was mesmerised by floating sunlit dust motes, I imagined being a tiny person down with the anemones while catching shrimp in small rock pools, and while travelling at night marvelled at how the moon kept pace with us, no matter how fast or slow we went.

Between the ages of seven and ten, we lived in the Adelaide Hills country where I was very happy – undulating farmland, natural bush, wildlife and a small school of 69 children and three teachers. My sisters and I explored the bush, one day coming home with a baby bird which had fallen out of its nest – a Dusky Woodswallow, which we raised until it took itself off when ready. It would bury itself against our necks and in our hair, which we then spent hours brushing out a very knotty mess.

At the age of ten, we moved to Brisbane suburbia, where dad set up his own electrical engineering business, with mum as secretary. Dad always had a 'project' on the go at any time, involving snakes, fish, birds, orchids, butterflies… so our family weekends were spent out in the natural environment, collecting termite mounds and fresh grass seeds to feed breeding birds, or collecting shrimp with fine nets from low tide rock pools to feed colourful fish and anemones in our large saltwater aquarium. I was very attracted to the lionfish which was just begging to be drawn… Drawing is something I have always enjoyed; being a very visual person, it is my way of learning about and understanding nature's world around me, and to

capture its beauty. This basic mind-set has never left me – illustrations and diagrams always explain things to me better than words do.

After high school, I enrolled in the Diploma of Fine Art course at the Queensland College of Art. Mum was keen for me to 'learn the basics' as she had done, but Dad told me not to waste my time since 'there is no career in art' and I certainly did not fit into the 'arty' world, my realist style (and therefore me) being scorned. One teacher (whoops, I think they prefer the word lecturer) asked me why I was there. When I told him 'to learn about

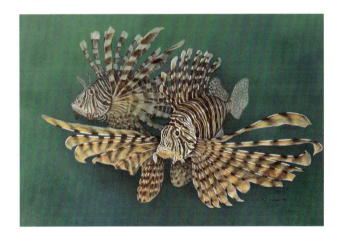

composition, perspective, colour, different media' his response was 'You can go to the library for that.' Another teacher told me to 'Express yourself.' I was! I wonder what they thought their job was? I quietly rebelled against throwing paint at a canvas and went from credits in the first semester to failing drawing and painting in the second. My work is now in the prestigious 'Birds in Art' collection in the Woodson Art Museum in America.

During my first college Christmas holidays, I volunteered at the Queensland Museum art department, remembering childhood visits to an uncle who worked in the art department of the New South Wales Museum. I was fascinated with creating the illusion of reality. Volunteering led, at the age of 19, to employment as a cadet museum artist, which, unfortunately for me, meant continuing with my Fine Art Diploma part time. Four years later, I was rewarded with a piece of paper that represents nothing to me, and was of no benefit to my work at the museum or to me. I loved my museum work, painting casts of animals, fish and reptiles for display, preparing information panels and illustrating anything from vintage cars, ship wrecks and insects to a dissected whale larynx for books, scientific papers and posters. These illustrations were measured and colour matched at every step. While working full time, I continued to draw and paint in my own time, further developing my technique/skills and exploring various paint materials. In 1983, at a Queensland Wildlife Artists Society exhibition, I discovered kindred spirits who shared my preference for a representational portrayal of nature. I joined them and the following year exhibited and sold my first two paintings.

After 15 years with the museum, things changed and I was keen to spend more time developing my own work, so I took the plunge and became self-employed, painting images of birds and animals in their natural settings. I also accepted commissions to design and paint murals, one being a 34m long by 2.5m high depiction of 'Rainforests Through Time' from the age of dinosaurs to the present day.

In 2006, Peter and I started working and travelling together – each sharing a strong link with the natural world. It is deeply satisfying and heart-lifting to quietly watch and have wild creatures accept us, and go about their lives: pelicans fishing in temporary desert creeks,

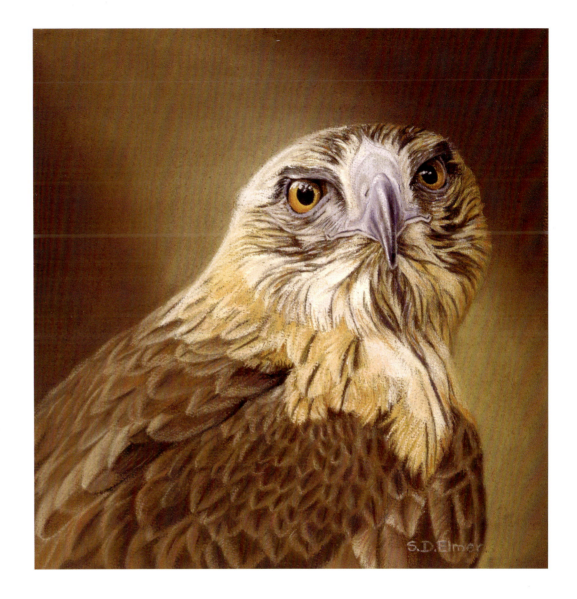

eagles tenderly feeding their chicks, or grebes floating on magical reflections. It is not always easy to stay quiet. The antics of the male Spotted Bowerbird had me in stitches as he pranced, skipped and flashed his wings, mimicking cats, Whistling Kites and Brown Falcons while rearranging his treasures to entice a female.

I work mainly in watercolour and oil – watercolour for more technical illustrations and oil for larger work. My watercolours are always carefully planned because the medium leaves little room for error, while with oil, I plan the basic composition, then let the work develop as I add light and atmosphere. My aims are to portray correctness, which is not the same as painting in detail, rather getting the proportions and colours right and capturing essence, or character, from the ponderous waddle of a pelican to the manic smile of a Blue-winged Kookaburra. Added to that is artistic licence, such as how I compose the picture, juxtapose colours and create atmosphere. Lighting has always been an important element of my paintings, particularly the influence of shadows and reflections.

In 2006, I was approached by the Isisford Shire Council to illustrate their ancient crocodile which lived 98–95 million years ago. Its fossil was found in a creek bed in the mid-1990s, and indicates that the adults appear to be only 1m in length. The mural, inside the Outer Barcoo Interpretation Centre in Isisford, depicts the habitat of the time, and was painted very small (only one metre long) and then enlarged to several metres and printed on a vinyl panel.

Themes from the natural world will always feature in my work – not a conscious decision, just something I am innately drawn to.

PAINTING THE BACKGROUND

Peter Slater

One of my reading primers at the Manjimup Primary School during the Second World War years included a story by James Pollard about a boy who was fascinated by birds. He knew the names of every species and where to find their nests. That seemed to me to be the ultimate achievement, something that became my most overwhelming ambition. I remember our headmaster, Mr Mack, one morning at assembly pointing out a cluster of birds on the flagpole. 'Does anyone know what they are?' he asked. I replied that they were Blue Martins, the name we kids used. Mr Mack kindly told us that they were actually 'Dusky Brown Wood Swallows'. They didn't look brown to me, so after school I went to the council library and asked the librarian if there were any books about birds. She gave me Neville Cayley's fabulous book, *What Bird Is That?* I devoured it from cover to cover and quickly discovered that the birds were Dusky Woodswallows, not brown at all. Cayley quickly became my bible, but I soon detected a serious error. I often went to stay on the Pearces' dairy farm at Middlesex, a few kilometres from Manjimup. Shirley Pearce was older than me but she was my favourite person in all the world because she knew the names of birds, learnt from Mr Rooney, the teacher at the small Middlesex School. There was one bird I often heard calling along the creek running through the farm – a sad, melancholy threnody that always seemed unfinished, as if the bird had meandered halfway through its song and forgotten the ending. I asked Shirley what it was and she said it was a Golden Warbler. Although I searched diligently I couldn't locate the bird, so checked Cayley to find out what it looked like. Guess what? I couldn't find Golden Warblers mentioned anywhere, so figured Cayley was wrong. It took a few years to work out that Shirley had confused the names of the Golden Whistler and the Western Warbler, but still, whenever I hear that unfinished symphonic gem in the bush, I think, 'Ah, a Golden Warbler!' By the time I was 16 I knew the name of every bird I was likely to encounter and where to find its nest, but it no longer seemed such a grand achievement; there is just so much more to birds than that.

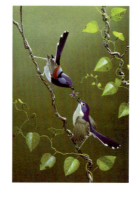

At the age of eight I did a drawing of a bird-of-paradise, copied from an encyclopedia, and taped it to the wall in my bedroom. Aunty Topsy came to stay and when she saw the drawing deluged me with high praise, just the thing every eight-year-old needs. So I started drawing birds, using coloured pencils for the shading. I remember the first book I produced, shortly afterwards, incorporating copies of illustrations from a book about British garden birds. Each drawing was on a separate sheet; Mum bundled them together and stitched along one side on her Singer sewing machine. So my *Opus One* was about Lesser Whitethroats, Blue Tits, Chaffinches etc etc.

When our family moved to Kalgoorlie I spent all of my spare time in the bush and accumulated a portfolio of drawings of all the birds I came across, and eventually exhibited them in the Town Hall. I showed them to Eric Sedgwick, Western Australia's premier birdwatcher at the time. He advised me to switch from coloured pencils to watercolour, and I value his early encouragement as well as that from Olive Seymour and John Halse.

While at Teacher's Training College I met a number of trainees who were similarly interested in birds. One was Eric Lindgren, with whom I used to attend meetings at the newly-formed chapter of the Royal Australian Ornithological Society. Vincent Serventy chaired the meetings and regularly suggested someone should produce a field guide to Australian birds. For some unknown reason Eric and I took the bait and over the next few years started work doing the illustrations, text and maps. With the assistance of the CSIRO Division of Wildlife Research, the first of two volumes, *Non-Passerines*, appeared and was immediately successful. Eric took up a position as biologist in Papua New Guinea, where he didn't have access to research material, so reluctantly withdrew from the project (but retains a keen interest in its various reiterations), so I did the text and illustrations for Volume 2, *Passerines*, on my own. This was followed by a book on *Rare and Vanishing Australian Birds* in 1970. Although the field guides were successful in terms of sales I was still learning how to paint, and was unhappy with the illustrations in both volumes, so worked on a single volume with new artwork and text. My son Raoul, who was still at school at the time, prepared the maps. My wife Pat, who would have been happier out photographing horses, typed literally

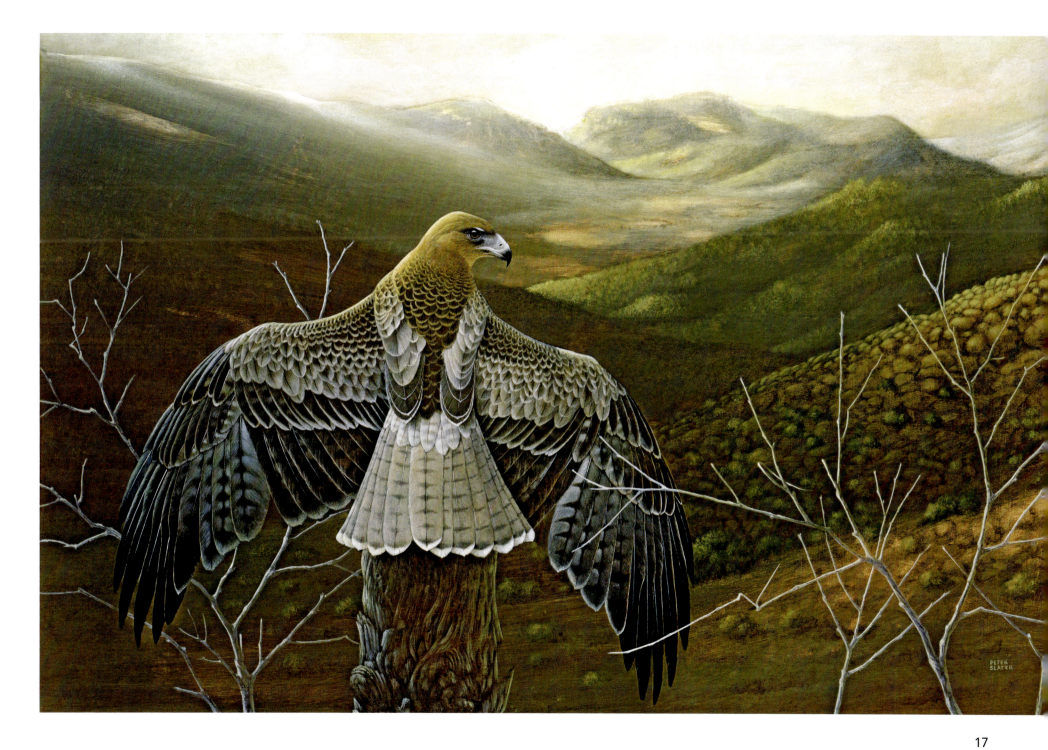

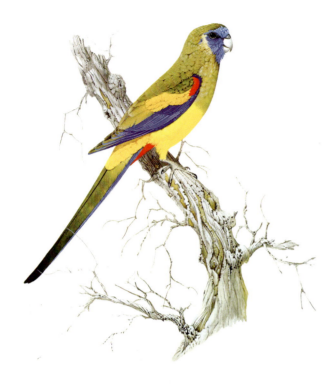

hundreds of pages of various drafts as well as the final manuscript with an old Olivetti typewriter, as it was in pre-computer days. Later she became expert with computers, working on manuscripts for our friend Steve Parish. He published a book of my paintings and drawings of birds in 1997 and another book of bird of prey paintings a few years later.

When Pat died in 2003 I inherited her computers and printers and set about the, for me, difficult task of working out how to use them. Steve was keen to publish a book about her and her horse photography so I came up with a manuscript with illustrations and text. The editor reorganised the photos, rewrote the text (grrr), and handed me a (very) rough draft, saying she wanted a completed InDesign manuscript by Monday (it was Friday). Pat's great friend and co-editor Kate Lovett gave me a quick one-hour course on InDesign, and I worked non-stop without sleeping until Monday morning, delivered the manuscript and crashed for a week. It wasn't the first time I was set an impossible deadline. A freelance writer approached me to see if I could help him. He was contracted to deliver an illustrated book about Australian waterbirds. I agreed to do it and he said, 'Oh, by the way, I need it in a fortnight'. Believe it or not, I designed, wrote and illustrated the book with photos taken by Raoul and me, as well as with birds we hadn't photographed from Tom and Pam Gardner, and delivered it 13 days later. I crashed again, for longer this time.

Adding a large-format printer and a scanner to the equipment inherited from Pat, I set about learning how to produce limited edition giclee prints. I had met Sally Elmer at the inaugural meeting of the

Above left: Cover illustration from *Rare and Vanishing Australian Birds*. Below left: A Spotted Bowerbird from a children's book, *Australian Bush Birds*.

Some of the photographic books I wrote and illustrated, including pictures by Sally and my son Raoul.

The preparation, illustration and production of field guides to birds occupied a large proportion of my life, basically from 1964 to 2008.

Queensland Wildlife Artists Society and was very impressed by her paintings. In 2006 she mentioned she was interested in having limited edition prints made, so I offered the use of my printer. Over the next month or so we produced editions of 24 paintings. With her background as artist and designer at the Queensland Museum Sally quickly became very proficient in colour matching and would often spend hours getting each print just right, something that would probably not be possible in a commercial studio. While we were working we chatted about this and that. I mentioned that the field guide was being reprinted every year, but over time the colour rendition was moving further away from the original. That inspired her to suggest we work on a totally new edition, using the techniques learnt while producing the prints. So all of my original artwork was scanned in the studio and meticulously colour-matched. We redesigned many of the plates and Sally became expert at moving images around and improving the backgrounds. I added a lot of new paintings that Sally slotted into place. Then we transferred them, an updated text and new maps to an InDesign document, and this second edition appeared in 2007. Work on a third edition is in progress, necessitated by birdwatchers adding new birds to the Australian list and taxonomists 'splitting' other species, as well as replacing all of the maps.

Another thing we discovered was that we shared a fascination with deserts, and in 2008 began making lengthy trips into the interior each year, concentrating on raptors. We also started work on a number of books, among them *Glimpses of Australian Birdlife* and *Visions of Wildness,* both including photos by Raoul.

I've been lucky to be able to spend my life doing what I love best, looking at, enjoying and illustrating birds. I doubt if there is a better occupation.

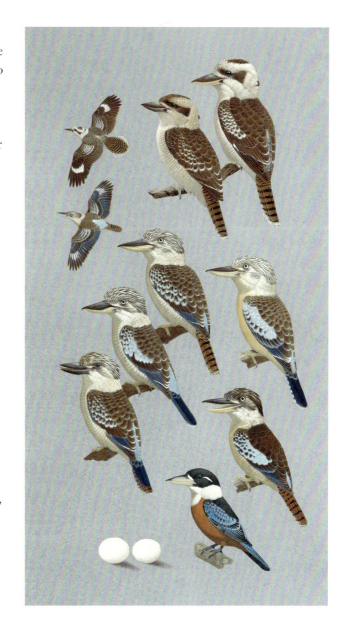

These kookaburras were initially painted for the *Handbook of Australian, New Zealand and Antarctic Birds*. Sally reorganised them for the *Slater Field Guide to Australian Birds*.

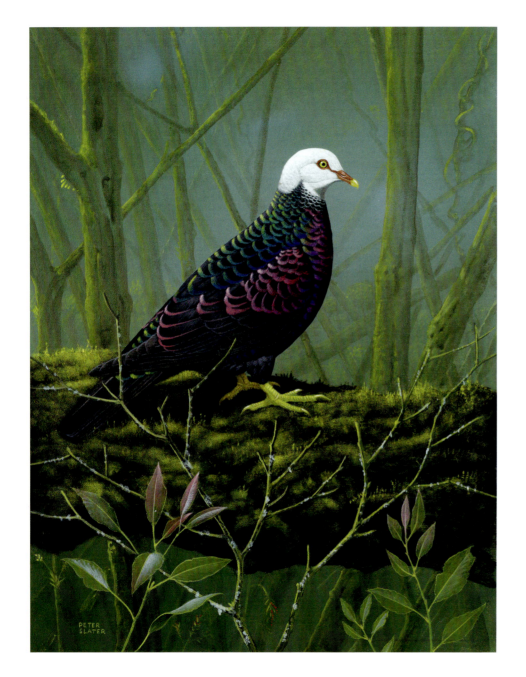

Yellow-legged Pigeon

Moustached Kingfisher

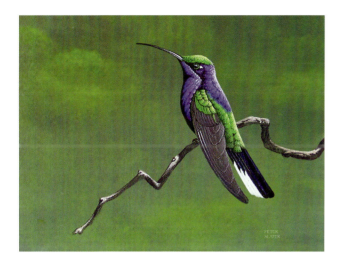

Hummingbird

At various times I have painted birds found in other countries. The Yellow-legged Pigeon, Moustached Kingfisher, Finsch's Pygmy-Parrot, Solomons Cuckoo-shrike and Black-faced Pitta (these last three overleaf) were painted for Don Hadden's book *Birds and Bird Lore of Bougainville and the North Solomon Islands*. Neither the kingfisher nor the pitta was used. The hummingbirds at Jurong Park in Singapore inspired a series of paintings of these incredible birds, trying to capture the glistening iridescence. Pat and I spent a fortnight in the desert near Abu Dhabi watching Gyrfalcons being trained. They were captive-bred birds and were flown freely every day. To be so close to these awesome birds was one of the most memorable highlights of my life.

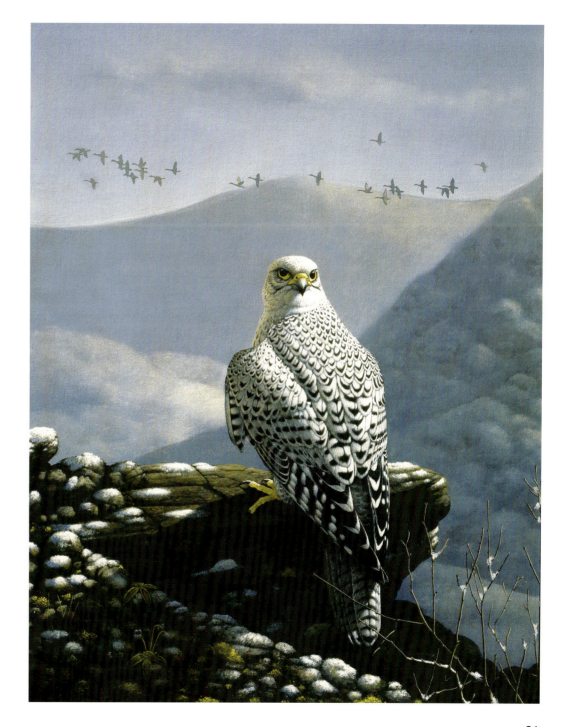

Gyrfalcon

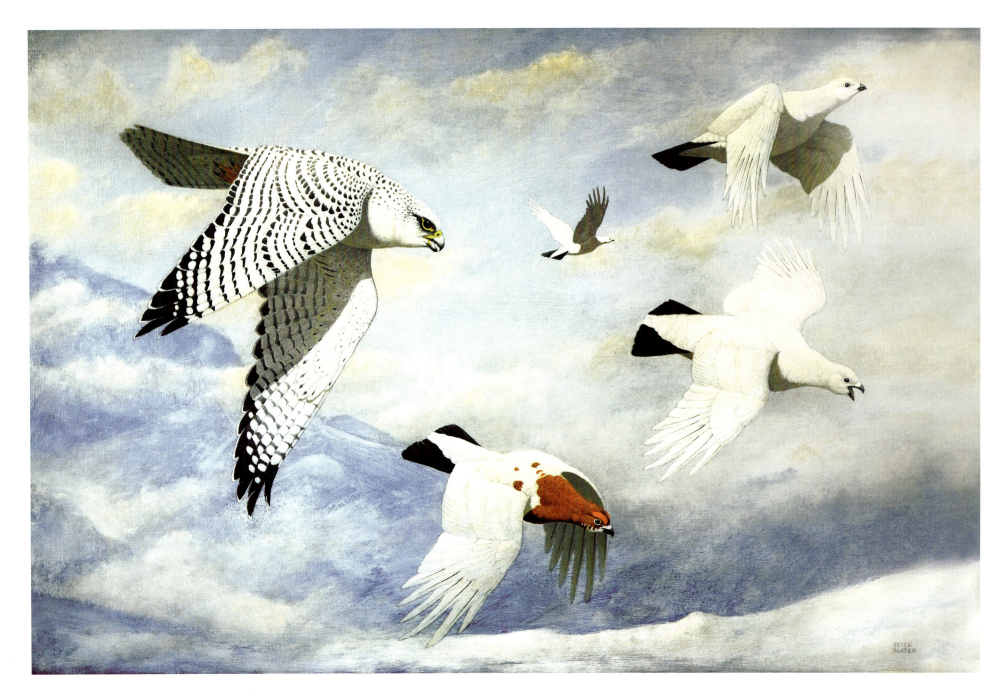

Gyrfalcon chasing Willow Grouse

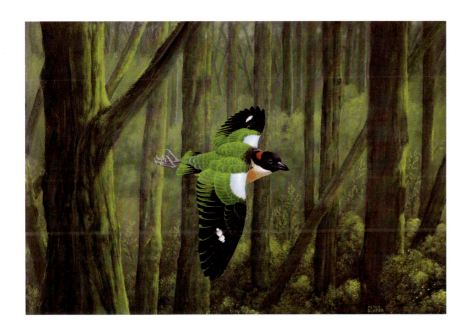

Black-faced Pitta

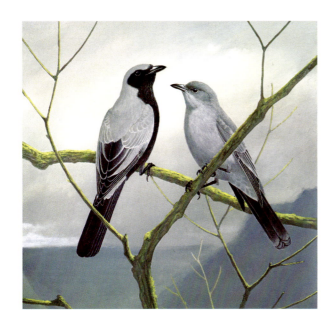

Solomons Cuckoo-shrike

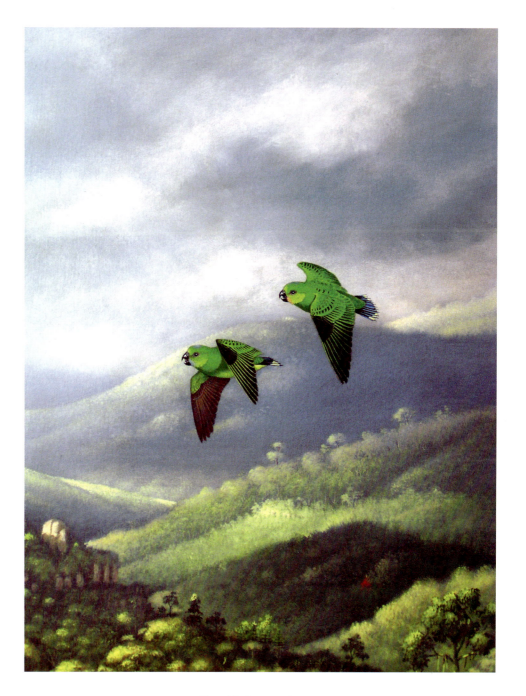

Finsch's Pygmy-Parrot

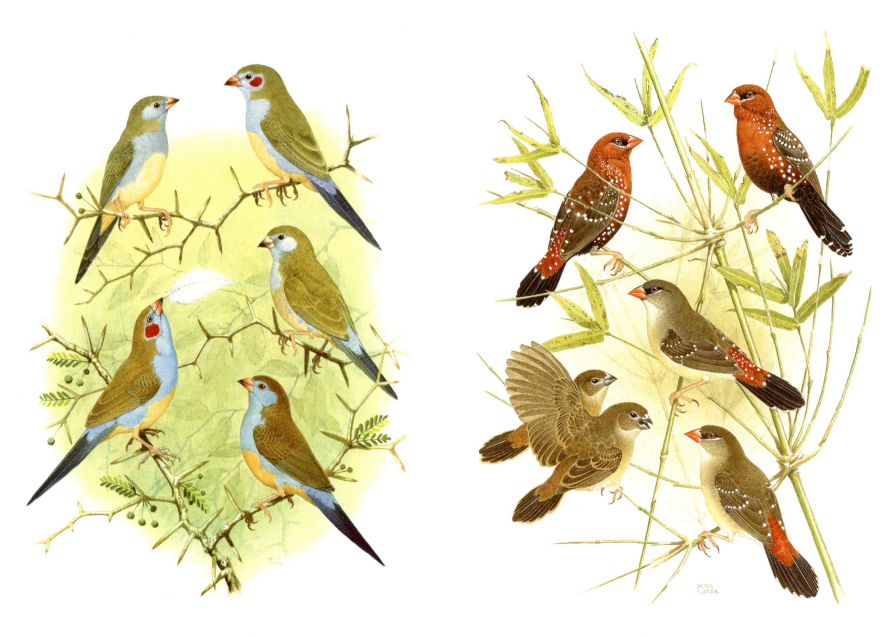

Red-eared Cordon-bleu

Red Avadavat

These illustrations were made for a proposed book on Grassfinches of the World.

Red-faced Parrot-Finch

Thou, Nature, art my goddess

King Lear: William Shakespeare

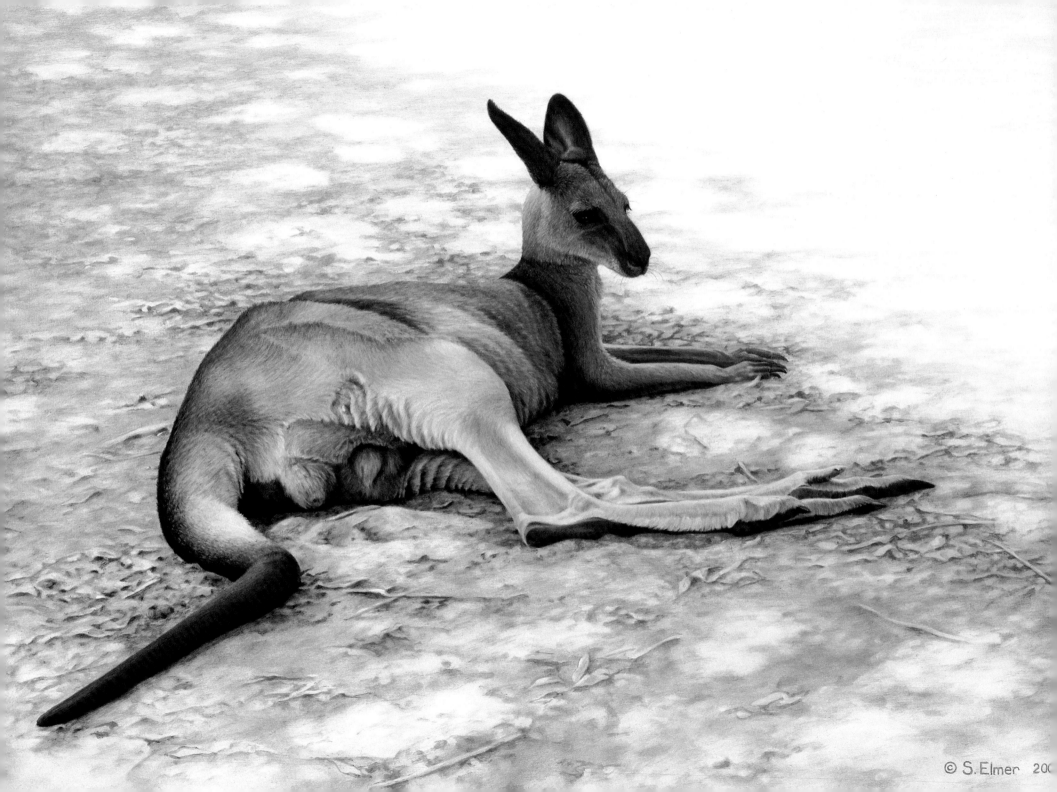

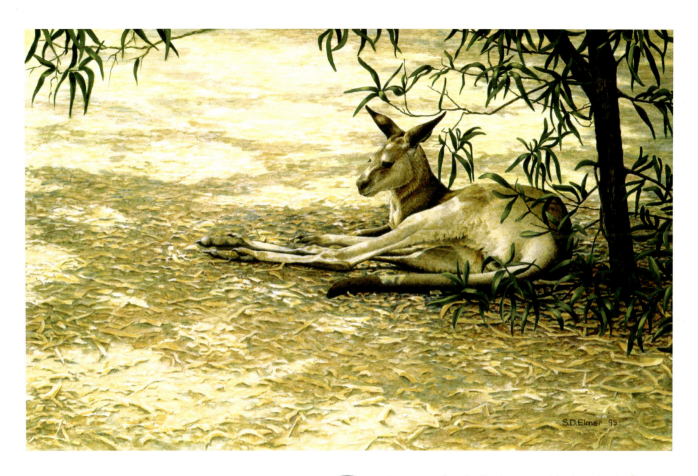

EASTERN GREY KANGAROO

Grey is a term for shades between black and white. But for artists, black is a 'dead' colour and mixtures of black and white to achieve a grey colour are wholly unsatisfactory. Many creatures are described as grey: Grey Whale, Grey Falcon, Grey Whistler, Grey Shrike-thrush and so on, but rarely are the shades of grey in them the same. So artists painting them use a variety of colours to achieve the desired effect. In the Grey Kangaroo opposite, Sally employed raw umber, burnt sienna, indigo, yellow ochre, purple and white. If all of these colours were mixed together on the palette the result would be 'mud,' so Sally used each in turn as an overlapping transparent glaze, alternating a warm colour with a cool one.

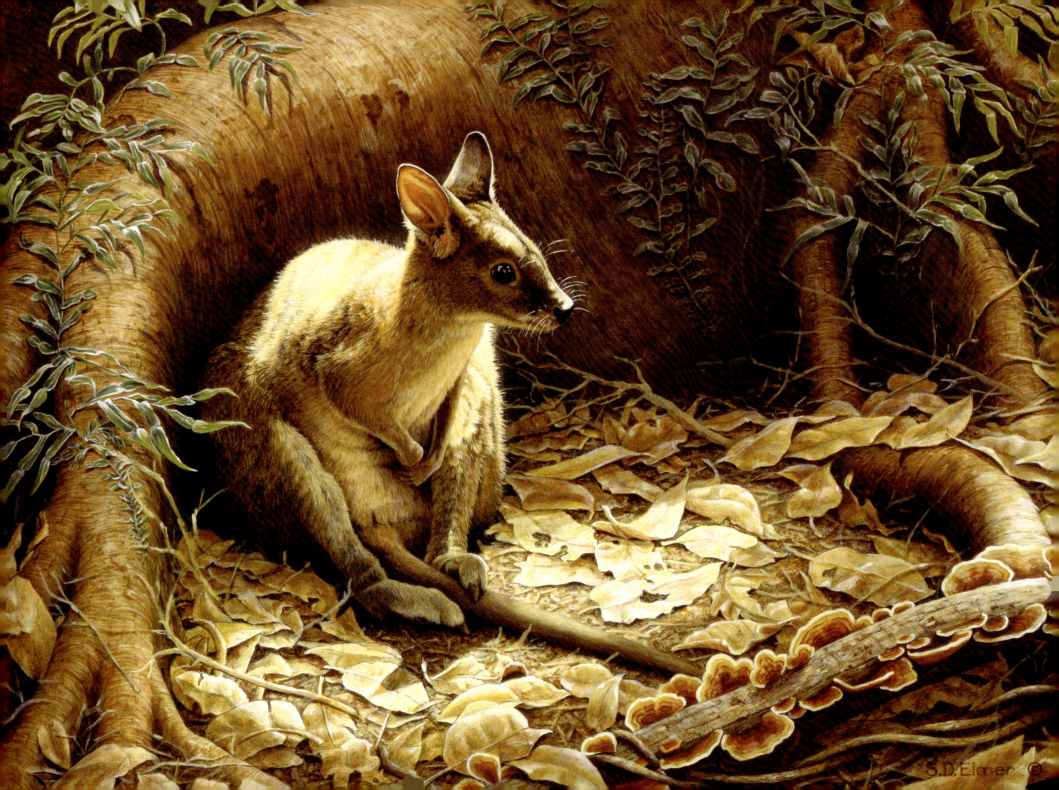

RED-NECKED PADEMELON

The name pademelon is an anglicised version of the aboriginal word 'bademaliyon', used by the original inhabitants of the Port Jackson area, and adopted by early English settlers. The Red-necked Pademelon is a rainforest species; Sally found her subjects in the Mary Cairncross Scenic Reserve, close to her home. On cold days, these small macropods habitually seek out patches of sunshine to keep warm – a sight that motivated Sally to paint her pictures. The reserve, within the precincts of Maleny, is a remnant of the rainforests that once clothed the ranges north of Brisbane. It was owned by the Thynne family; three sisters gifted the 55-hectare property to the Landsborough Shire in perpetuity and named it after their mother, Mary, whose maiden name was Cairncross. Among the magnificent old trees conserved in the park are these massively-buttressed figs.

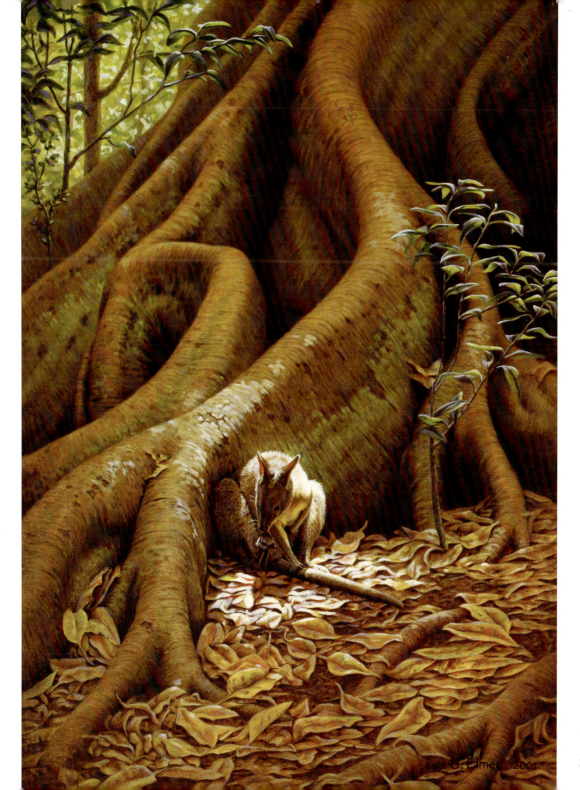

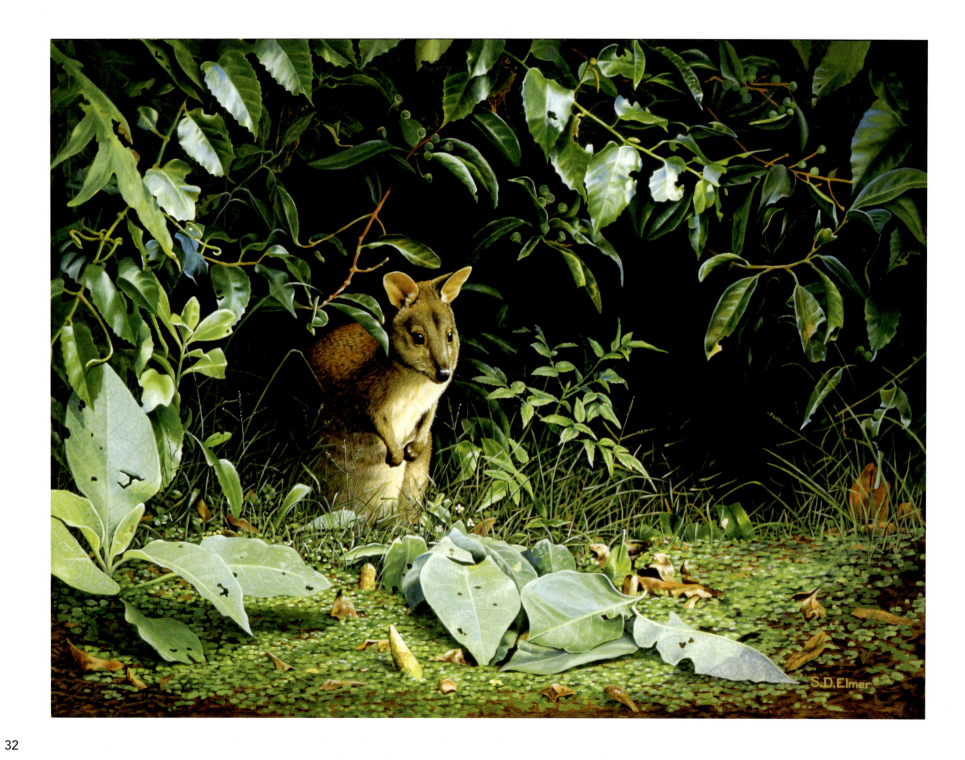

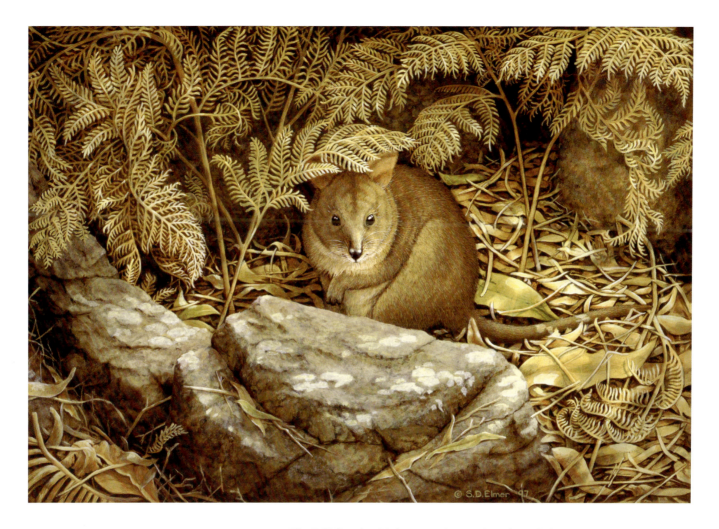

RED-NECKED PADEMELON

TASMANIAN PADEMELON

Hiding in thick vegetation at the edge of the forest, making sure all is clear before coming out to graze. Pademelons are nocturnal creatures, and rest by day deep in the rainforest. I have used totally different colour palettes for each of these paintings – the Red-necked Pademelon in the lush green edge and deep shadows of a Queensland rainforest, and the Tasmanian Pademelon in ochre tones under dead bracken fronds.

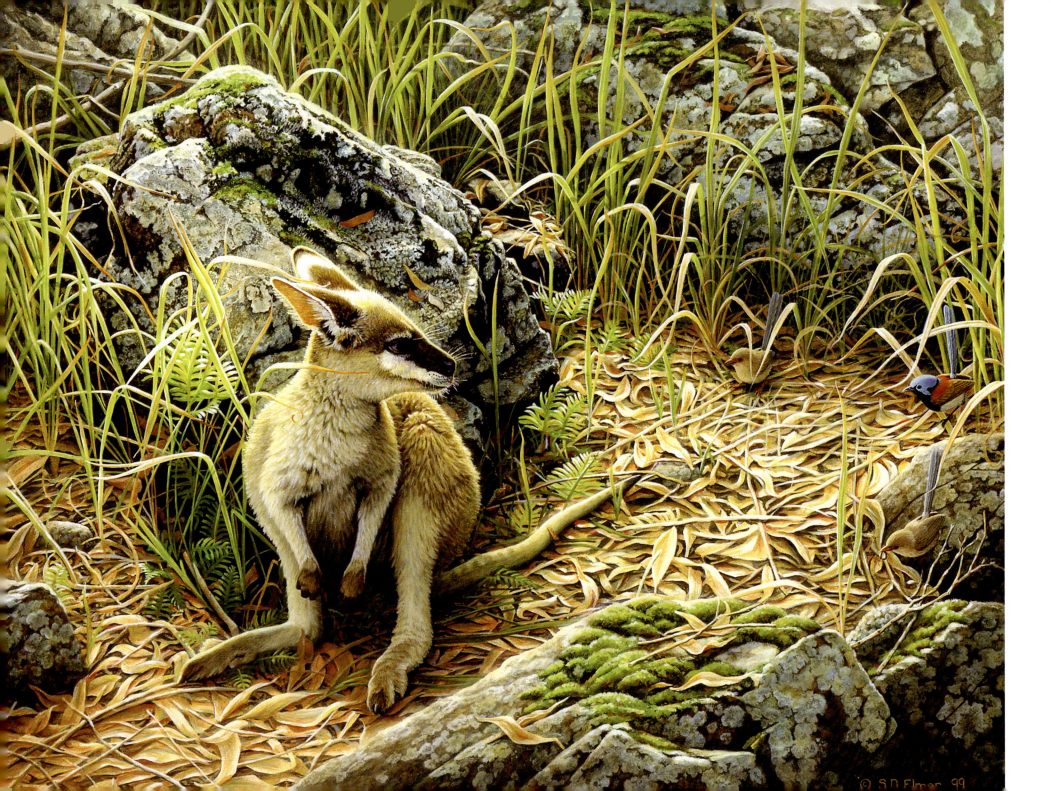

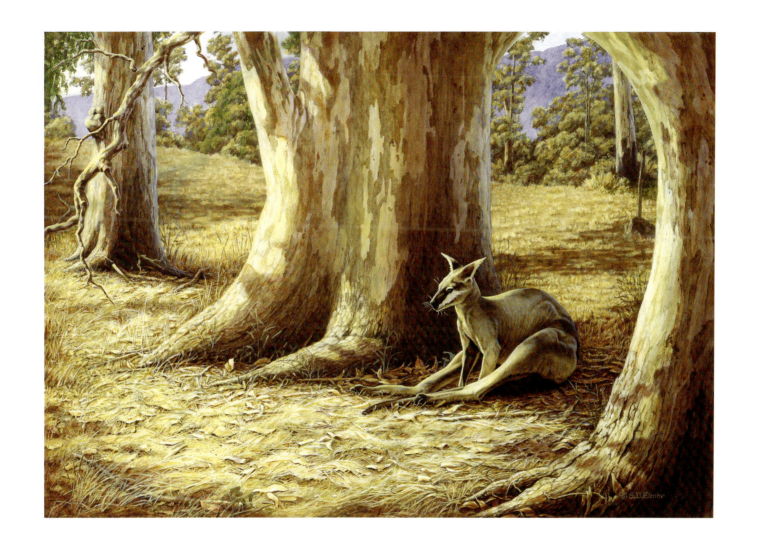

WHIPTAIL
WALLABY

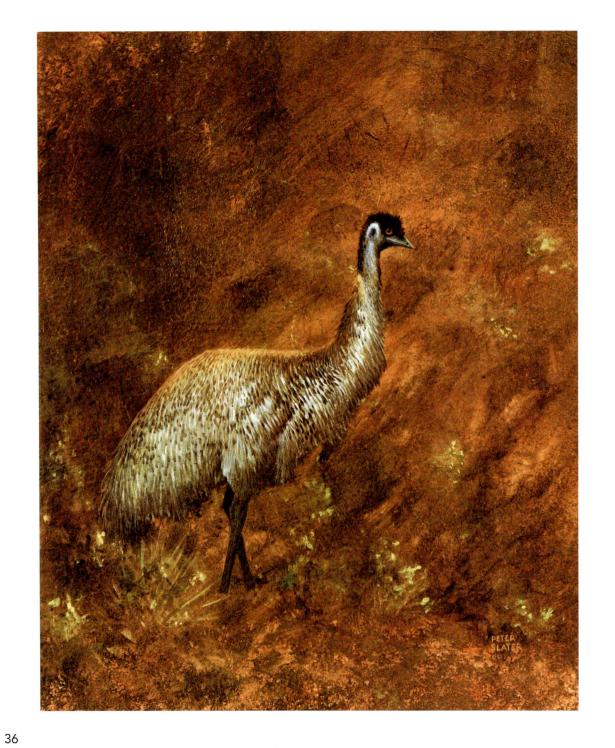

TASMANIAN EMU
SOUTHERN CASSOWARY

Tasmanian Emus became isolated from the mainland when the thawing of the last ice age inundated Bass Strait, about ten thousand years ago. Aboriginals were cut off as well; they undoubtedly preyed on the emus, but probably not to the extent of affecting numbers. That equilibrium soon changed with the European colonisation of the island, and by the middle of the 19th century all island emus had gone, killed either for food, because they were considered to be pests, or due to habitat destruction. A recent theory suggests that non-native egg-eating rats may have contributed as well. The precise date of their demise is not known because some mainland emus were introduced about 1860. The last captive bird died in 1873. There are no known specimens of Tasmanian Emus in Australian museums although a few landscape paintings from the colonial years include small rather obscure images, so my rough sketch is pretty much guesswork. The Southern Cassowary is still here, thank heaven (or whoever was responsible for preserving at least some of the rainforest it inhabits), nevertheless its vulnerability has led to it being listed as Endangered. For a bird that lives in north-eastern Australia it might seem strange to call it the Southern Cassowary, but there are two other species, as well as several possibly distinct subspecies of this one, on islands to the north. All are important to the ecology of rainforests thanks to the role they play in disseminating seeds.

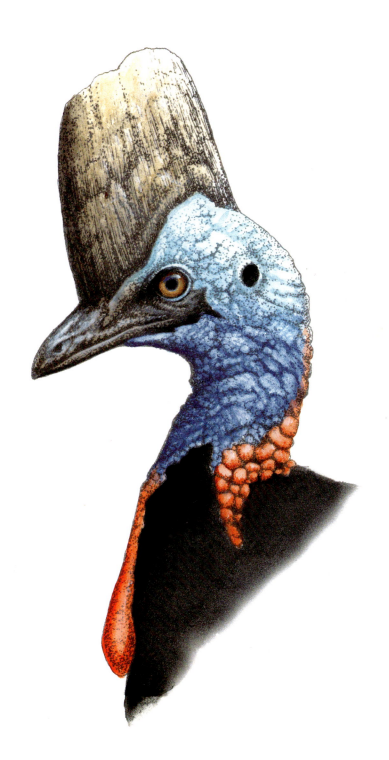

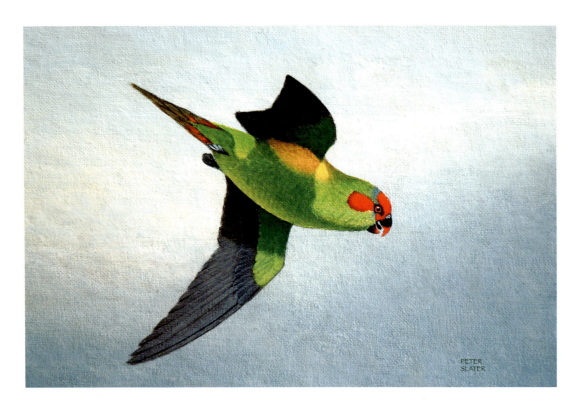

MUSK LORIKEET

RAINBOW LORIKEET

In times past thousands of Musk Lorikeets were trapped on long poles covered with horse-hair nooses, attracted by cages of call-birds, and just as many were destroyed in orchards, due to their penchant for ripening fruit. Early reports mention a strong musk smell in nesting hollows, but people who have handled live birds, among them parrot authority Joseph Forshaw, suggest that there is little or no odour in the feathers. John Gould wrote in 1865: '... in the more southern country of Tasmania, ... it is known by the name of Musk-Parrakeet, from the peculiar odour it emits.' Musk Ducks have a strong smell, and, to a lesser extent, so do Red-winged Parrots and Apostlebirds. We have never detected any odour from the Rainbow Lorikeets that frequent our backyards. Sally has a number of euodia trees near her house, where the lorikeets feed on the nectar-rich blossoms (right).

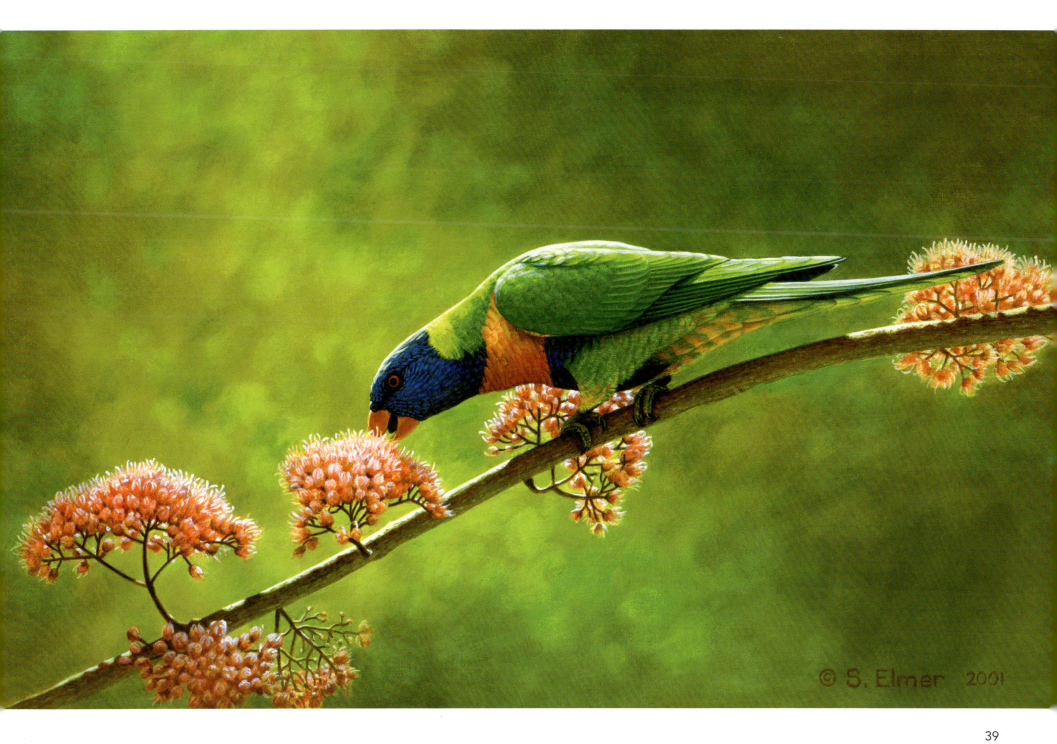

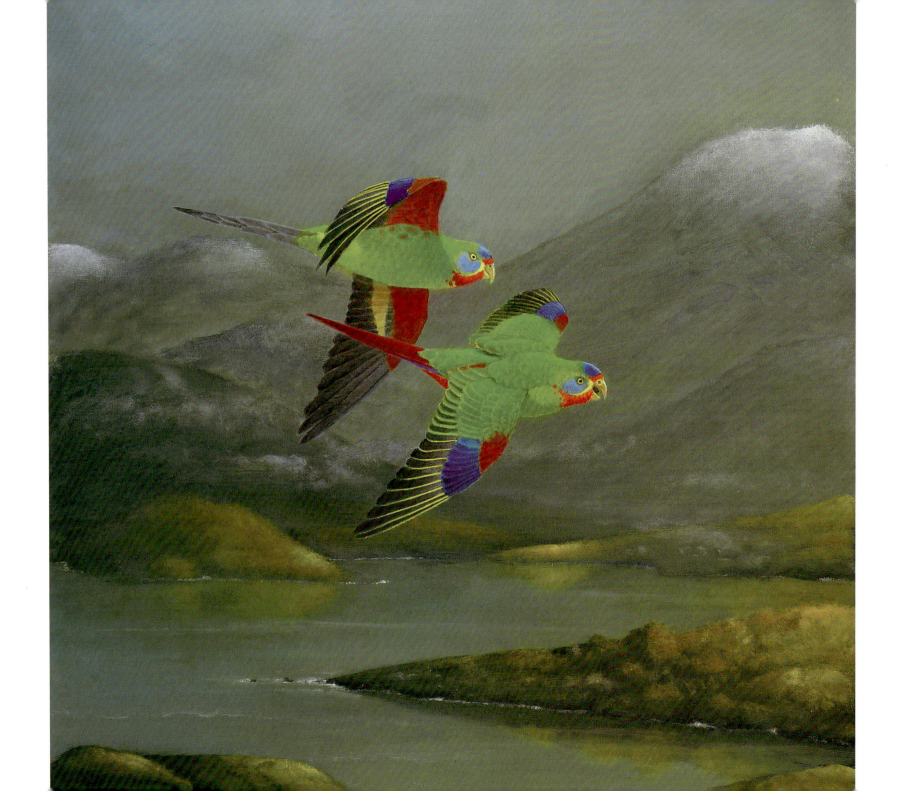

SWIFT PARROT
SUGAR GLIDER

Swift Parrot is now listed among Australia's most Critically Endangered birds. When I first saw a small flock in Victoria in the 1960s I thought they were still reasonably common, but a combination of factors have led to a rapid decline since then. They breed in Tasmania, migrating each year to the mainland where the eucalypts they rely on for nectar have decreased. In many areas interested observers have been replanting suitable eucalypts to provide winter forage. In Tasmania, a decline in the number of trees suitable for nesting is one reason for diminishing numbers; the other is the proliferation of the introduced Sugar Glider. Like many introduced species, the glider in Tasmania is a feral pest; it enters the nesting hollows of the Swift Parrot and devours eggs and chicks. Efforts are being made to provide hollows that exclude marauding gliders.

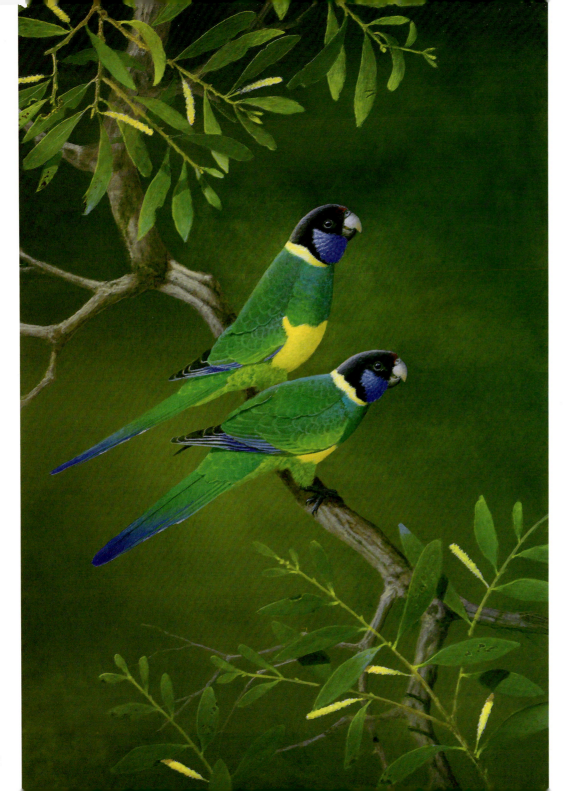
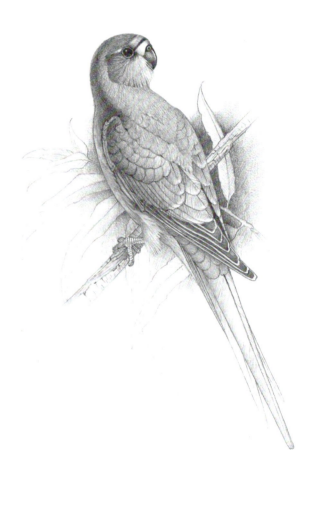

AUSTRALIAN RINGNECK
ELEGANT PARROT
RED-WINGED PARROT

Red-winged Parrots are still common in drier woodlands of the east and north. We see them frequently on our annual trips through the interior, either in pairs or small flocks, flying with lazy wing-beats. Our best views come when they are feeding on mistletoe berries in trees like the native bauhinia; they seem to be more approachable then. Maybe the sugar-rich flesh surrounding the berries is so succulent that they are reluctant to fly, or perhaps it has a soporific effect. Australian Ringnecks come in a variety of forms, some of which were thought to be different species in the past. This pair is characteristic of arid country birds, once known as Port Lincoln Parrots; Ferdinand Bauer made a painting of the first known specimen, collected by his travelling companion Robert Brown in 1801 near where Port Lincoln now stands. The pair, artist and botanist, were accompanying Matthew Flinders on his epic circumnavigation of Australia. The Elegant Parrot doesn't appear to me to be any more elegant than its relatives, the Blue-winged, Rock, Scarlet-chested, Turquoise and Orange-bellied Parrots, but they are all very attractive, each in its own way.

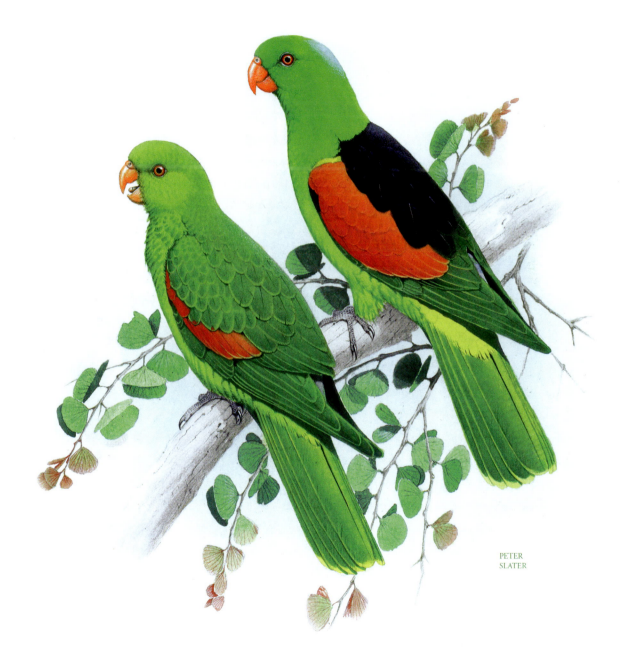

PETER SLATER

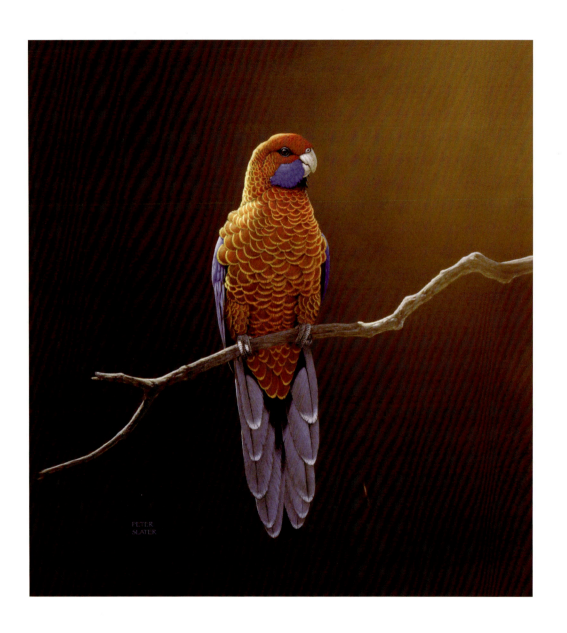

ADELAIDE ROSELLA

EASTERN ROSELLA

The Crimson Rosella comes in a variety of colours so its name is not really satisfactory. The crimson element of the species is confined to the humid forests of the east, while the population inhabiting the Murray Darling confluence is yellow. In the zone between the two, birds are a varying mixture of the two colours. Imagine the scene: birdwatcher and son see a yellow parrot on the lower Darling River. 'What's that, dad?' 'It's a Crimson Rosella, son'. 'Really?' One particularly spectacular bird I saw in the hybrid zone in South Australia inspired me to do this painting (left). It makes some sense to retain the old names, Crimson, Yellow and Adelaide Rosellas for the three forms, so I think of the bird I painted as the Adelaide. There is an alternative possibility. Thomas Pennant was a friend of Joseph Banks and from him received specimens of Australian birds, among them a Crimson Rosella which was named after Pennant by John Latham in 1790. Gould also referred to the rosella as Pennant's Parrakeet, as did North and Campbell in their early 20th century books about birds' nests and eggs. So Pennant's Rosella might do. Maybe not; there have been enough name changes already.

Sally was inspired by the sight of Eastern Rosellas feeding near an old wagon (right); some would suggest it epitomises a nostalgia for times past, when birds occupied a bigger space in the environment.

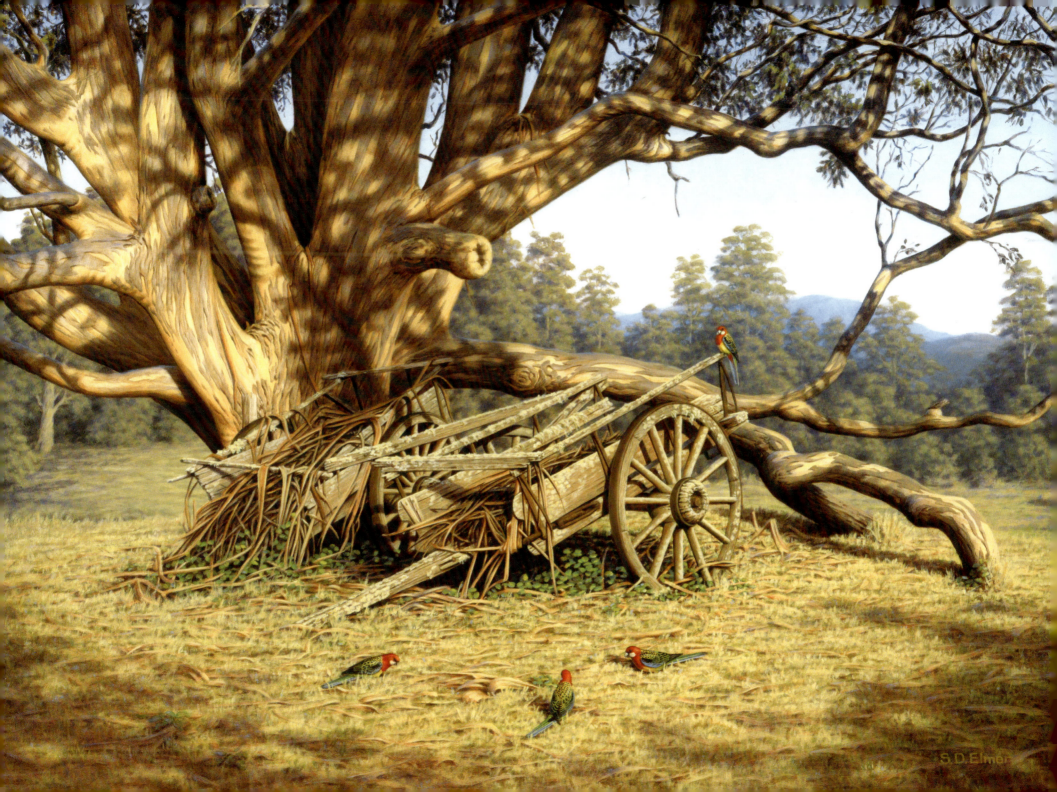

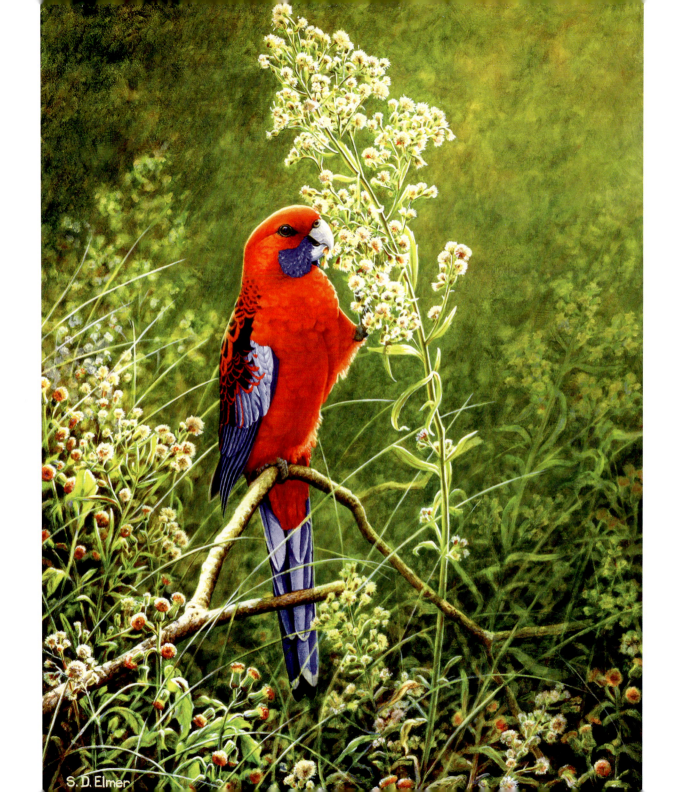

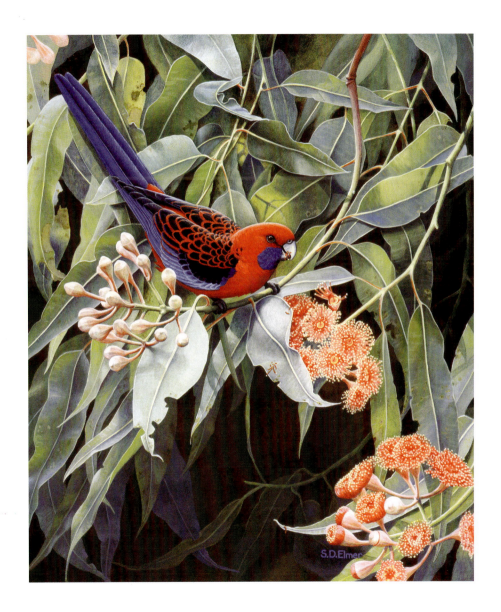

CRIMSON ROSELLA

Some birds are too easily seen. To be properly appreciated they should require considerable effort to locate them. Like the grasswrens, scrub-birds, bristlebirds, Night Parrot, Grey Falcons, Buff-breasted Buttonquail, Princess Parrot and Golden-shouldered Parrots. Crimson Rosella is one species that should be hard to find; they should be extremely shy, requiring a stealthy, creeping approach through tangled snake-infested jungles on steaming mountain-sides to catch the most fleeting of glimpses. But they are not. They are too easy to see; in some places where flocks are fed they will clamber over people for handouts. Too familiar; what twitcher would travel one, let alone a thousand, kilometres to see one? Just too easy, but still, incredibly beautiful. So next time you see one, pretend you have never encountered one before, and enjoy the visual sensation.

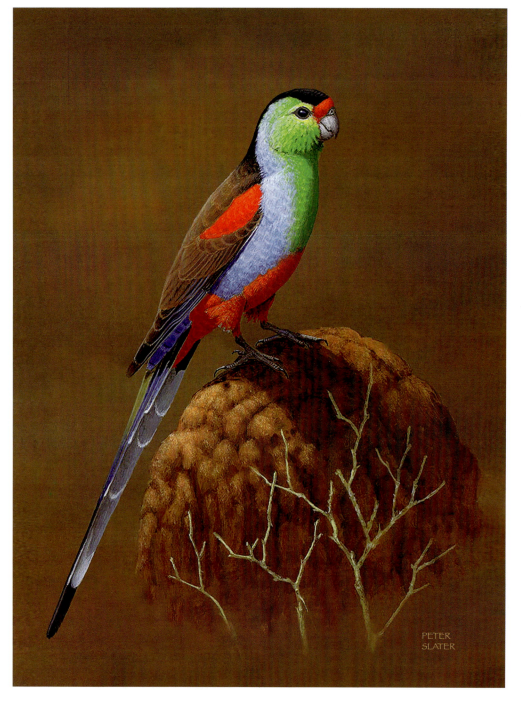
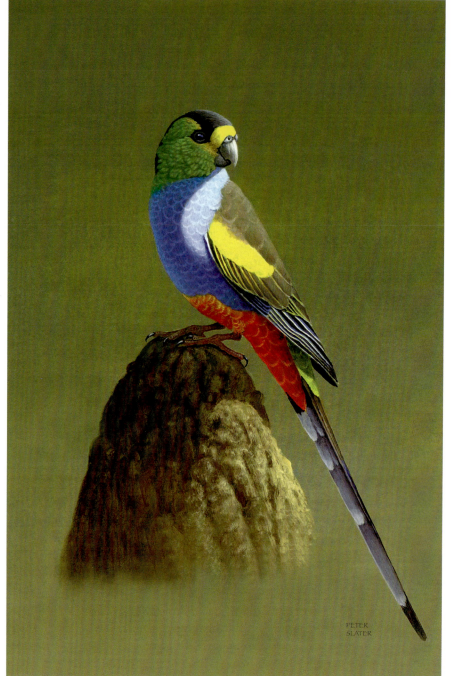

PARADISE PARROT
GOLDEN-SHOULDERED PARROT
HOODED PARROT

John Gilbert, collector for John Gould, discovered the Paradise Parrot (far left) while he was in Queensland in 1845. Such was the impression that this exquisitely-plumaged bird made on him that he requested that Gould should name it after him. Gould's response was that he had already given his name to Gilbert's Whistler – elsewhere Gould wrote that the whistler was one of Australia's plainest birds, so although it is nice that the collector is memorialised, I feel the parrot would have been more in keeping with Gilbert's contribution to Australian ornithology. So deep inside I think of the Paradise Parrot as *Psephotus gilberti*. The world is a poorer place because it is extinct, although one of my friends is convinced it is still out there and spends a lot of time looking; we still hope for the best. The Golden-shouldered Parrot (left) of Cape York Peninsula was sighted by Gilbert in 1846, a few days before he was fatally speared, but he didn't collect any. A young doctor, Joseph Elsey, was in the vicinity a few years later and managed to secure some specimens that Gould described and named *Psephotus chrysopterygius,* which basically means 'golden winged pebble-face'. I wouldn't have minded if he had named it after Elsey, who discovered a number of Australian birds and who died too young at the age of 24. The Hooded Parrot (right) was one of the birds painted by Ferdinand Bauer while travelling with Matthew Flinders, circumnavigating Australia in 1801. Apparently no specimen survived so the Hooded wasn't named until 1898. It wouldn't have hurt if it had been called *Psephotus baueri*.

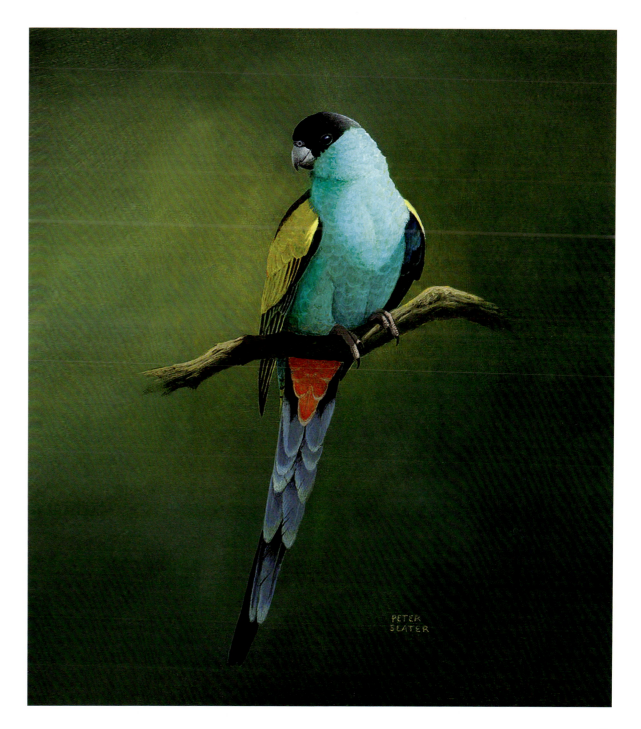

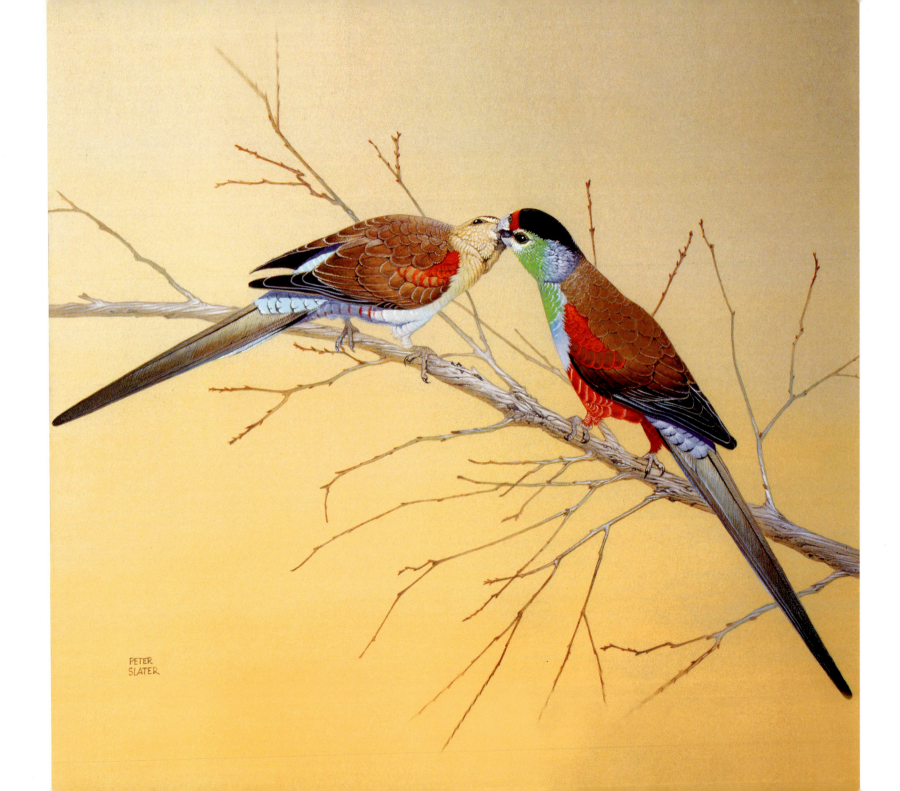

PARADISE PARROT

My friend, Grant Squelch, at that time farming near Guluguba, Queensland, contacted me with the news that a party of presumed Paradise Parrots had been sighted on a nearby property, Mapala. Between Taroom and Mapala there is an abundance of unspoilt bush, and in fact some time previously I had suggested it as a likely place to search. Grant and I drove out to Mapala and spent a few days looking; there were plenty of termite mounds among the open woodland, but we were unsuccessful. Anyway, our contact, Chris, described what he had seen, a small group of birds attracted by the sprinkler on the lawn, and his description of them seemed to fit. He was due to commence studies at university, so I counselled him to keep the news to himself until he had a degree, then, if the identification was verified, approach the owner of the property, Janet Holmes à Court, while seeking funding for a study hopefully culminating in a PhD. Despite my advice, in his first year at university, Chris wrote a paper about Paradise Parrots, including his presumed sighting, creating a lot of interest. Several parties of really good birdwatchers visited Mapala, conducting thorough searches, without result. The general feeling was that Chris had made an error in identification and that the birds could have been the local variety of the Bluebonnet, which also has a red shoulder. Penny Olsen wrote about the incident in her book, *Glimpses of Paradise,* and dealt rather critically with Chris, more or less equating him with individuals who had made spurious claims about the parrots. However, from our early discussions with Chris I am convinced he genuinely believed he had seen Paradise Parrots.

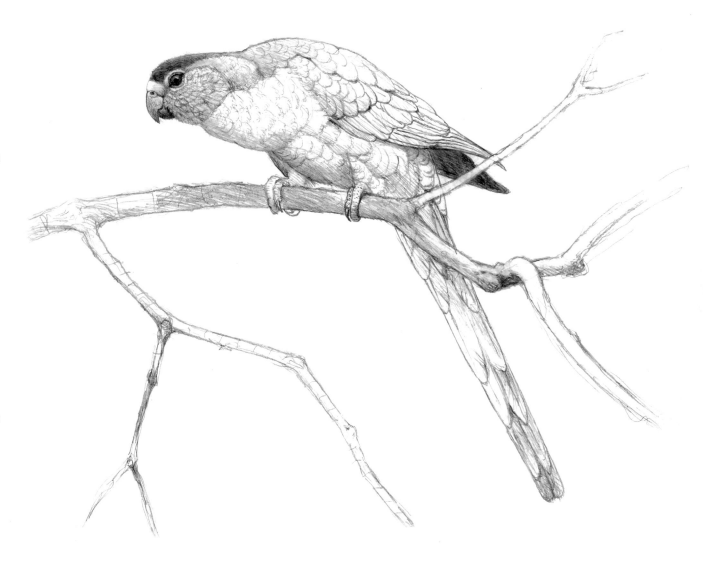

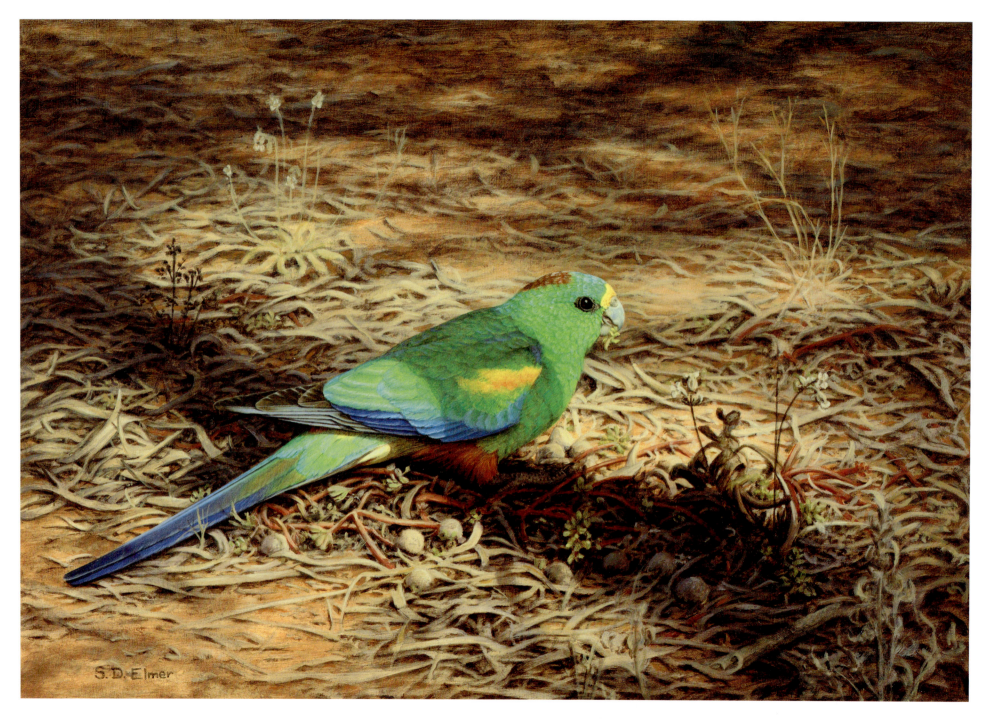

MULGA PARROT

Mulga Parrots aren't confined to mulga country: we have found them in mallee and other eucalypt woodlands, gidyea thickets and callitris groves among other places. Wherever they are, we have usually found them to be more tame than other parrots, allowing a fairly close approach to admire their glowing colours while they feed on the ground, mostly in our experience on vegetation rather than seeds. We have come across a number of nest hollows, some quite low. Sometimes we are led to a nest when we see a courting male feeding a female; we wait patiently and when she is satisfied, she flies directly to her hollow. After laying eggs she sits closely and is called out of the hollow by the male to be fed. Once the chicks hatch, they are fed by the male at first, but as they grow the female leaves and goes foraging as well. The pair often travel together to forage and return to the nest at intervals of about 90 minutes. While we were watching one nest over a period of several days, on each occasion the pair returned together and both entered the hollow; we could hear the chicks being fed and the adults emerged in quick succession. One feeding session we recorded lasted for 12 minutes.

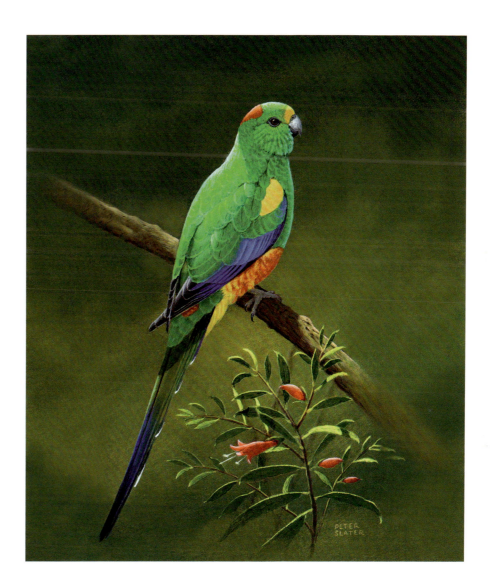

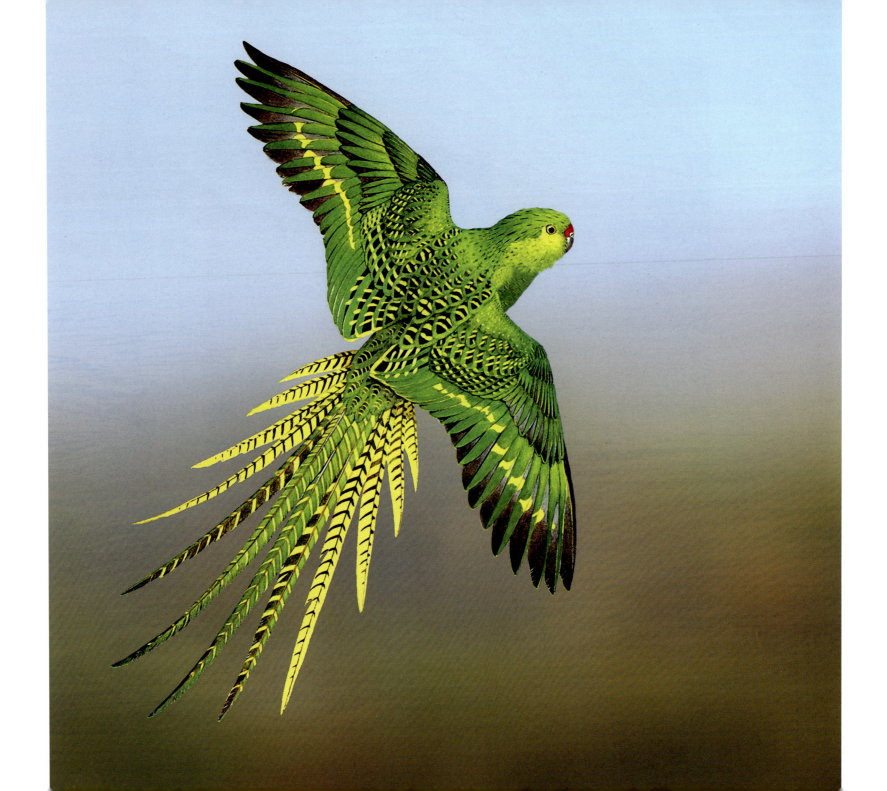

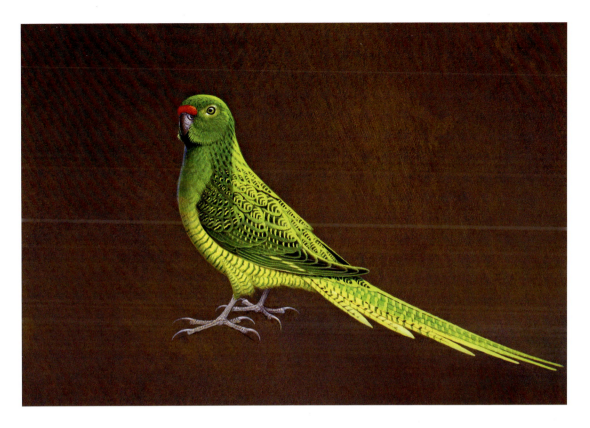

EASTERN GROUND PARROT

WESTERN GROUND PARROT

The Western Ground Parrot (above) is Critically Endangered but still holds on, just. It inhabits a small swathe of remaining mallee heaths on the south-west coast. Its tenuous hold on existence was not helped when fires swept through the mallee east of Esperance, the last stronghold. I saw two in 1964, flushed from low but thick heath, when I was actually looking for bristlebirds. They disappeared over the heath and dropped back into cover about a hundred metres away. Nowadays I would definitely leave them alone but back then I hurried over to where they pitched, but couldn't relocate them. I was not too concerned, because I hoped to live a lot longer with many more opportunities: anyway back then it was not realised it was a separate species from the Ground Parrot of the eastern heaths. But the opportunity has never recurred. One of my paintings of a flying eastern bird (left) was used for a while as the logo of the Barren Grounds Reserve, New South Wales. The original of it disappeared somewhere in Melbourne, so if you rescued it from a rubbish tip I'd love to have it back.

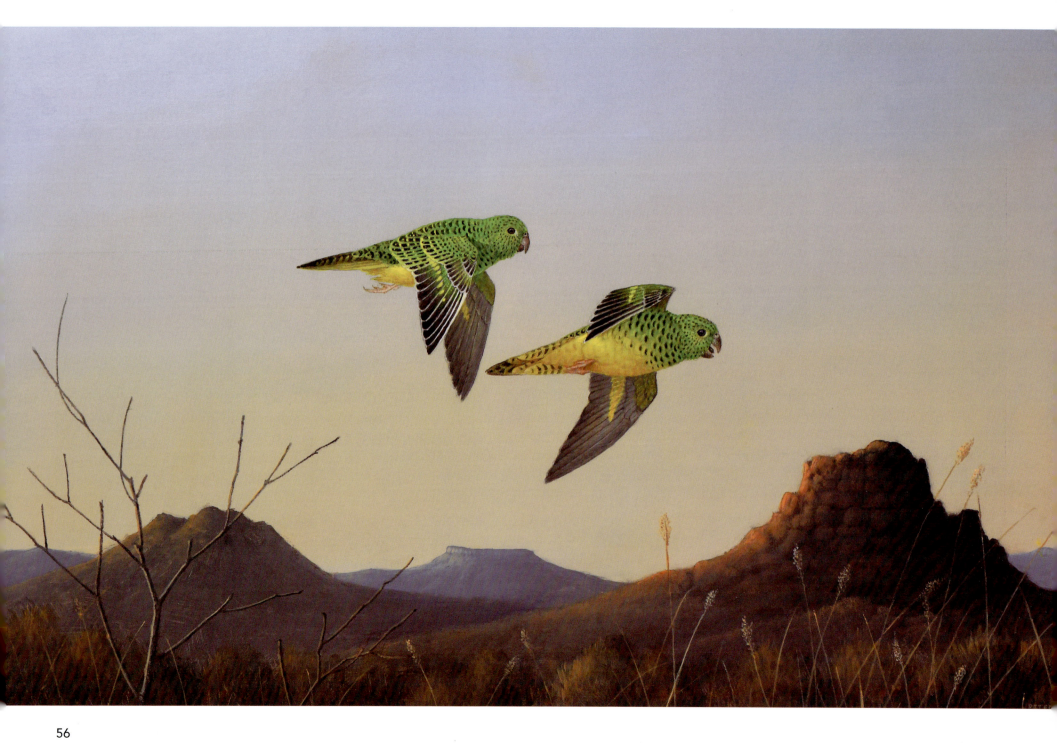

My father, a Methodist minister, emigrated to Australia in 1924 where his first parish, said to be the largest in the world, was on the edge of the desert at Cue, Western Australia. Seventy years earlier, in 1854, Kenneth Brown was in precisely the same locality with the Austin Survey Expedition, and collected a Night Parrot about twenty kilometres from where Cue now stands. He thought it was a Ground Parrot, as did John Gould at first when he received the specimen. Subsequently the great birdman realised it was different and described it in 1861 as a new species, *Geopsittacus occidentalis,* the Western Ground Parrot. Regrettably my father was more interested in parishioners and music than in birds, so didn't go searching for a bird which by then was presumed to be extinct. More recently, a number of people more interested in birds did come across the bird, renamed the Night Parrot by then, in widely spread localities, among them Martin Burgoin, Noel Ives, Brian Powell, Glen Holmes, Shane Parker and Rex Ellis. All of these people had excellent credentials as observers but nevertheless the consensus of ornithological opinion was that the bird was probably extinct. Wayne Longmore and Walter Boles disproved that contention when they picked up a recently-dead Night Parrot on the road near Boulia, Queensland, and Shorty Cupitt discovered one tangled on a barbed wire fence further east. Then John Young and John Stewart obtained photographic evidence near Shorty's site. Since that time reliable evidence has emerged elsewhere in Queensland, as well as in Northern Territory and Western Australia. One night, Sally and I were driving slowly along a bush track, somewhere between the localities where Shorty and Glen Holmes made their findings, when a bird flew across the track. I didn't get a good enough sighter but Sally said it looked green to her. So I didn't tick it off, but Sally got pretty excited.

NIGHT PARROT

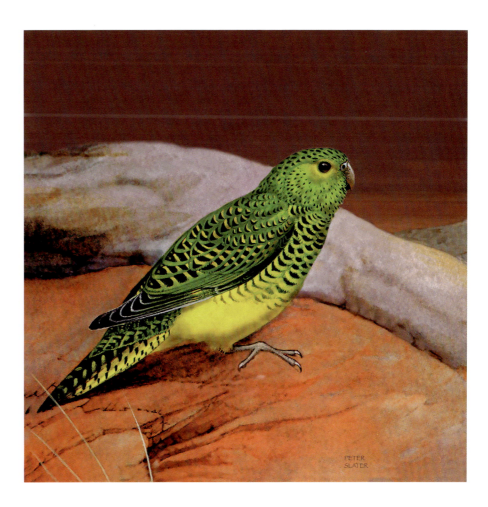

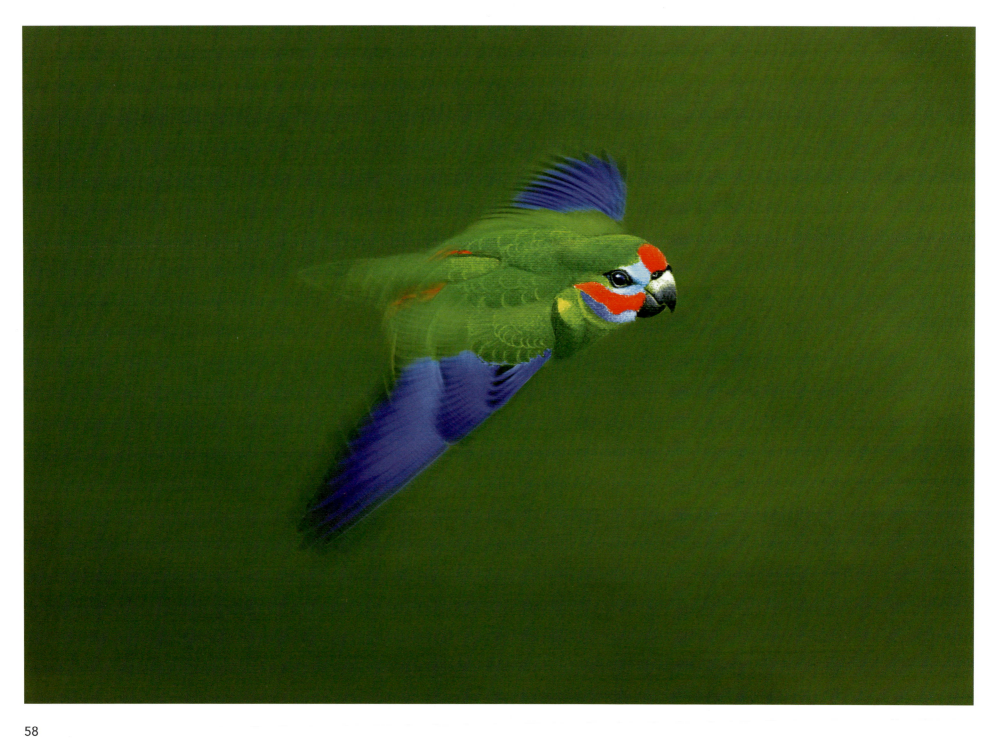

DOUBLE-EYED FIG-PARROT
COXEN'S FIG-PARROT

Shortly after surgeon John White arrived with the First Fleet in 1788 he commissioned artists to illustrate birds, among other subjects. These illustrations were taken to England and were used by John Latham to describe and name new species of Australian birds. It was soon agreed that an illustration is not really satisfactory to base descriptions on, so subsequently a specimen was considered to be essential as a basis for a new species – it needs to be housed in a museum and is called the 'type'. However there was one further exception. In 1867 John Gould received a painting of a small parrot from his brother-in-law, Charles Coxen. He realised that it was a new species so named it Coxen's Fig-Parrot *Cyclopsitta coxeni*. Coxen based his drawing on specimens collected near Brisbane by a timber-cutter, given to Eli Waller. Gould eventually received the specimens from Waller and they are now in the British Museum. There are not many specimens of Coxen's in museums, a reflection on their rarity. Some controversy persists over a photograph of a fig-parrot, similar to Sally's painting (overleaf), taken by John Young. I painted some heads in the museum (right) showing probable stages of development from juvenile to adult for a paper by parrot authority Joseph Forshaw about the controversy. In north Queensland there is another fig-parrot, which is smaller, much more brightly coloured, and much more common, called the Double-eyed Fig-Parrot. I saw a lot of them while I lived up north, even in a fig tree next door to my place, and took the opportunity to paint one (left).

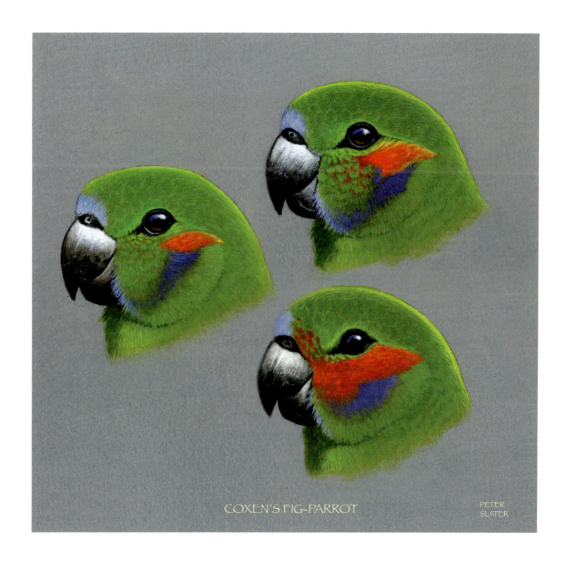

COXEN'S FIG-PARROT
PETER SLATER

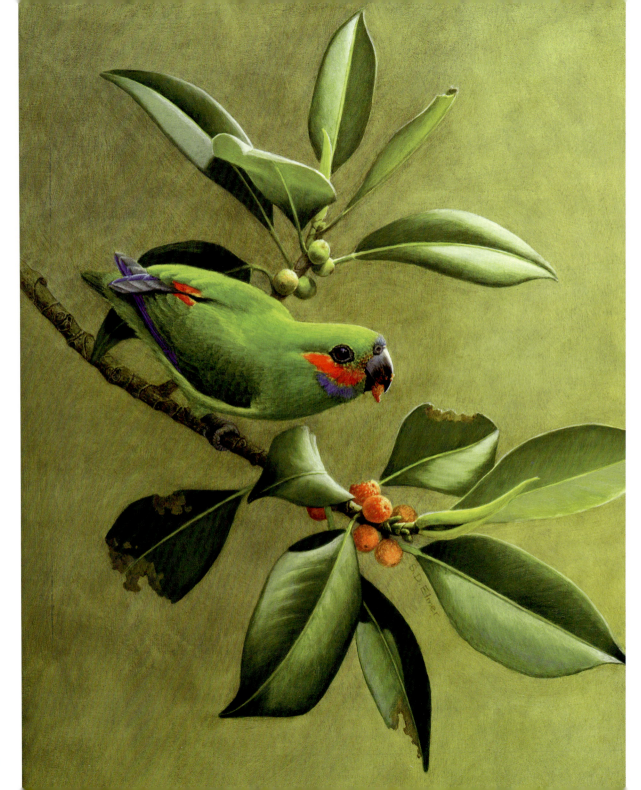

COXEN'S FIG-PARROT

Sally painted a Coxen's Fig-Parrot (right) for the Queensland Environmental Protection Agency based in part on information from naturalist and film-maker John Young. Following Young's advice she added blue feathering to the forehead and crown; the specimens in the Queensland Museum show only a small patch of blue on the forehead. After much controversy involving the colouration of this bird, she referred only to museum skins for a second painting (left). Coxen's is among Australia's rarest birds; on the evidence of recent sightings it is as rare as the Night Parrot. One of the ironies of a statistical approach to deciding categories of endangerment is that Coxen's has been downgraded from Critically Endangered to Endangered because there is 'no evidence that it is decreasing in numbers.' How this determination can be made of a bird so rarely sighted and so few in numbers is beyond belief. Sally may have seen some once on her 16-hectare rainforest property at Bellthorpe, where there are suitable fig trees, but most recent sightings have been in the Conondale area.

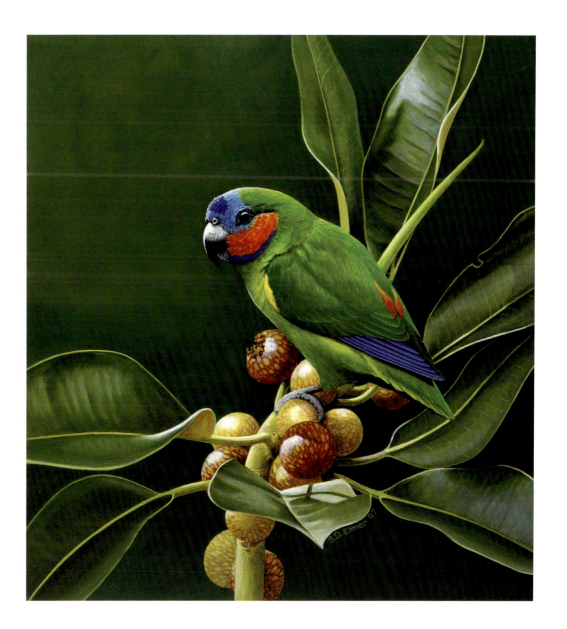

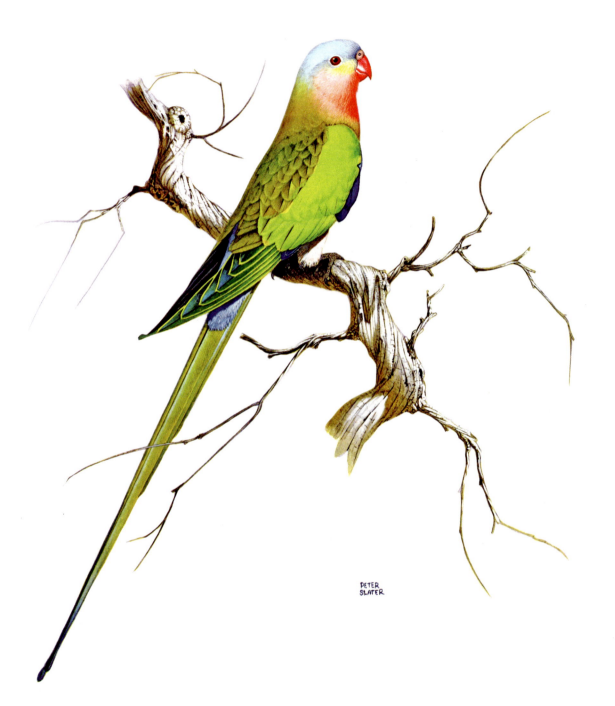

PRINCESS PARROT

Princess Parrots are more or less confined to the western deserts with occasional irruptions further eastwards into central Northern Territory and western South Australia. The first ones I saw were in a small flock at Youie's Find, north of Paynes Find, Western Australia, in the 1940s. That year all the lakes around Kalgoorlie and further north were full. I can still remember the parrots' long tails waggling as they took off from the ground. One was paler than the rest and I suspect it was a mutation, common now in aviaries, in which the yellow pigment in the feathers is suppressed. Forty years ago in another book I wrote: 'I can think of no other bird with the same perfection of proportion. In coloration it epitomises the inland – the olive of mulga trees, the yellow-green of fresh spinifex, the pink and blue of hazy distance'. I still think so.

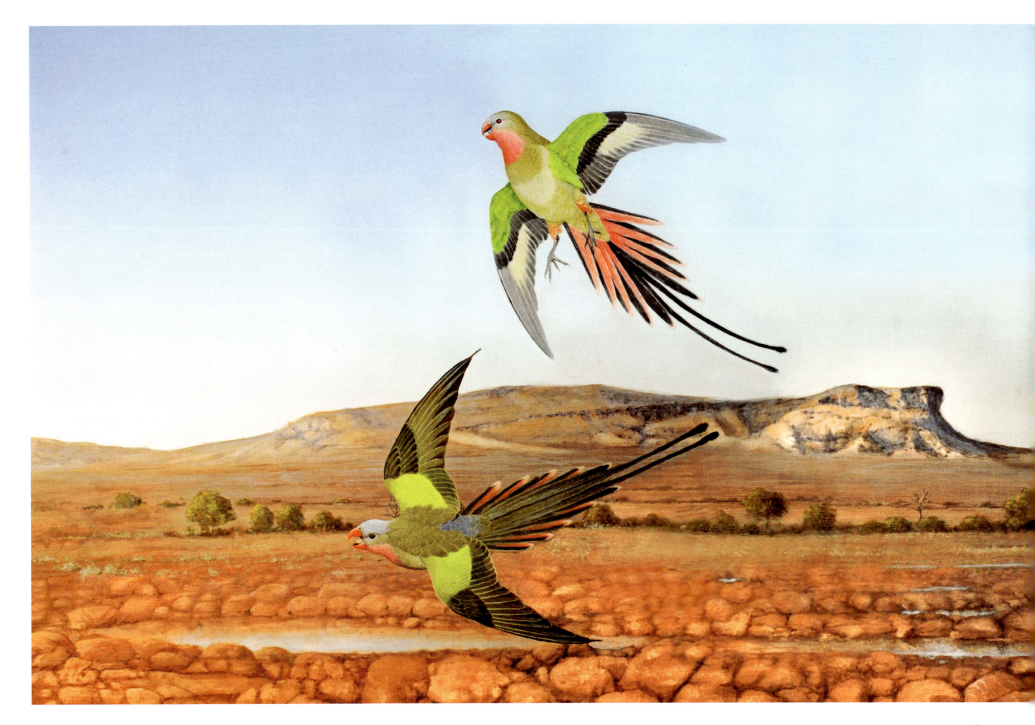

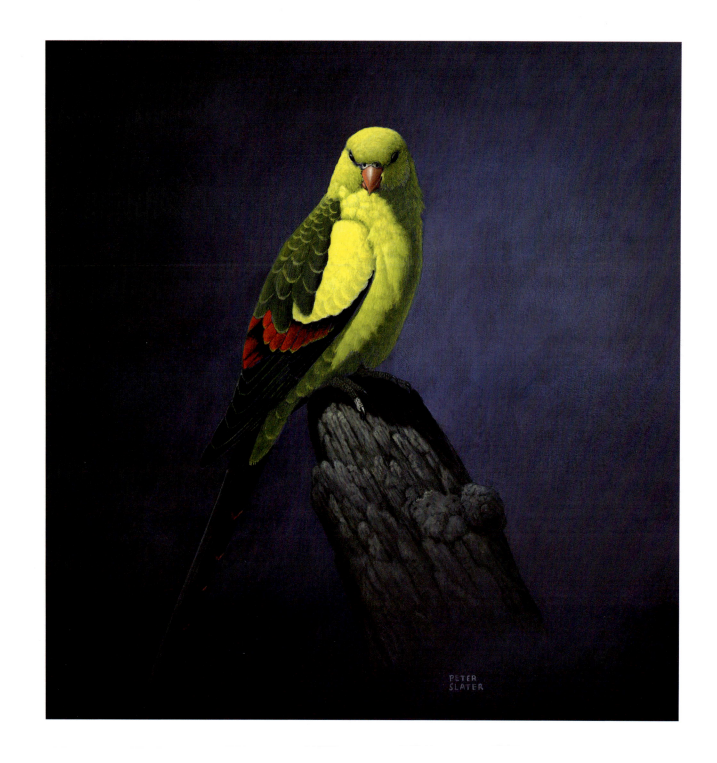

REGENT PARROT

Over the years I have painted quite a few Regent Parrots for several reasons – I love the smoky-yellow plumage complementing the red flashes in the wings, and it is one of the first birds I remember seeing. The very first were crows in a wheat paddock and the second was a flock of Regents feeding on the ground at the bottom of a hill. I remember trying to roll a stone down the hill so I could catch one. It didn't work. I must have been two years old at the time because it was in Bruce Rock and we left that town when I was two. Many years later I returned to the Bruce Rock area and saw a very brightly coloured one that I painted (right). The Regents were common in Western Australia then; as kids we called them 'smokers', but they are less common now. There is a different race in the east and it has become very rare, so is classified as Endangered (left).

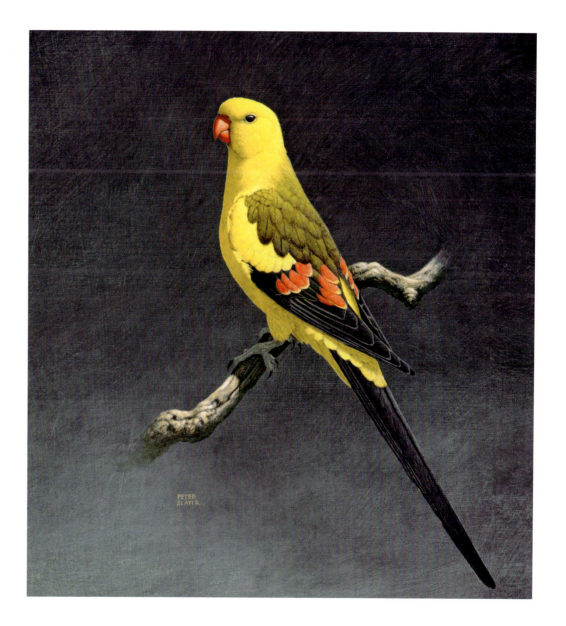

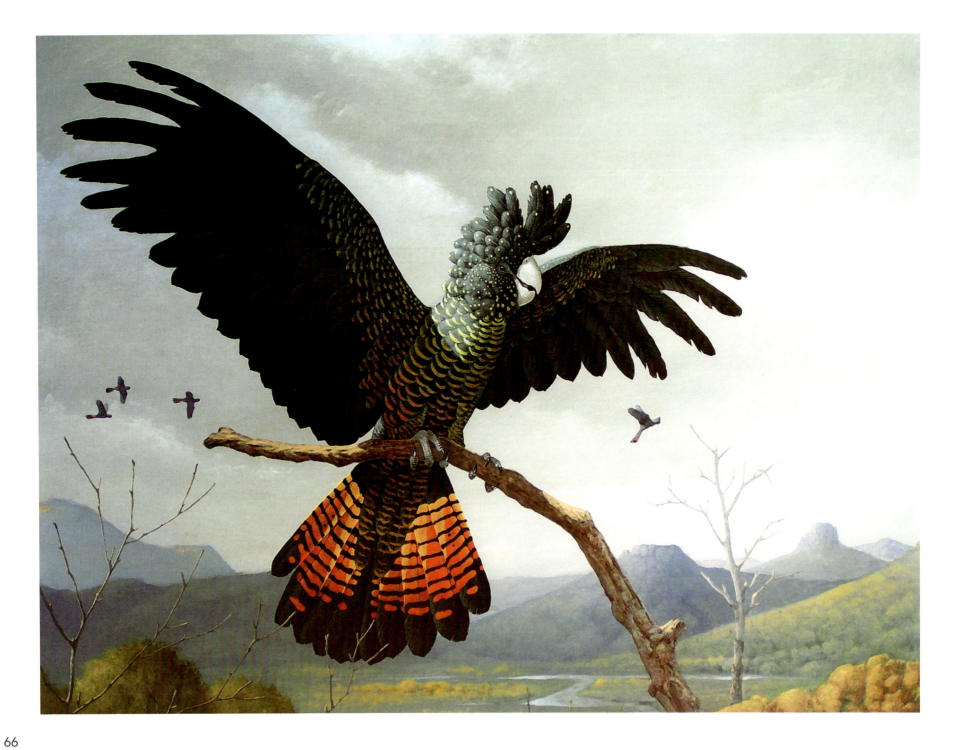

RED-TAILED BLACK-COCKATOO

Halfway between Erldunda and Uluru, Northern Territory, we saw some black-cockatoos perched in an isolated patch of eucalypts, so walked across, hoping for a better view. As we got closer it became clear that there were hundreds concealed among the foliage. Many rose at our approach to settle again further into the grove. At our feet were thousands of tail feathers and I came to believe we had stumbled across a moulting ground. I collected a sample thinking to do a painting of the cockatoos flying past Uluru. When we arrived at the rock, we were told by aboriginal custodians that although they knew of the black-cockatoo, which they called 'kar-rack' or something similar, it was only a very rare vagrant, so I felt such a painting would be inappropriate. However, I did use the feathers as models for the bird on the left, a female of the central Australian race *samueli*. One has to be careful, because the different populations of Red-tails have subtly different feather patterns and bill-shapes. The different bill-shapes are indicative of evolutionary modification to different food sources, so when some taxonomist gets around to it we may start thinking of at least three different species. The painting on the right is titled 'Storm Warning', a reference to our strongly-held childhood belief that black-cockatoos flying over were a sure sign that rain was on the way. It is a female from south-western Victoria, of the endangered race *graptogyne*.

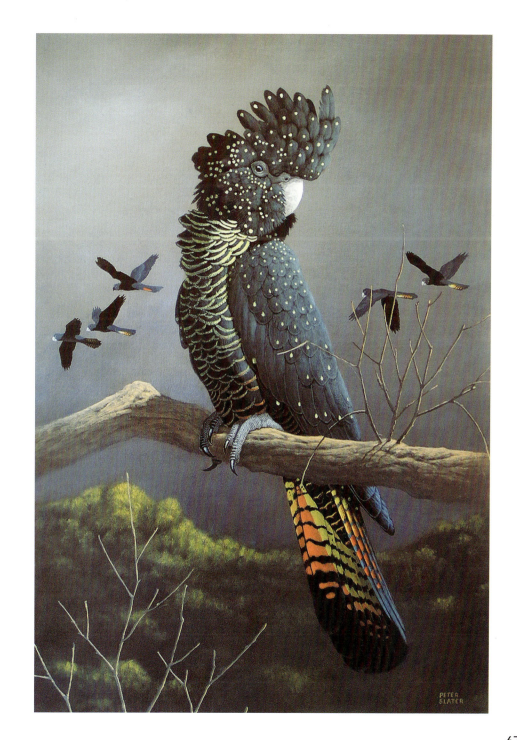

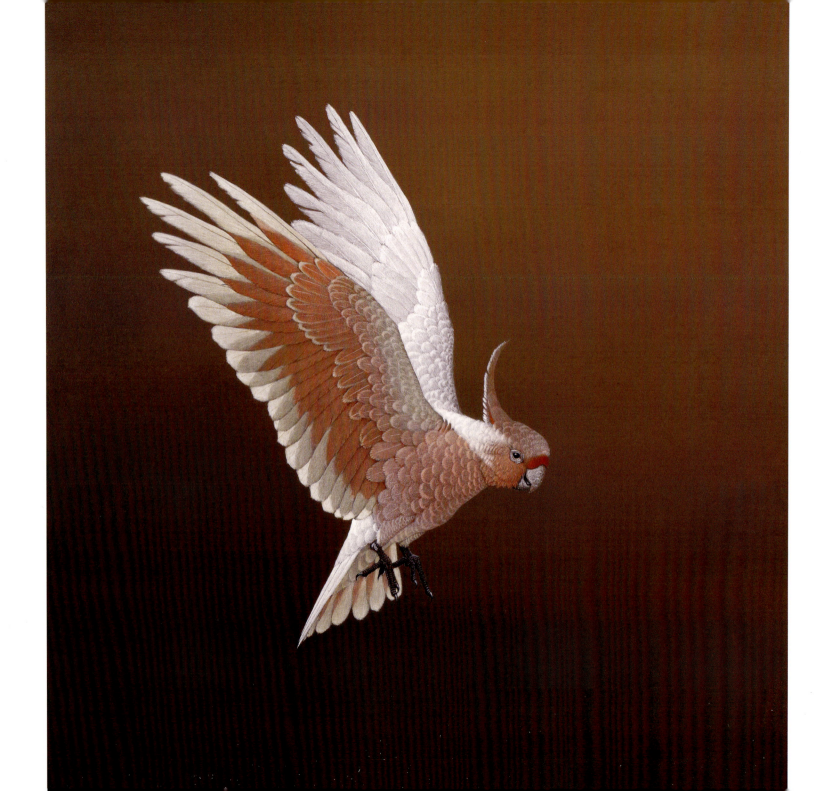

MAJOR MITCHELL'S COCKATOO

Despite its name, Major Mitchell's Cockatoo wasn't 'discovered' by the great explorer. I don't know who collected the first specimen but it found its way to Benjamin Leadbeater, a dealer in items of natural history in London. There it was seen by Nicholas Vigors who described and named it as *Phyctolophus leadbeateri*, Leadbeater's Cockatoo, in 1831. Major Mitchell came across the cockatoo on 10 July 1836, in the interior on one of his expeditions. He wrote in his diary: 'the pink-coloured wings and glowing crest might have embellished the air of a more voluptuous region'. He made a lovely painting that was reproduced in his book, *Three Expeditions into the Interior of Australia*. For a while it was referred to as Leadbeater's, but then became known as the Pink Cockatoo. In the outback and among aviculturalists it has long been known as the Major Mitchell, so in the latest review of names, it at last became known officially as Major Mitchell's Cockatoo, *Lophochroa leadbeateri*. Pity about poor old Leadbeater; anyway, his son emigrated to Australia and worked in Melbourne as a taxidermist. Leadbeater's Possum is named after him.

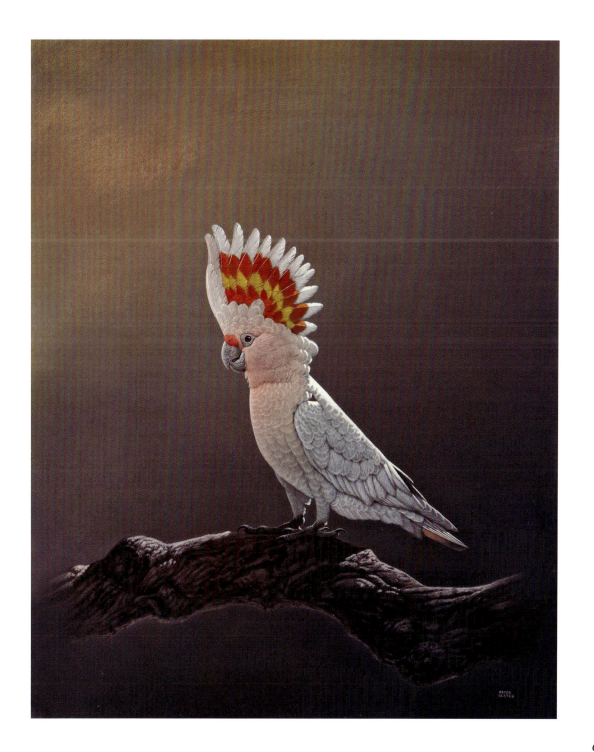

GALAH

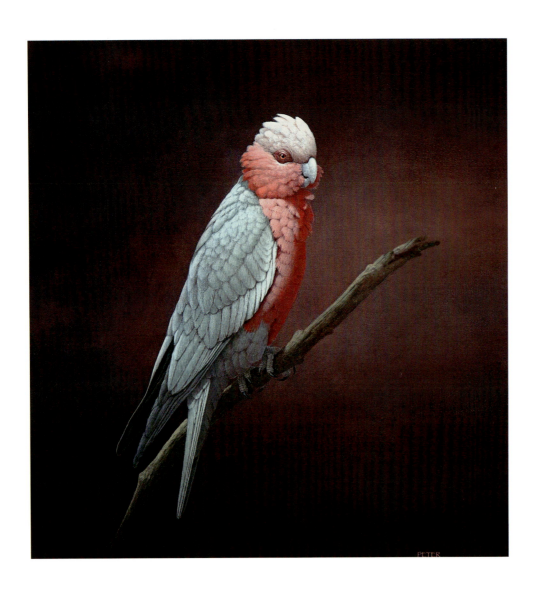

In many cases Aboriginal names of birds are onomatopoeic, based on local interpretations of the sounds they make. The calls of Galahs across Australia are much the same, so it is surprising that Aboriginal names for these birds vary so widely from place to place. In the north-west the name is *Caloret*. When the first Galah specimen from Australia, collected on the French expedition led by Nicolas Baudin, arrived back in Europe, it was given the name *Cacatua roseicapilla* by Louis Vieillot in 1817. The Baudin expedition spent a lot of time in the Shark Bay area, and also visited Tasmania, Sydney and Kangaroo Island, among other places. It was assumed that the Galah was collected in the east, so western birds, that differ mainly in having a pink rather than pale crest, were given the subspecific name of *assimilis*. Ornithologist Richard Schodde felt that it was more likely that the French specimen came from Shark Bay, in which case western birds should be *roseicapilla*, not *assimilis*, because the oldest name applies. That meant eastern birds didn't have a name, so Schodde called them *albiceps* (white crown). But to be sure, the specimen in France needed to be examined to determine which it actually is, eastern or western. Unfortunately it is not in good condition, so it was left to DNA analysis by Leo Joseph and Jeremy Austin, who found that the bird *was* western. Problem solved. Perhaps the matter could have been settled much earlier if reference had been made to a painting by Nicolas Huet in the French National Museum of Natural History, made in November 1811, six years before Vieillot's description, and probably from the same specimen. It has a bright pink crown and is undoubtedly a western bird. The Aboriginals in the Shark Bay area could have told us the correct name is *Caloret*.

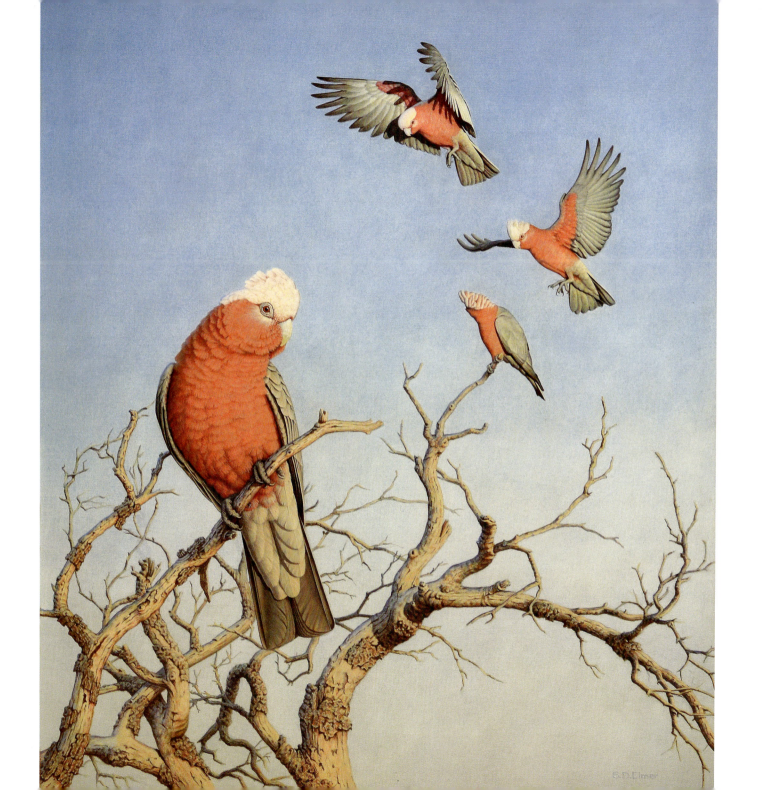

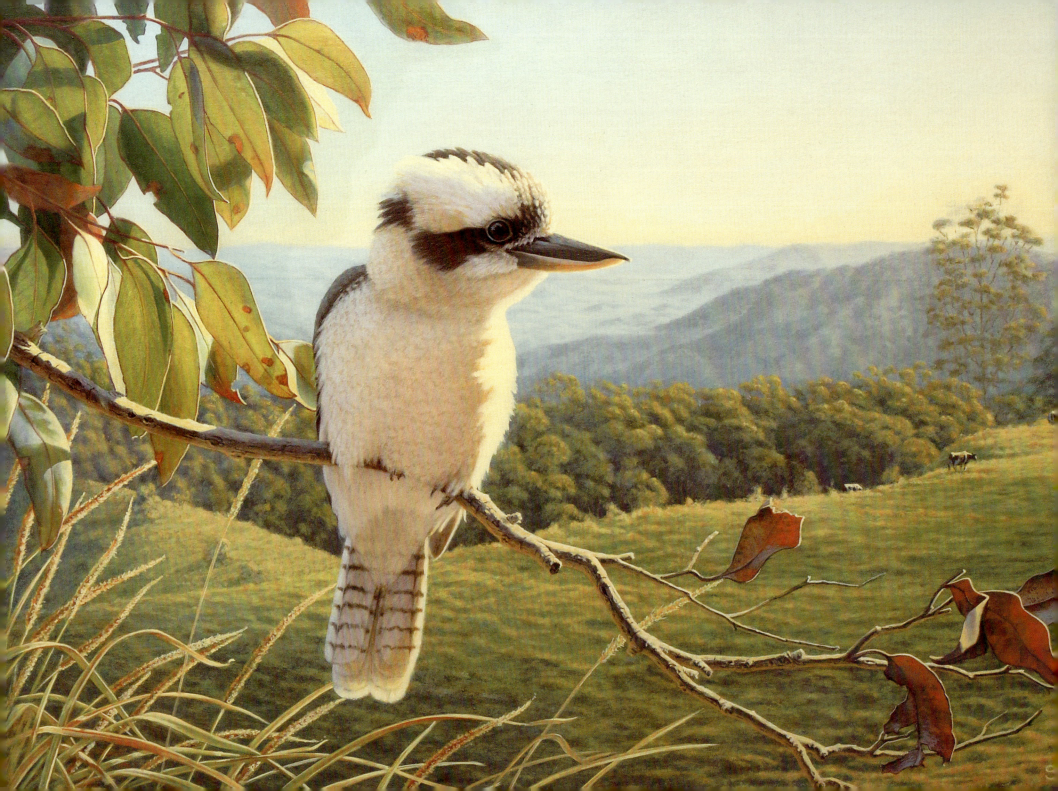

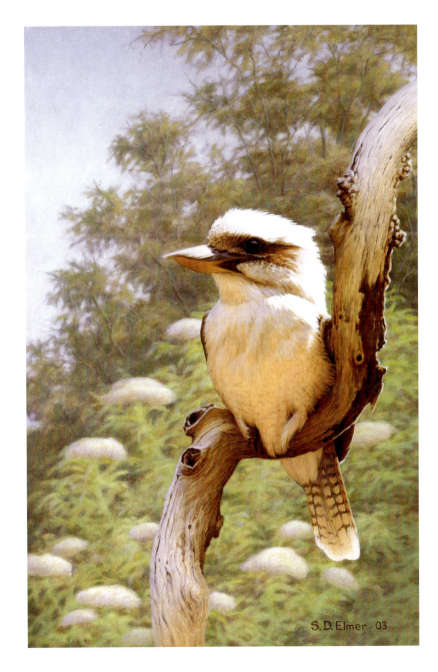

LAUGHING KOOKABURRA

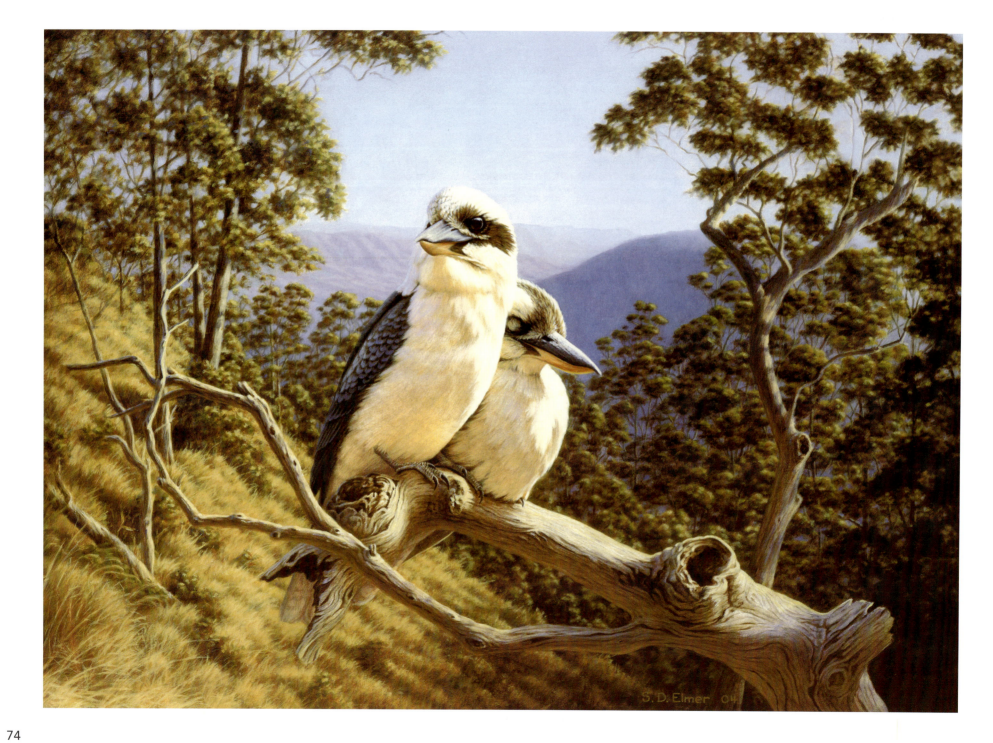

LAUGHING KOOKABURRA

The bill of the kookaburra has a curve to it that makes the bird look as if it is smiling. That erroneous impression is backed up by the call. But there is nothing merry in the chuckling laughter of the kookaburra; it is not laughter at all but the serious business of proclaiming territory and warning off intruders. I realised how serious it is when I was given an injured kookaburra to care for. When it was on the mend I sat it outside to get some sun. It was immediately attacked by the resident kookaburras and knocked to the ground, where the attack continued. I had to dash in to save it. The locals then flew up to a perch and gave vent to their victorious war-cries. It's often said that kookaburras are the first birds to call in the morning, but in our experience Eastern Yellow Robins call earlier, sometimes when it is still quite dark.

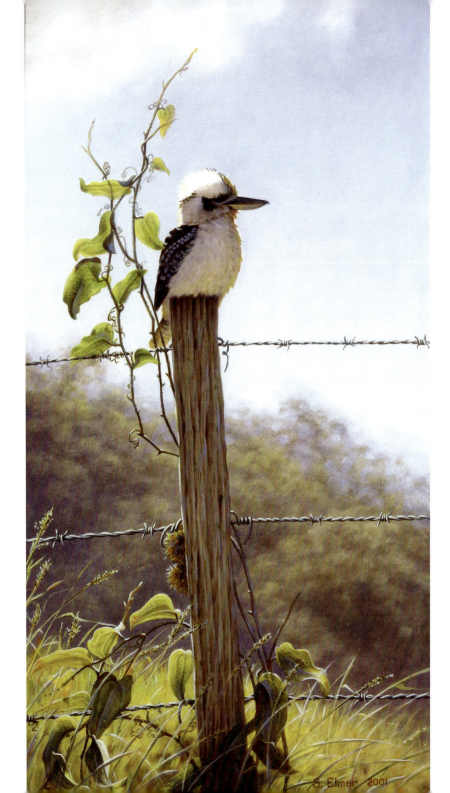

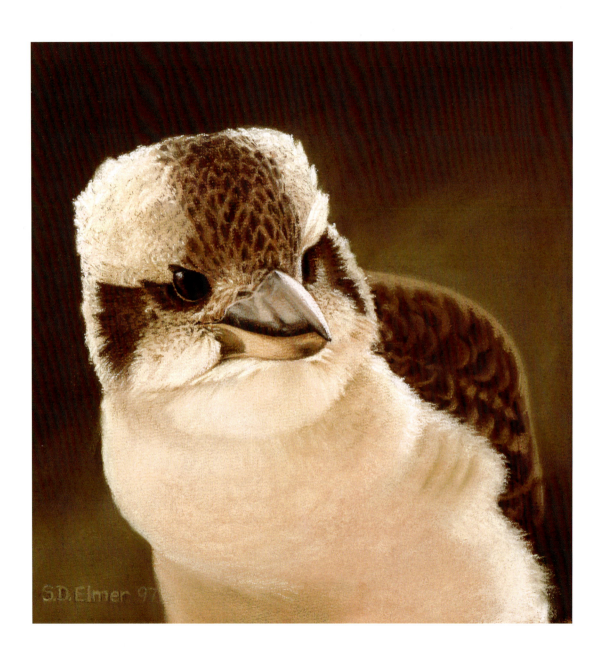

LAUGHING KOOKABURRA
BLUE-WINGED KOOKABURRA

While the curve on the bill of the Laughing Kookaburra gives the impression of a happy smile, that of the Blue-winged Kookaburra is rather sardonic, exaggerated by the pale lower edge of the upper mandible and the white iris, shown perfectly by Sally in her painting opposite. If one must describe calls by analogy, then that of the Blue-winged could be described as maniacal. It is very loud and carries for a considerable distance. Like that of its more southerly relative, the call is a vocal statement, staking claim to territory. When we come across them they seem to be in small groups of up to half a dozen, but because they are rather shy, we are seldom able to spend much time observing them. My best views were when I found a nest containing eggs near Derby, Western Australia, on 9 December in a white-barked eucalypt, about seven metres from the ground. The chicks had hatched when I checked on 28 December, and emerged 30 days later on 27 January.

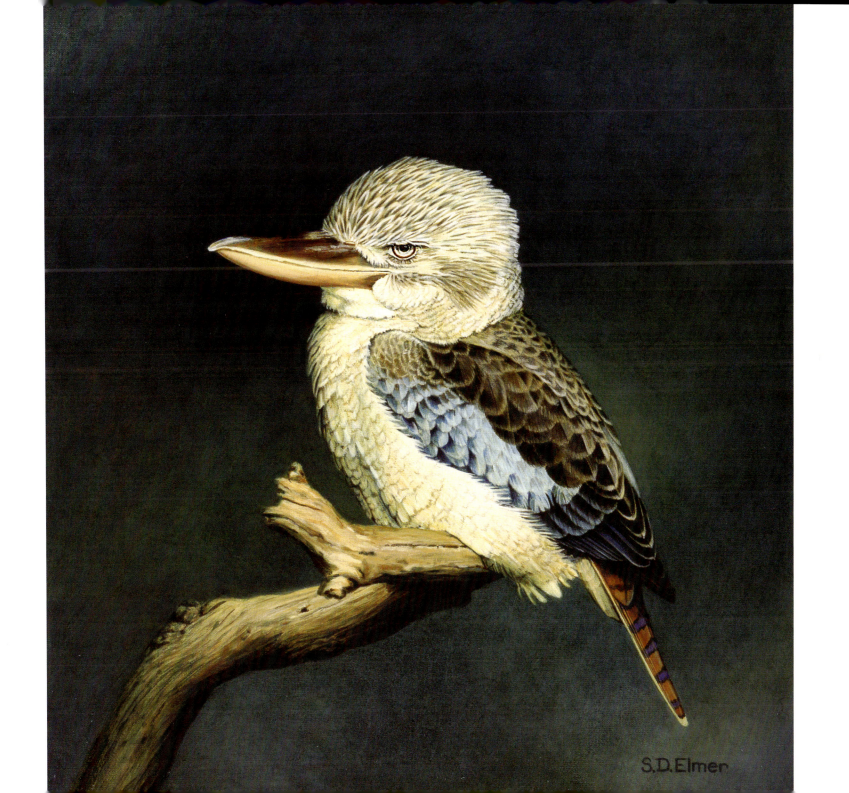

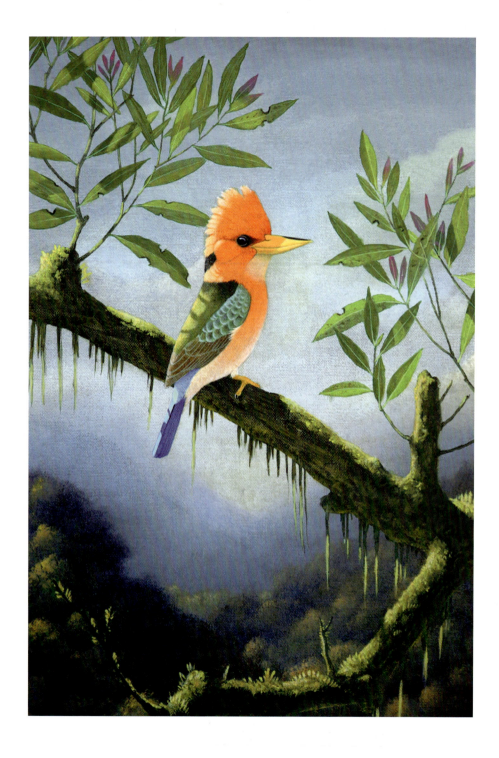

YELLOW-BILLED KINGFISHER

BUFF-BREASTED PARADISE-KINGFISHER

For 20 or so years I spent a fortnight each January on the tip of Cape York as the guest of Klaus Uhlenhut, one of the most accomplished naturalists of my experience. In the magical Lockerbie Scrub we encountered dozens of Buff-breasted Paradise-Kingfishers. They had only just arrived back from their winter quarters in New Guinea and the males were noisily selecting and defending their territories, chasing through the trees like brightly coloured comets. Central to each territory was a termite mound, usually quite small, in which a tunnel was drilled to house the eggs. Once the eggs were laid they were incubated and the long tail of the sitting bird could often be seen jutting out of the entrance. On one occasion, the leader of a party of birdwatchers, who should have known much, much better, decided to catch one to show his adoring followers, so crept up, and as the bird flew out, made a grab at it. Poor reflexes. Result: a handful of feathers. I picked up a long tail feather there later and wore it in my hat for many years, until it was stolen by a dastardly miscreant. Wherever we saw the paradise-kingfishers we also saw Yellow-billed Kingfishers, although more often on the edges of the rainforest than in the interior. Like the paradise their loud extended calls were a feature of the Lockerbie Scrub.

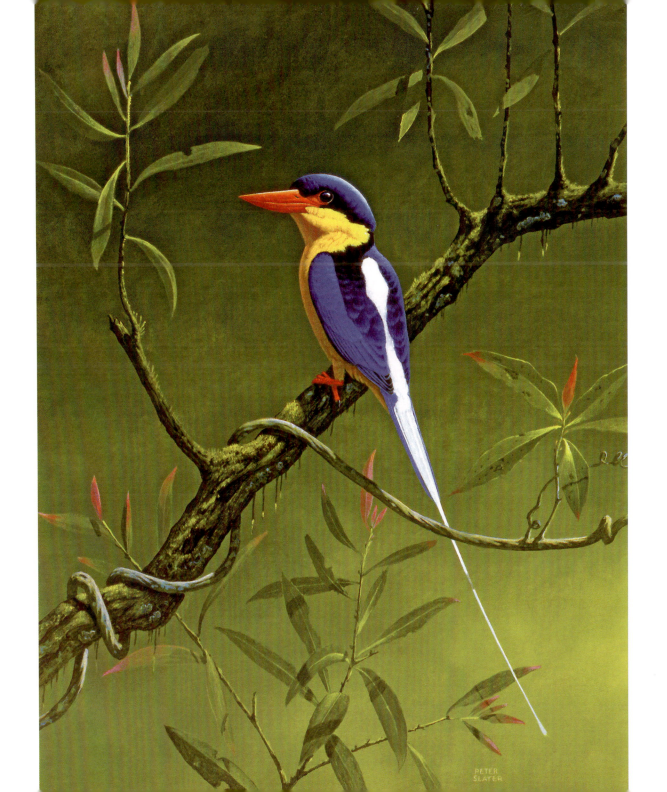

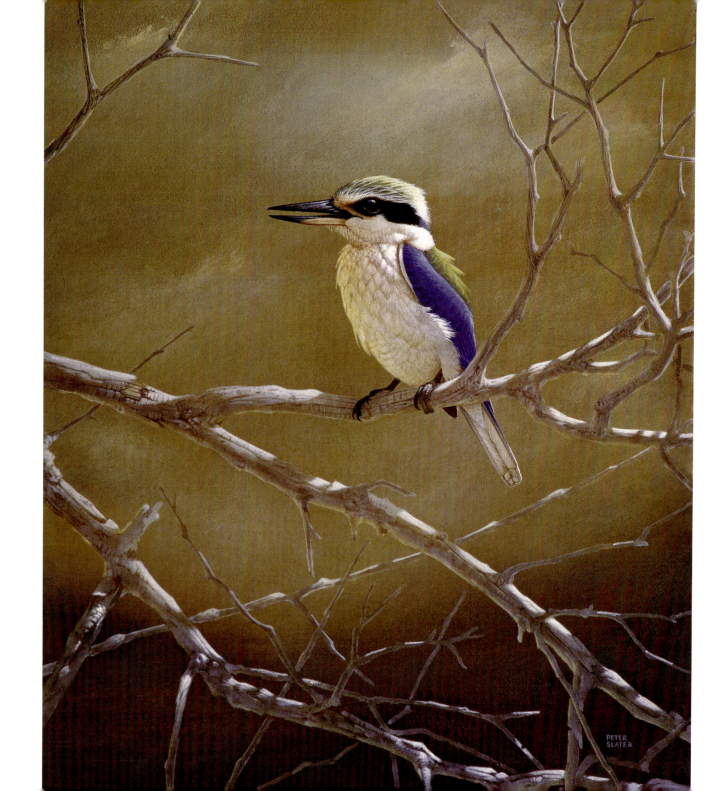

RED-BACKED KINGFISHER

When I exhibited my painting of a Red-backed Kingfisher (left) in a gallery, an elderly patron quite rightly chastised me for not showing the 'red' back. Why otherwise would one paint the bird? Anyway it's not really red, and it's actually on the rump, not the back, but that's no excuse. Just put it down to my contrary nature. But I have done a number of paintings showing the appropriate hue. In this one (right), the bird is depicted holding a Blue-tailed Ctenotus, a denizen of desert dunes where the kingfisher is also at home. Have you ever thought it should be called a kinglizarder? Four of us were in a hide photographing a nesting pair one pleasantly warm January in the Great Victoria Desert in 1956 when one brought in a skink much longer than the bird itself. Unfortunately we couldn't see how whichever chick received the offering managed to swallow it because the domestic drama was hidden inside the nest-tunnel. But we could see the tail in the entrance, slowly inching inward as the front end was digested.

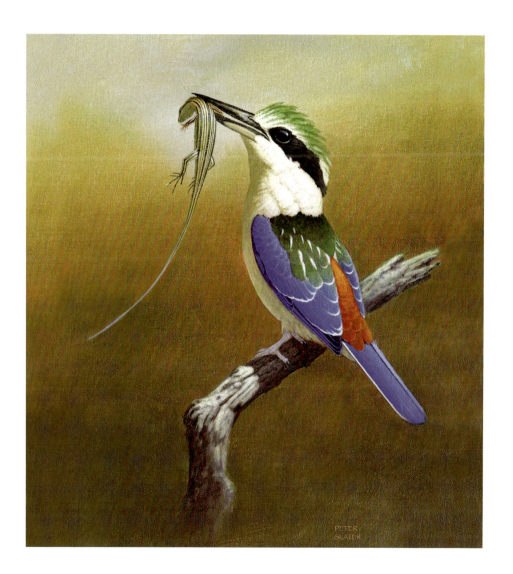

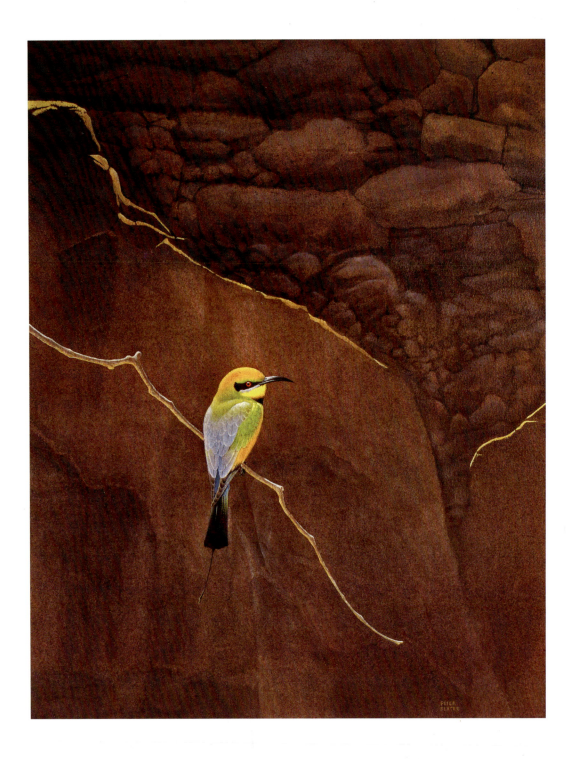

A LETTER FROM THE QUEEN: RAINBOW BEE-EATERS

There are some magical moments in childhood that set the course for the rest of one's life. One for me, at the age of five or six, was seeing a Red-eared Firetail feeding on the ground within a metre as I sat in my hideaway under the drooping branches of an old fig tree. The other was when I was eight or nine; Mum put me on the train in Manjimup to visit Auntie Alice in Bunbury. Each morning auntie made me a hamper of orange juice, ham sandwiches and fish fillets which I would take out into a nearby paddock and sit in the shelter of a huge uprooted gum tree. Every five minutes a most beautiful bird carrying a dragonfly or a wasp in its beak would land on one of the dead twigs just above my head, noisily bang its prey on the branch then fly down to the ground, disappear, then emerge and fly off. It never occurred to me that it was feeding chicks in a burrow in the sand. When I described it to Auntie Alice she said it must be a kingfisher. It wasn't until a few years later that I realised it was a Rainbow Bee-eater. Those magical moments culminated in me dedicating my life to painting birds. Every time I paint bee-eaters I am reminded of Auntie Alice, who died a few weeks short of her hundredth birthday, narrowly missing out on something she had set her heart on, a letter from the Queen.

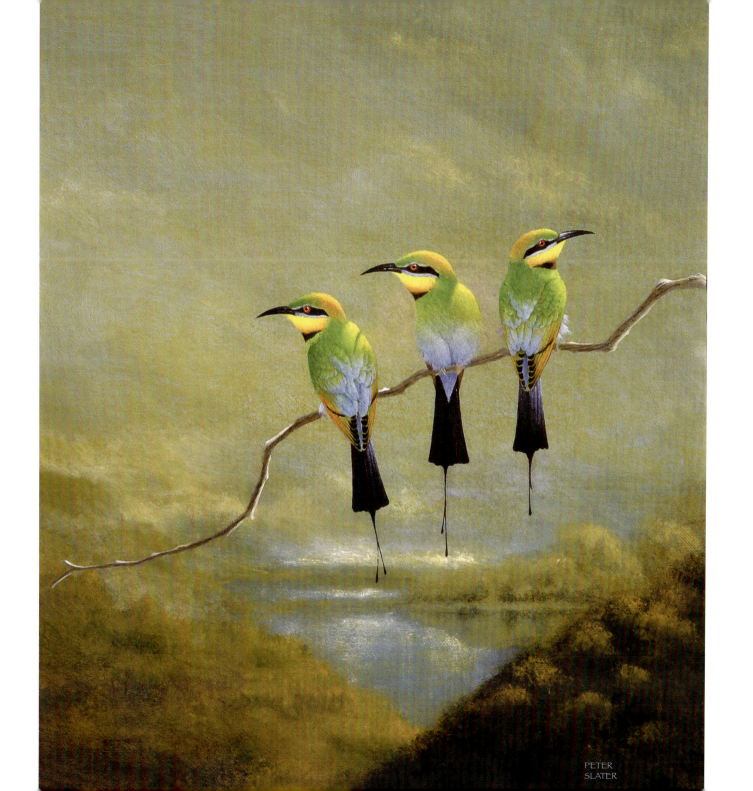

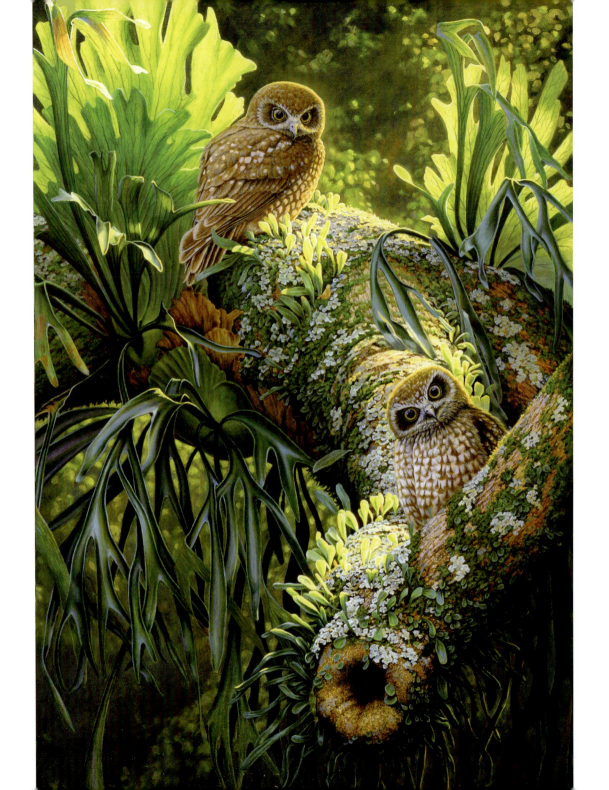

SOUTHERN BOOBOOK

There are some bird-songs that seem to epitomise Australia. The laughter of kookaburras and the *tink-tink* of the Bell Miner are probably the best known; inland the persistent notes of the Whistling Kite, Crested Bellbird and the wedgebills characterise the outback. At night, the Southern Boobook's bisyllabic call is the most-often heard of the nocturnal birds. Although it is known as the Southern Boobook, it actually occurs all over Australia; the name alludes to the fact that there are other boobook species on the islands to the north of Australia. Within Australia there is a dark race inhabiting the upland rainforests of north Queensland that might prove to be a separate species.

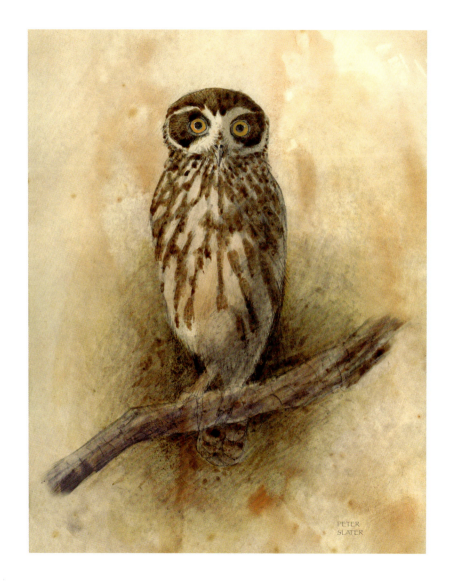

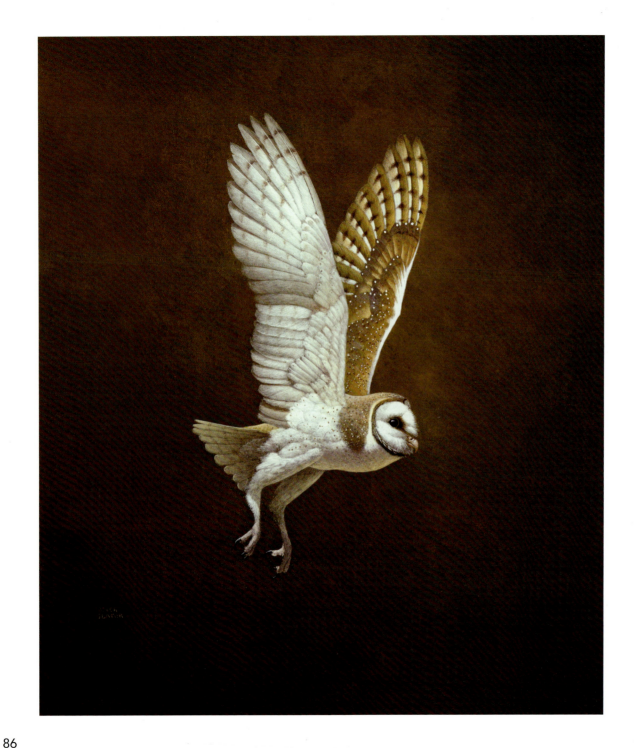

EASTERN BARN OWL

RUFOUS OWL

Five species of barn owls occur in Australia and another five inhabit islands in our region, while there are only three in the rest of the world, so it is reasonable to assume that they evolved here. Barn owls are characterised by the flat facial disc, which could be thought of as a noise-collector for the highly-sensitive ears, enabling them to locate their prey, principally rodents, by sound, even in total darkness. The eyes are very large, adapted to nocturnal vision; they are able to see quite well in daylight as well. The Rufous Owl is the northern counterpart of the Powerful Owl. It is not as big, and has a slightly different range of prey items: arboreal mammals such as possums and gliders, flying mammals (mainly fruit bats), terrestrial mammals, birds and occasionally insects. Although it often roosts during the day in monsoon forest and thick riverine vegetation, it tends to hunt at night in more open forest and woodland. The nest is in a large hollow, cleared out by the male if necessary, where the usual clutch of two eggs is laid in winter. When the chicks emerge, they retain down on the breast and abdomen for a few weeks, looking like giant powder-puffs with enormous staring eyes until the barred feathers grow through.

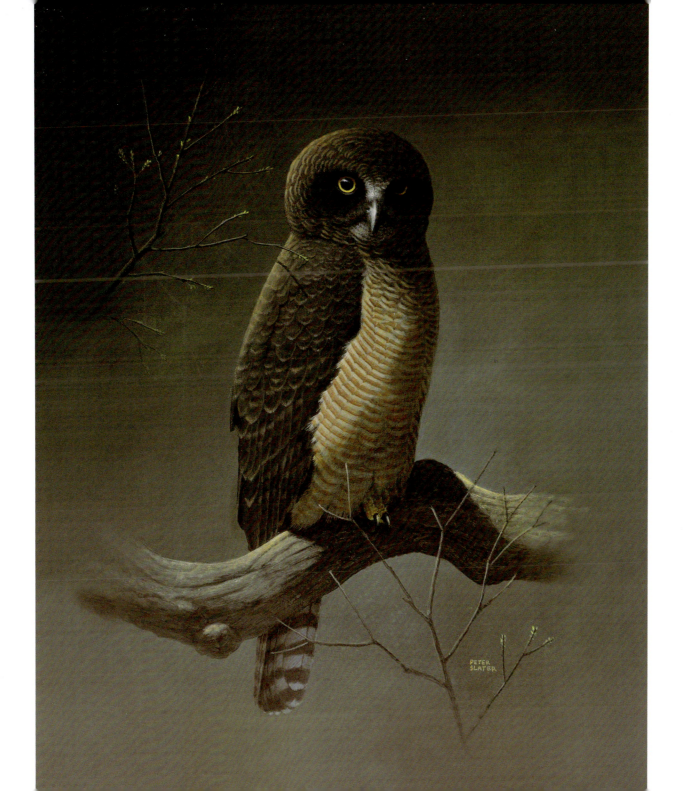

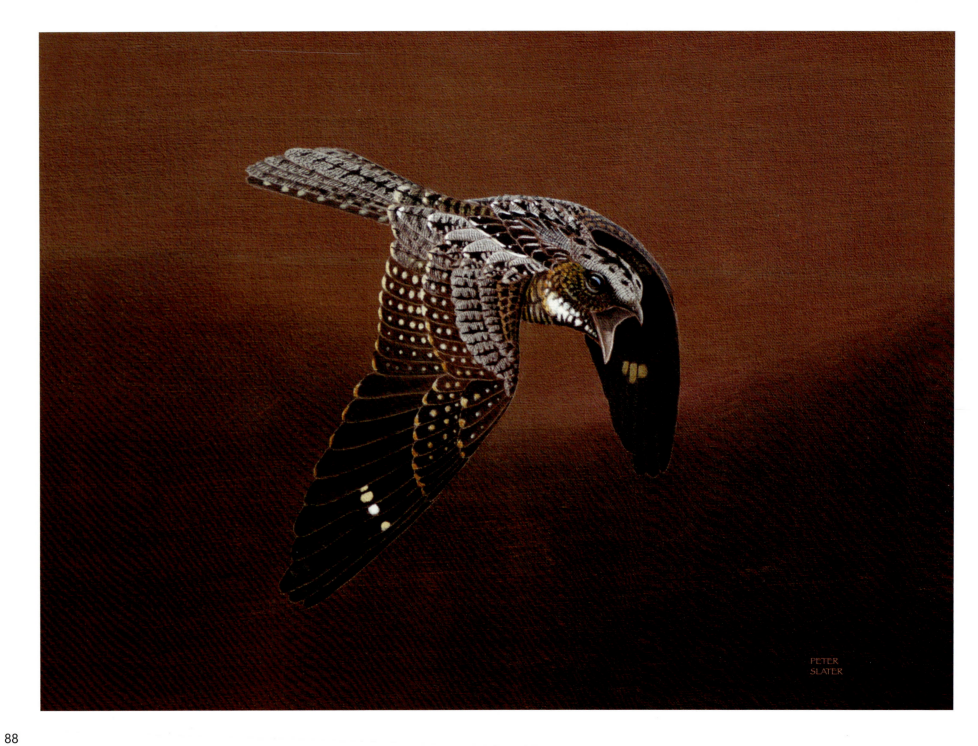

WHITE-THROATED NIGHTJAR
SPOTTED NIGHTJAR

Camped near a breakaway in the desert. Night sky jewelled with stars, much, much more brilliant than at home near the city. No campfire; that kills the splendour. Then, up on the breakaway a Spotted Nightjar calling, eerie voice of the desert night. Another calls further away like an echo, then another, then another, each further away, echoes dying, dying, dying. The closest one issues once more its challenge, its challengers respond, and so it goes, through another magical night, interspersed with periodic silences while they hunt for moths. Near home I hear the White-throated Nightjars calling in spring, back from wherever it is they go in winter; similar but, without the ambience of the desert, not quite so soul-stirring.

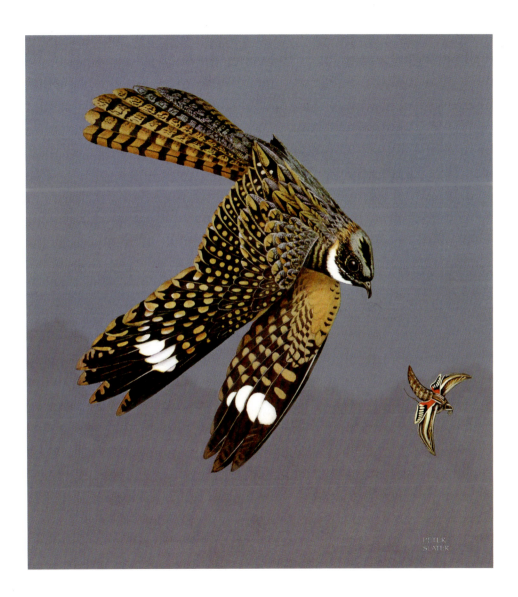

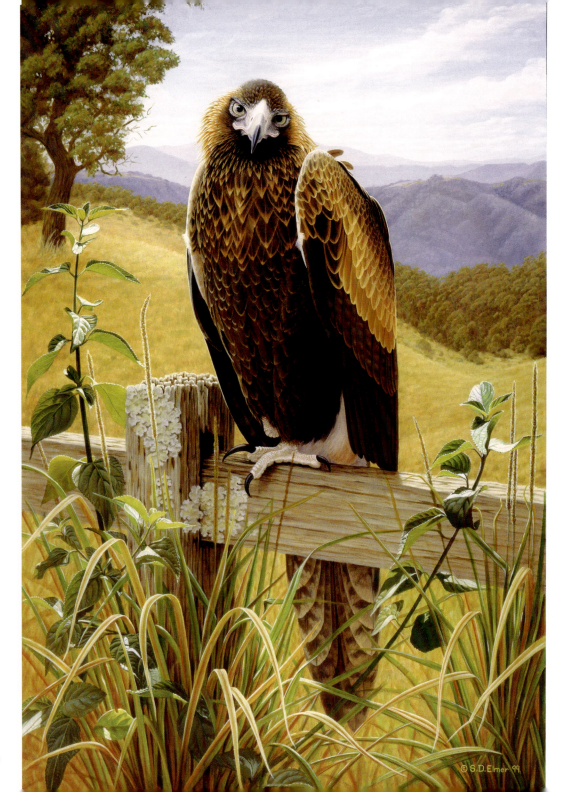
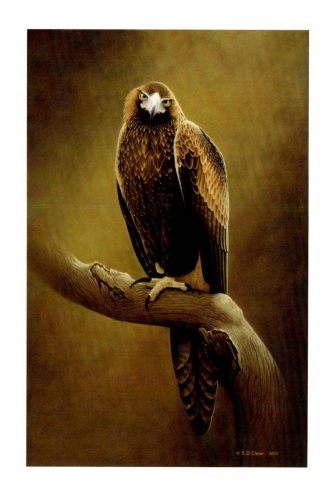

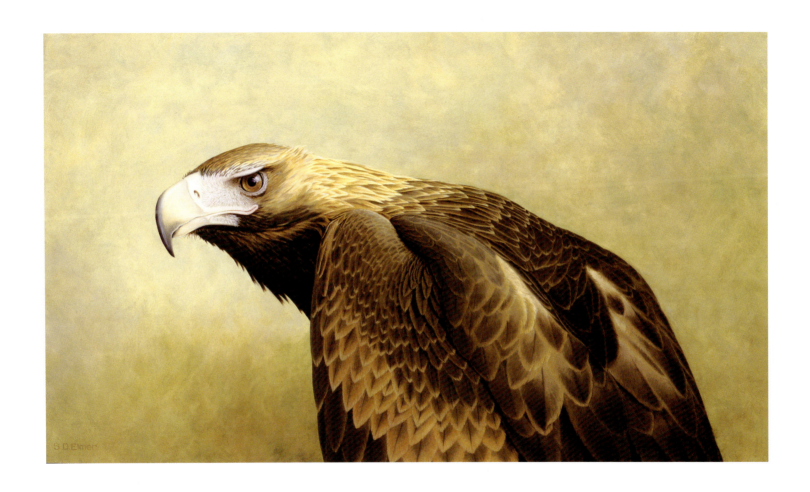

WEDGE-TAILED EAGLE

After Sally painted her wedge-tail on a fence-post (far left), she decided she wasn't all that happy with the background. Despite the fact that I loved it, she had a brain-fade and replaced the background (near left), leaving me with a dilemma: which do I prefer? Neither! I love them both.

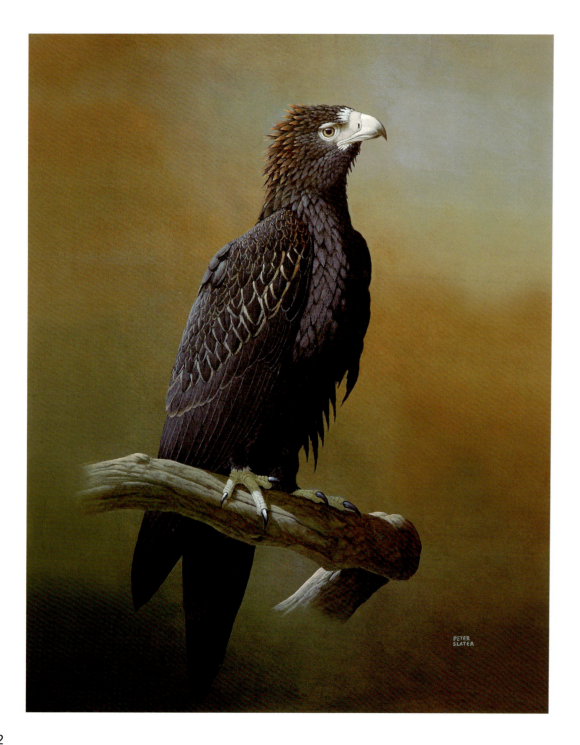

WEDGE-TAILED EAGLE

The wedge-tail is rather dichotomous in behaviour, either a lowly scavenger of roadside kills; kangaroos, wallabies, rabbits, emus, pigs and cattle; or a majestic hunter of awesome power, taking quarry up to the size of large kangaroos. Sally and I were shown a big Grey Kangaroo that had been dispatched by a pair hunting cooperatively, witnessed by the rangers at Welford National Park. Only a short time later we saw a pair trying to take a joey but the female Grey kept them at bay, and they broke off the hunt. We didn't ask how the eagles actually managed to kill their prey – we have several times dispatched severely mangled kangaroos, Red and Grey, left by inconsiderate motorists, and found it is not an easy task at all, even to the extent of getting injured ourselves. So how did the Welford pair of eagles manage; in this instance their quarry outweighed them many times. We didn't ask the rangers, but will do so next time we pass through. Nearer to home I have several time seen wedgies take crows, hence the painting opposite. The background is some sort of commentary on the desertification of the outback through overstocking and poor pasture management, ideal habitat for scavenging crows.

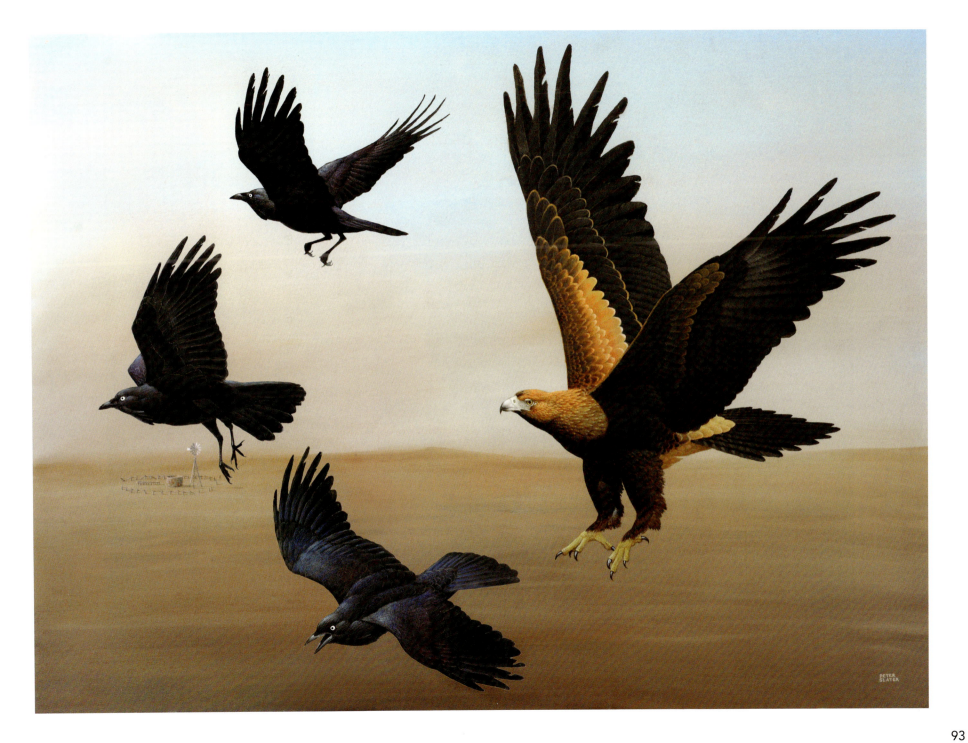

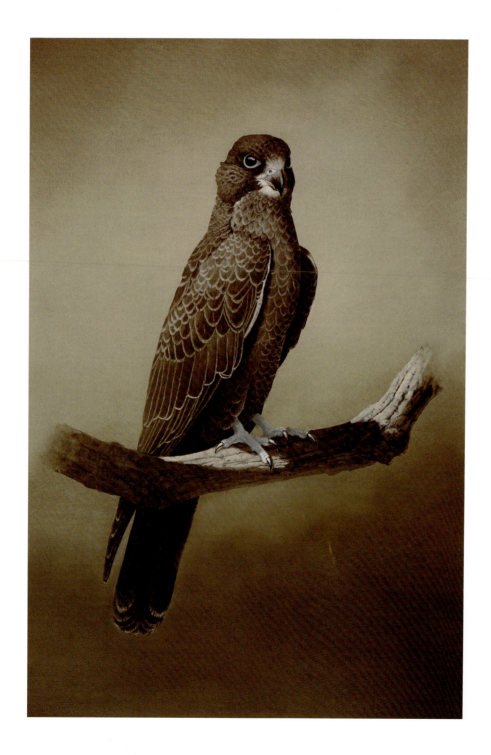

BLACK FALCON

WHITE GOSHAWK

The Black Falcon is not really black, more of a slaty dark brown, but the White Goshawk is really white. Why each is so coloured is something of a mystery to me. The falcon inhabits the interior where it gets very hot for much of the year, so one would suspect that dark plumage would absorb more heat, but the only times I've seen panting in any of the several hundred I have come across is after they have been really active. Then again crows that live in the same areas are even darker, as are some dark Brown Falcons, so obviously I shouldn't be in charge of evolution. The White Goshawk is so obvious in the forest gloom that one wonders how it can escape detection long enough to capture prey. Perhaps a superficial similarity to cockatoos helps. But both the Black Falcon and White Goshawk are very efficient hunters, each in its own way. Each is very high on my list of favourite birds.

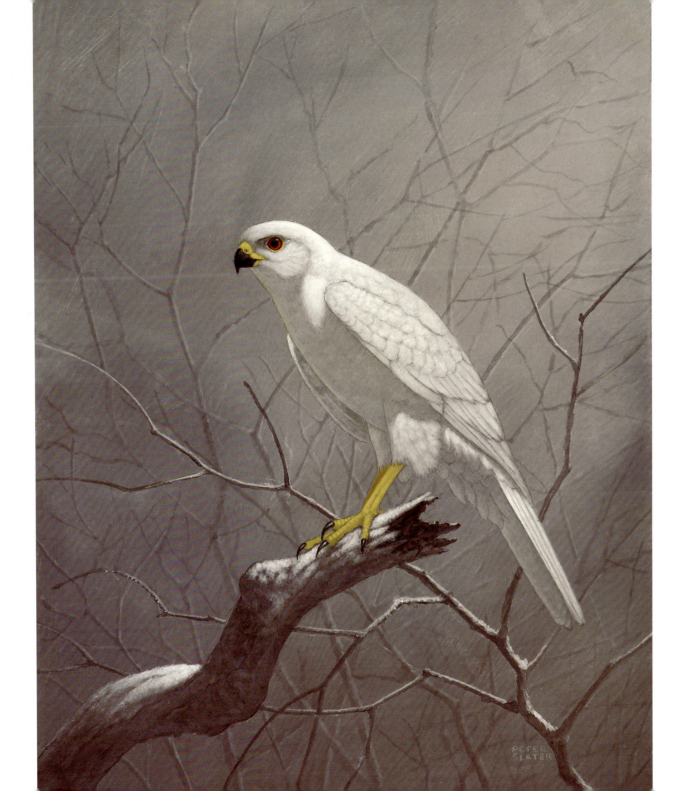

PEREGRINE FALCON

Once, long ago, an anthropocentric theologian decreed that *Homo sapiens* was positioned at the top of the evolutionary tree, and that all other creatures, great and small, as well as plants, bacteria and fungi were lesser beings. For some reason the idea caught on, and multitudes came to believe it. But *Homo sapiens* is not without imperfections, so in the interests of objective judgment, one should seek a being that is perfect in every way. Behold, look no further than the Peregrine Falcon. There it sits at the top of the evolutionary tree and all lesser creatures, including *Homo sapiens*, can but gaze upon it in reverence and awe. At least the Egyptians got it right and worshipped the falcon (Ra) as a god. But as for us: *sapiens* means wise. Hmm.

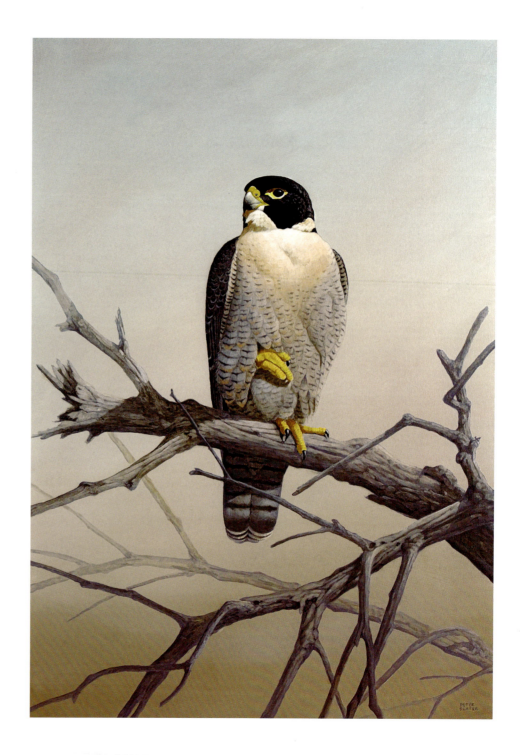

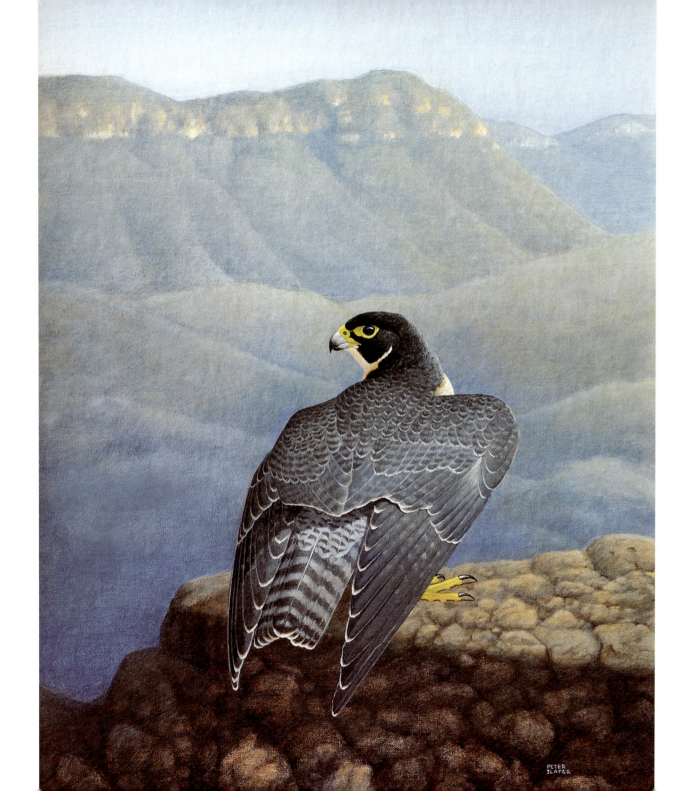

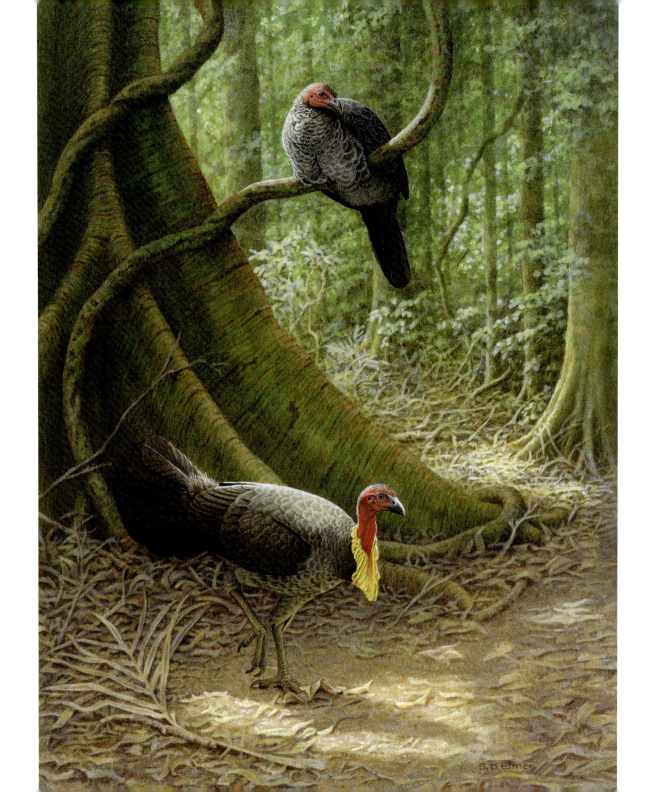

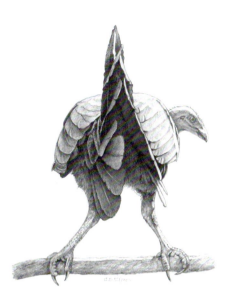
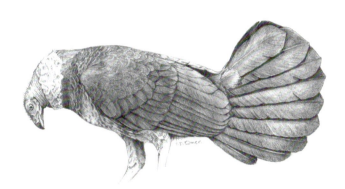
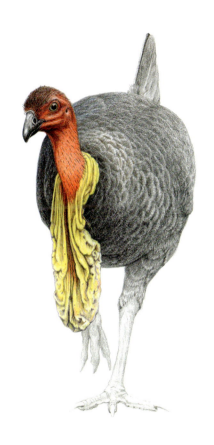

AUSTRALIAN BRUSH-TURKEY

Shortly after we purchased a home on some acreage on the outskirts of Brisbane, a brush-turkey decided to construct a mound at our back door. Soon the nearby wall was supporting some tonnes of dirt and debris scraped up from the surrounding bushland. We were delighted to have the opportunity to see close at hand the way the male opened and closed the mound, checking the temperature, and excavating holes for the females to deposit their eggs. We often saw young ones but were never lucky enough to see one digging its way out. After Graham Pizzey visited, he described our backyard as not much of a garden, but a good place to see birds. Long after Graham died, when I was well into my eighties, I remembered his words and decided belatedly to make a garden. Suddenly the half-dozen or so turkeys for some reason were no longer so welcome. Sally's mum, living in inner Brisbane, also loves the half-dozen that help rearrange her plants.

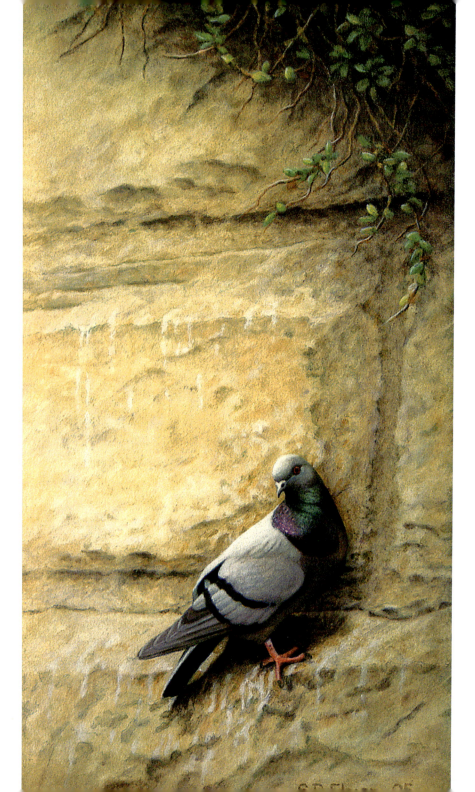

ROCK DOVE

Rock Doves are the ancestral form of the many varieties of domestic pigeons. Escapees all over the world have proliferated in cities and towns, and over time will probably revert to the original type. One of the reasons Peregrine Falcons have also chosen to live and nest on high-rise buildings in cities is the large numbers of feral pigeons available as food. Racing pigeon-fanciers generally are antipathetic to Peregrines, blaming them for losses suffered during races. But there are so many other factors that contribute to losses that it is unreasonable to blame the falcon, particularly as there are far fewer in the environment than fanciers assume.

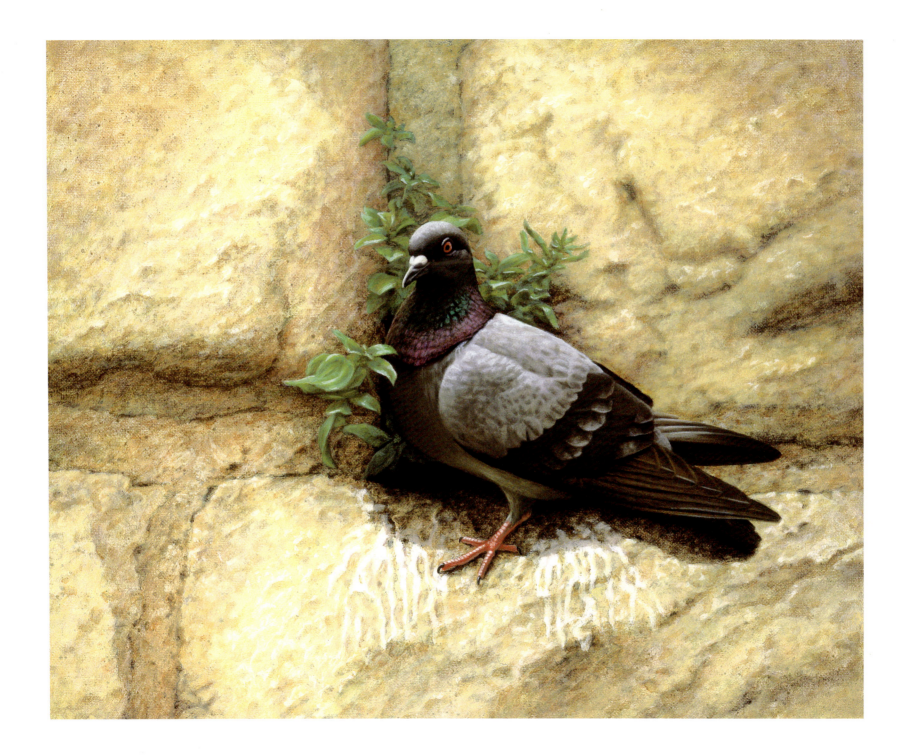

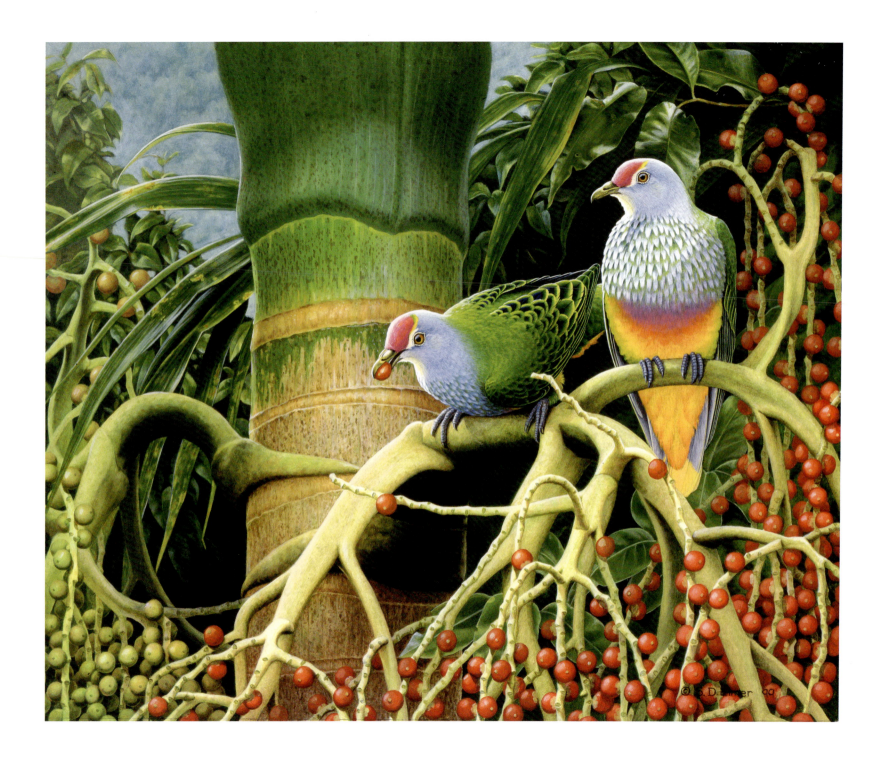

ROSE-CROWNED FRUIT-DOVE

Colour accuracy is an all-important goal to the painter of natural history subjects. Unfortunately very few of the pigments and paints available to the artist actually match precisely the colours one sees on a bird, a rock or a flower. So it becomes necessary to mix different paints to get the shade required, a task made more difficult because many mixtures dry darker than they look when wet. One of the most difficult colours to mix is the particular shade of pink found on the head of the Rose-crowned Fruit-Dove. In fact, it took the best part of a day to match that little patch of rose-pink in the painting (right). Of course, in the printing process, the colour has changed again, which is one of the reasons I don't have much hair on my head. Sally, in her painting to the left, has taken a much more sensible approach, showing her birds back-lit, allowing the colours to be influenced by light and shade in a more realistic manner. My painting is part of a larger vignette-style illustration prepared as a sample for a proposed book about fruit-doves that never eventuated.

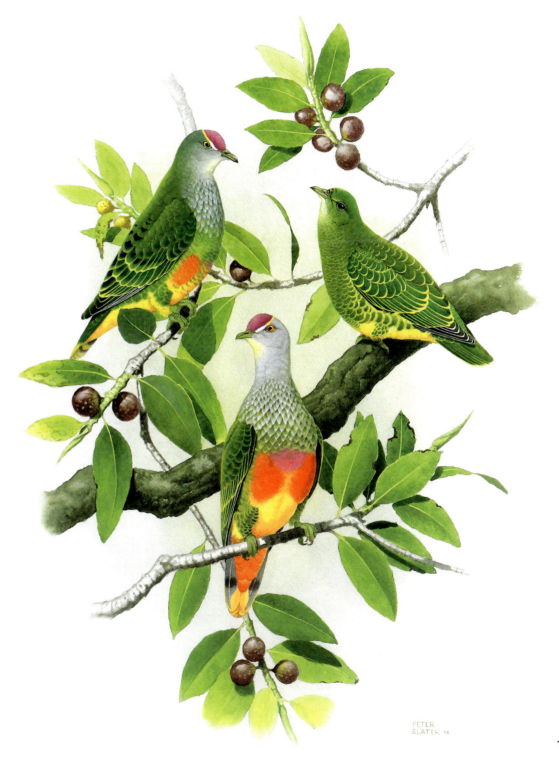

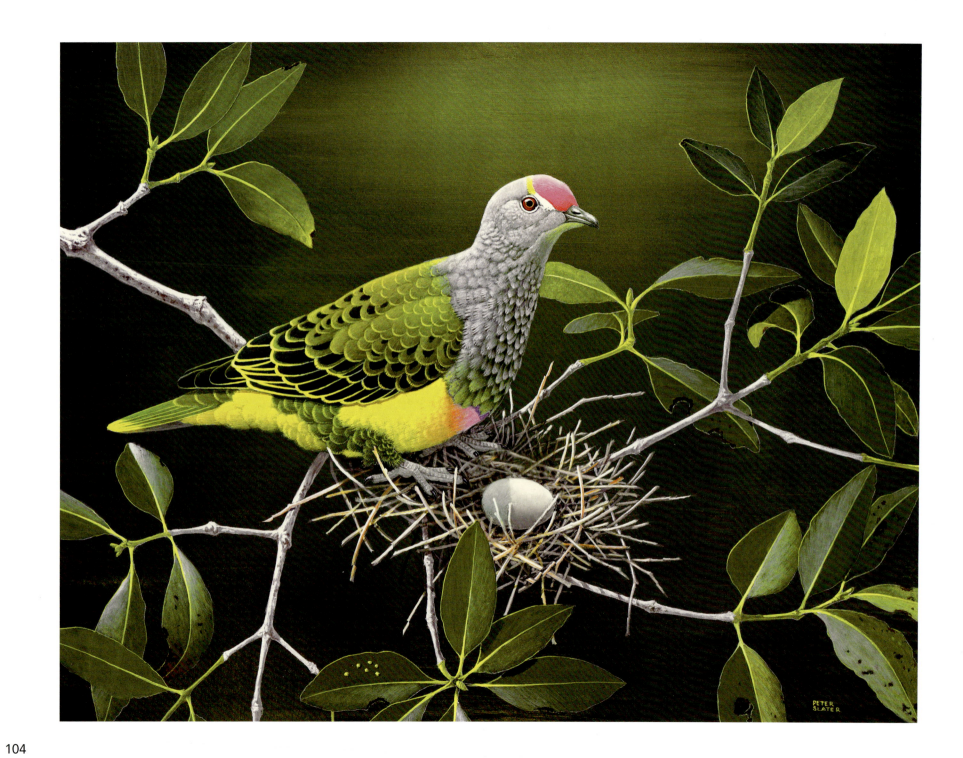

ROSE-CROWNED FRUIT-DOVE

There is no excuse for making a glaring error in a bird painting – if one spends the appropriate amount of time looking at a subject, and doing proper research, there should be no mistakes. On several occasions when we were at Pajinka, on the tip of Cape York, we came across Rose-crowned Fruit-Doves nesting along mangrove-fringed creeks. To access the waterways we used a dinghy, slowly puttering our way along the banks. The dove nests were on horizontal branches overhanging the water, well above our heads, so we were looking up at the birds. It was such a beautiful sight that I determined I would paint it, so set to work as soon as I returned home. Alas, because the birds were sitting tightly, I didn't realise that each nest only contained one egg, which I now know is the normal clutch for fruit-doves. In my original painting I included two eggs, the usual number for other pigeons and doves. Even more unfortunately the painting was reproduced in a book. So to set the record straight, here I have removed one of the eggs from a digital image in my files, using Photoshop (left). On one of the occasions when we were heading to the creek in our dinghy the border patrol aircraft flew over, and circled us a few times waggling its wings. We all waved back. Later we learnt that the spotter, an islander lass with incredible eyesight, had noticed a huge crocodile directly under the dinghy.

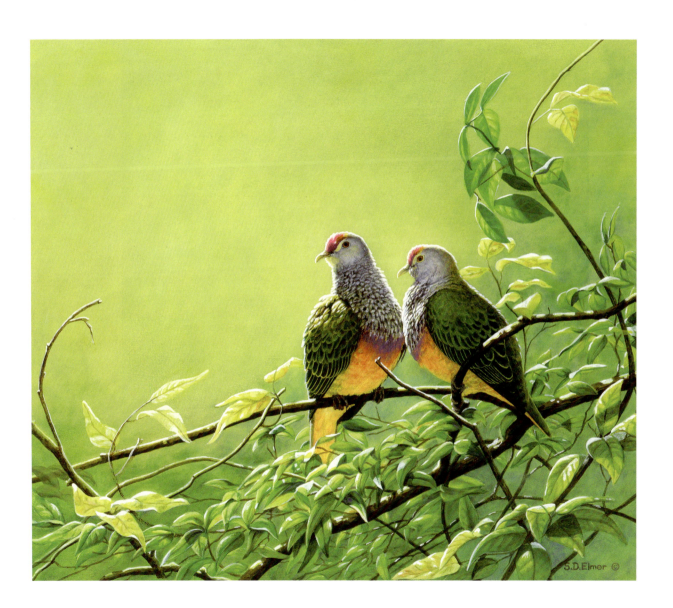

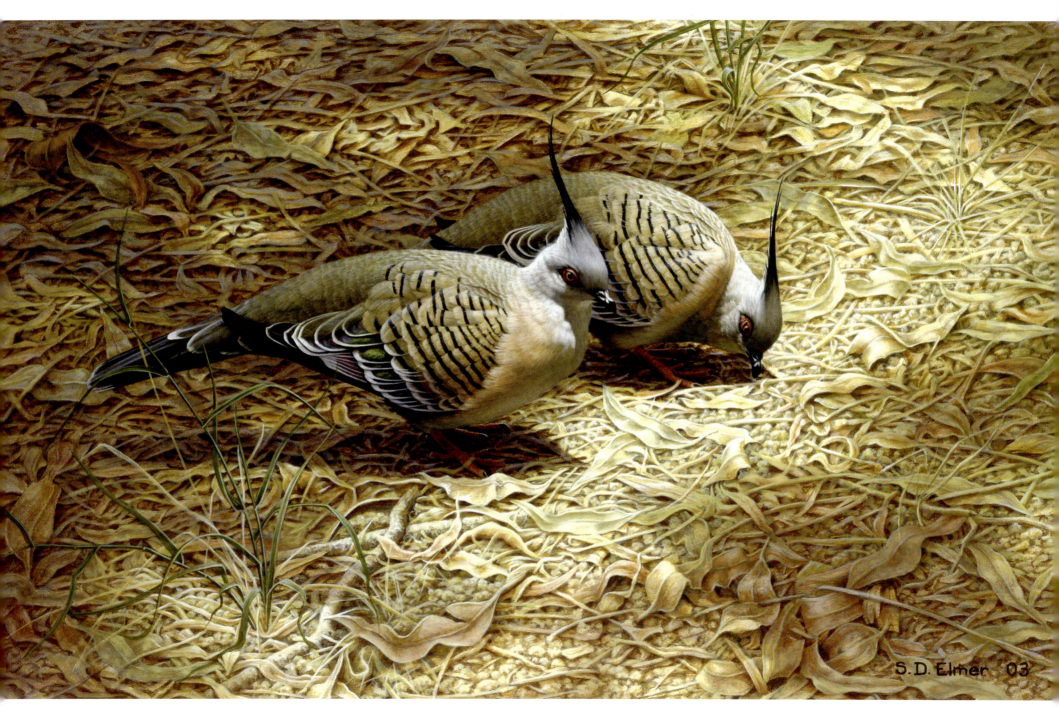

CRESTED PIGEON
PEACEFUL DOVE

So many creatures have been adversely affected by human impact on the Australian environment – from the giant kangaroos, mihirungs and diprotodons whose demise coincided with the arrival of aboriginals, to the massive extermination of mammals following the Caucasian invasion – that it is of some relief that a few have benefited. The Crested Pigeon is one such; it is now a familiar visitor to many a backyard. In the outback it is one of the most familiar of birds, proliferating due to the provision of water for stock. Perhaps because of its familiarity, its quiet beauty is overlooked. But its flight is not so quiet; the emargination of the third primary in the wing creates a loud whistle, no doubt evolved as a method of distracting predators.

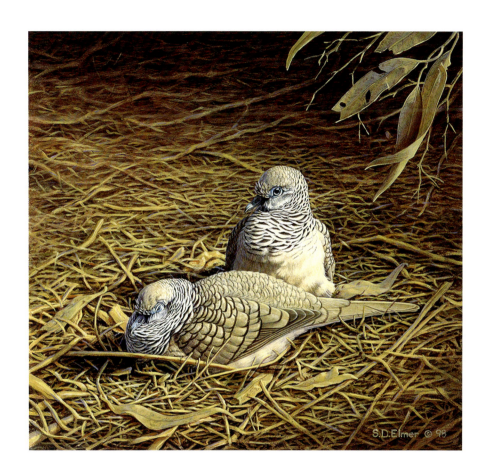

PARTRIDGE PIGEON

SQUATTER PIGEON

SPINIFEX PIGEON

Triodias are a group of spiky plants that proliferate in the Australian arid zone. There are many species; two of the most common are *Triodia basedowi* and *T. pungens*. The various species cover about 20 per cent of Australia (1,372,500 sq km), and 43 per cent of Western Australia. One year after a good season I sampled the number of seeds on 20 stalks in a clump, and multiplied the average by the number of stalks in the plant: result 7,325 seeds.

I counted the plants in an area of 100 sq m and arrived at a figure of 183,125 seeds, or about 18 million seeds per hectare. So one can see that there is plenty of potential food available for graminivorous creatures like the Spinifex Pigeon, Painted Finch and various native rodents. Generally, the pigeon and finch tend to be localised in areas where there is access to water. Sally's painting is of a courting pair in a group of about 50 we saw near a dam on the edge of the Simpson Desert.

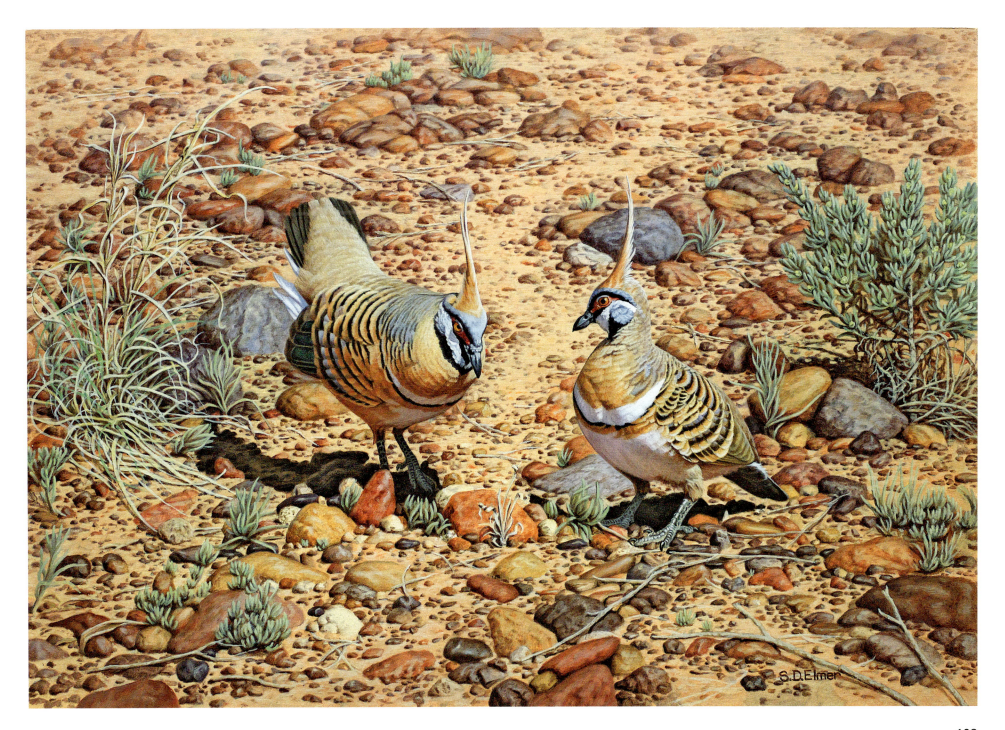

AUSTRALIAN PRATINCOLE
INLAND DOTTEREL

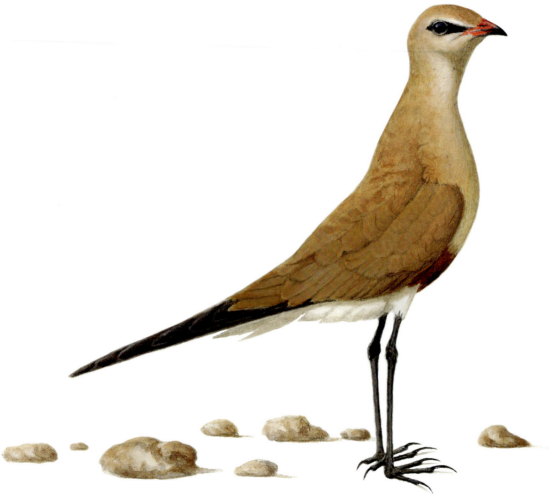

Gibbers are treeless stony plains in central Australia; they would appear to be uninhabitable but were within the foraging range of desert aboriginal groups. Explorers such as Burke, Wills, Giles, Carnegie and Sturt struggled their way across them. Sturt wrote of the sharp stones in the desert named after him that they played havoc with the horses' hooves. Carnegie described the Gibson Desert in Western Australia as a great undulating desert of gravel. On many gibber plains the stones are rounded from the abrasion of wind-borne dust and are coated with a 'desert varnish' so that they seem to reflect the light. They are only lightly vegetated with chenopods except after rain, when ephemeral plants briefly appear. Very few creatures inhabit them. Two that we see often on our travels are the Australian Pratincole and the Inland Dotterel. Both have plumages that match the colours of the gibbers. Some years there are plenty of them; other years we only encounter a handful, so from this evidence we assume that they are nomadic, seeking out areas where rain has recently fallen.

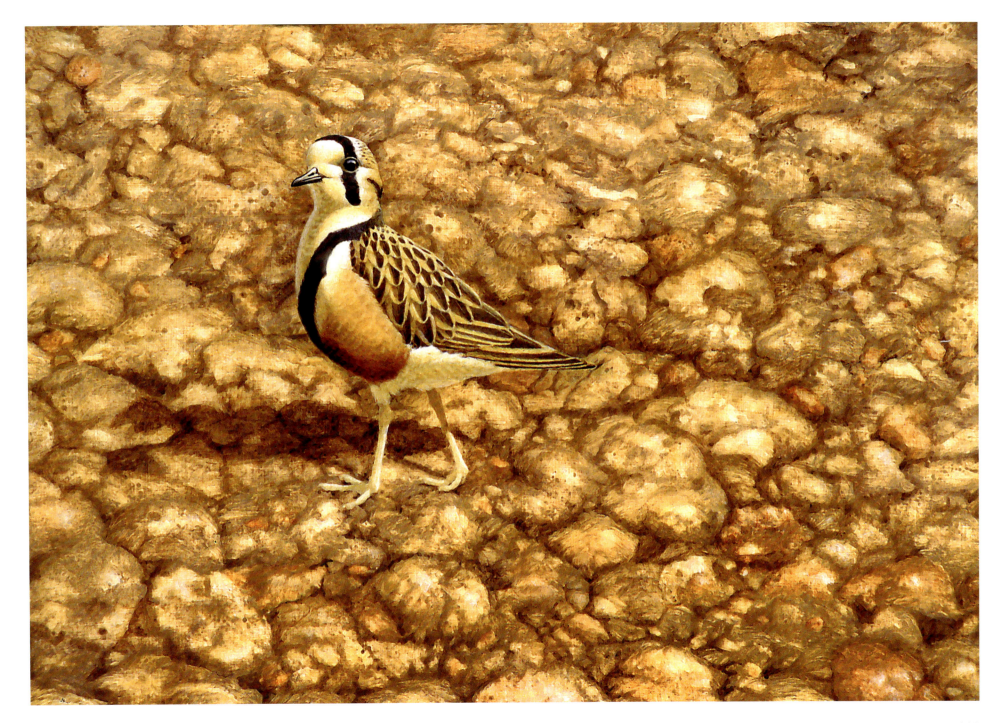

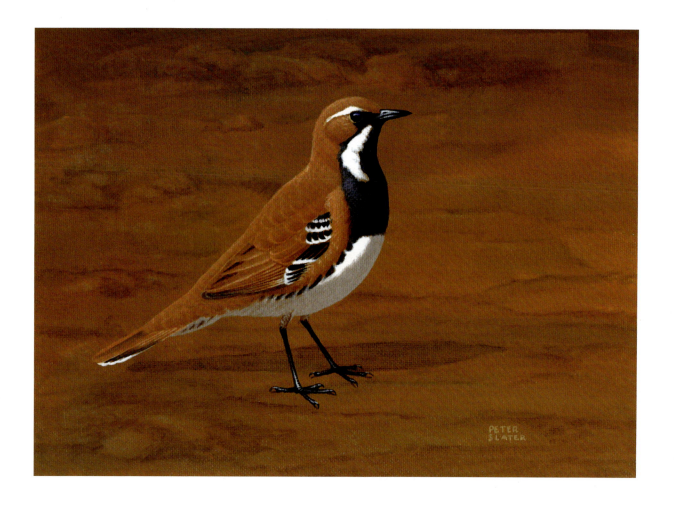

NULLARBOR QUAIL-THRUSH

RUFOUS FIELDWREN

While I was living on the edge of the Nullarbor Plain I heard that a lady at the Lime Kiln near Rawlinna was rearing Naretha Bluebonnets she had taken as chicks from nesting holes in Desert Oaks. I was keen to see these parrots so hitched a ride. The kind lady drove me out on an old track to see if we could see wild parrots. On the way we flushed a Nullarbor Quail-thrush, which as far as I was concerned, was even more desirable. Unfortunately the bird had the typical quail-thrush reluctance to be spied upon, so I didn't get much of a look, just enough to verify it is a very handsome bird. I love the patterns in the plumage of the Rufous Fieldwren. It is one of those birds that is a joy to paint; in the field it is not so easy to see, usually remaining hidden in the desert shrubbery, but I had one delightful morning near Port Augusta after rain when dozens of males were up on dead sticks proclaiming their territories in a concert almost loud enough to drown out the Chiming Wedgebills.

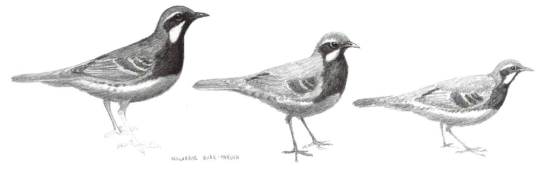

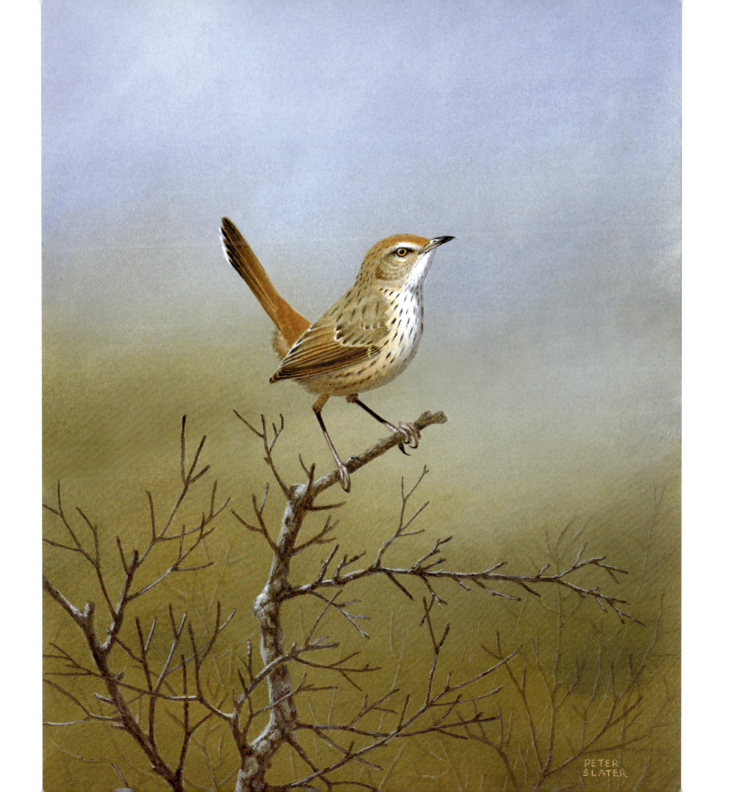

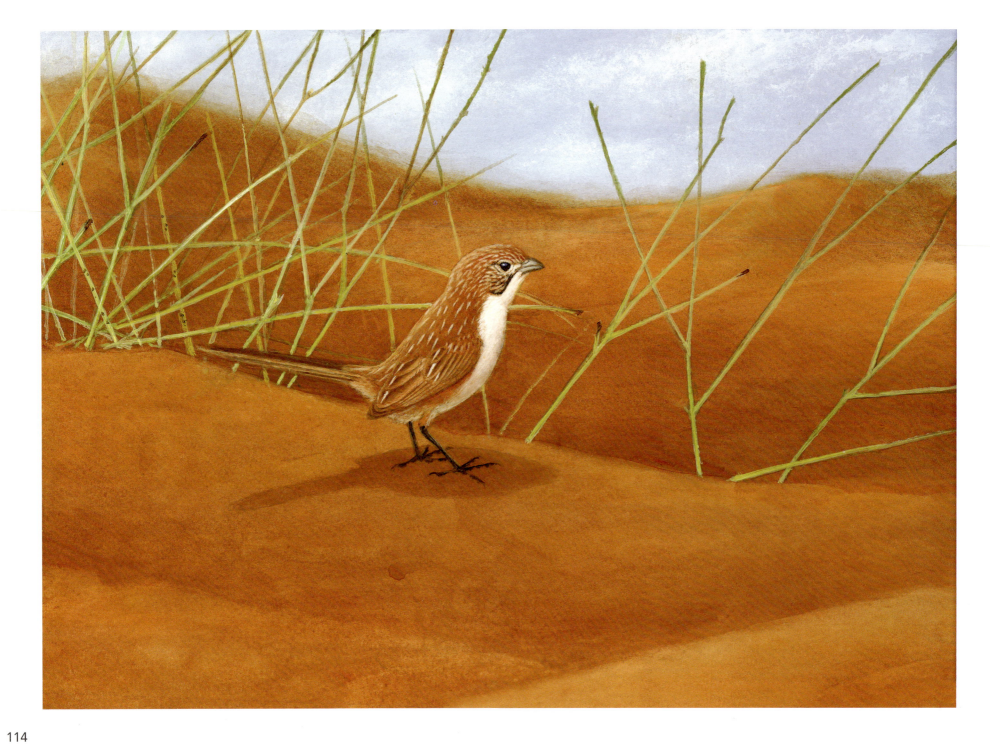

EYREAN GRASSWREN
SANDHILL GRASSWREN

We were lucky enough to find Eyrean Grasswrens in a few places: the first ones were in cane-grasses on top of Big Red, the highest dune in the Simson Desert; and, on a trip down the Birdsville Track, we encountered them at the southern end of Mungerannie Dune, the longest in the Tirari Desert, which inspired this painting. We also saw their tracks in dunes further south, mostly around small shrubs that appeared to have shed loads of small seeds. Eyreans have bigger, stouter beaks than other grasswrens, so it is likely they feed on seeds as well as insects. We also saw Brown Falcons, Cinnamon Quail-thrushes, Zebra Finches and White-winged Fairy-wrens in both places where we found the Eyreans, so we were happy. At first sight one would think that desert dunes would not be places to harbour birds, but throughout the arid interior they are inhabited by a number of other grasswren species, such as the Sandhill Grasswren (right), and numerous small skinks. I am a bit ambivalent about looking for grasswrens on dunes. I love looking at the mini-landscapes they inhabit, but to do so, I leave footprints that disrupt the harmonious ambience. Sure, the ever-present wind will smooth them out, but that's not the point. I hate the unmindful morons who hoon their 4x4s up and down the dunes, one of the multitude of reasons why I believe there are far too many humans on the planet. But my footprints, while smaller than ugly wheel-tracks, are just as much a disrespectful desecration. So, alas, I am also one of the 'too many'. The problem is, how to get rid of the excess, say five billion, without hurting anybody.

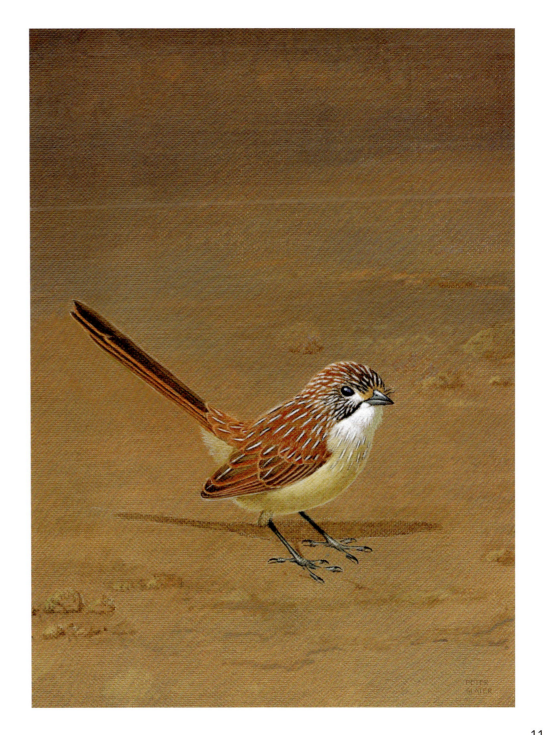

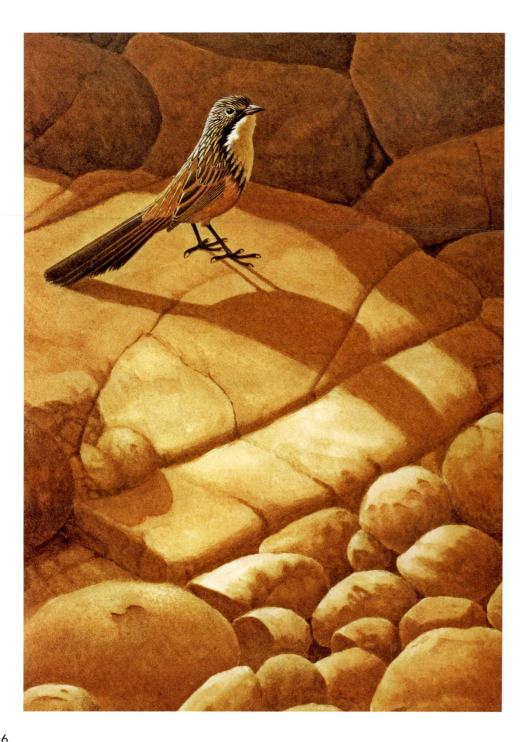

WHITE-THROATED GRASSWREN

BLACK GRASSWREN

I climbed the escarpment at Gunlom, Northern Territory, early one morning hoping to see White-throated Grasswren – a new bird for me. Diligent searching failed to locate the elusive birds but other nice ones turned up: Sandstone Shrike-thrush, Sandstone Friarbird, a beautiful Grey Goshawk and a nest of Weebills. I wearily sat down on a sandstone ledge; looking around I saw a flat rock nestled near a patch of spinifex, and thought, 'That would be a good place to see a grasswren'. Believe it or not a grasswren hopped onto the rock, soon followed by four others. Two of them started wrestling and I spent the next few minutes immersed in the most magical moments of my life. I later tried unsuccessfully to paint the scene, so settle for an image of the first bird that arrived. At one stage I was experimenting with different artistic effects and in one experiment squeezed dollops of sienna, umber, orange and ochre paints onto a board, then squeegeed another board onto it. When I pulled them apart and saw the result, I immediately thought of the Black Grasswren, I don't know why because it is one of the few Australian birds that I haven't seen, and not for the want of trying. If you have seen one you will know that this is not a very accurate representation, nevertheless it represents a certain point in my development, so I include it here, perhaps as a warning: only paint what you know from personal observation.

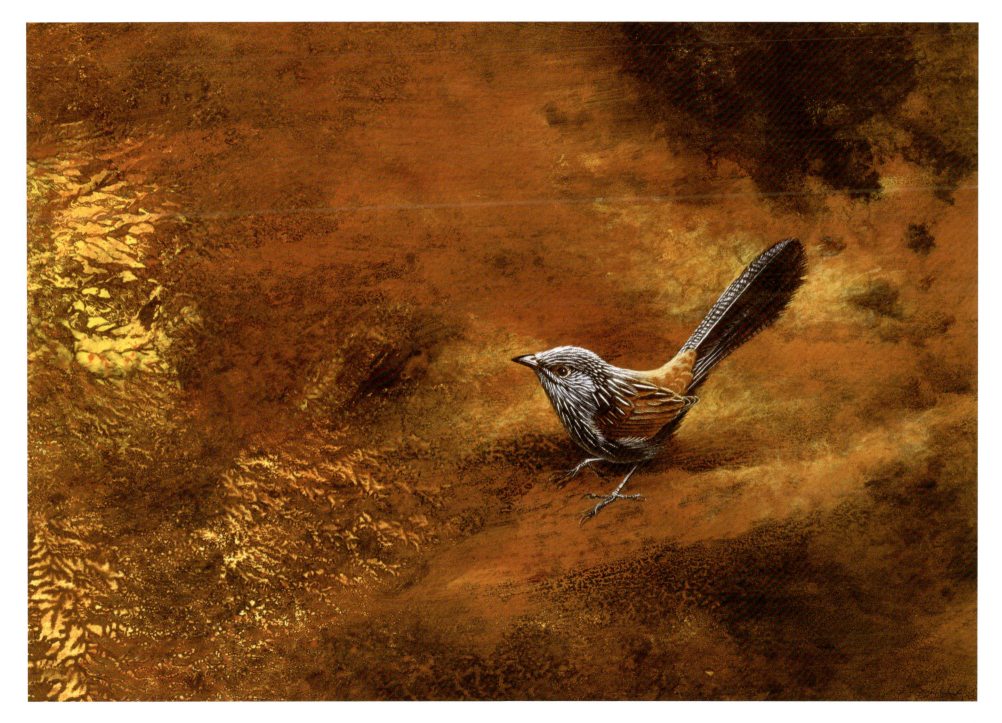

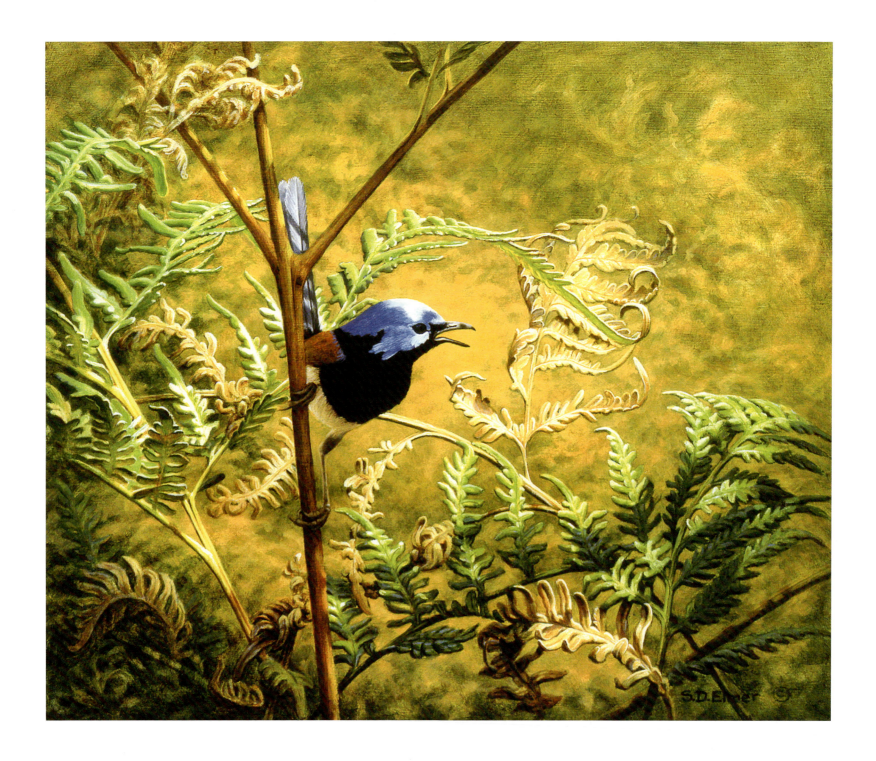

VARIEGATED FAIRY-WREN

This is the most widespread fairy-wren species, occurring over much of Australia. We have seen it in the Kimberley, the Top-End, central deserts, in mallee, mulga, spinifex, gidyea, chenopods, wallum, lantana, and forests; everywhere we travel except the south-west, Cape York Peninsula, Tasmania and, inexplicably, southern Victoria. We usually find small groups of about half a dozen or so, mostly brown birds, but we photographed one nest where there were four fully-coloured males bringing in food for the chicks, as well as a number of brown females and immatures, and another at Sally's place with three males and one female. Obviously the nestlings were well fed. Conversely, a nest Colin Lloyd and I photographed was attended by one male and one female.

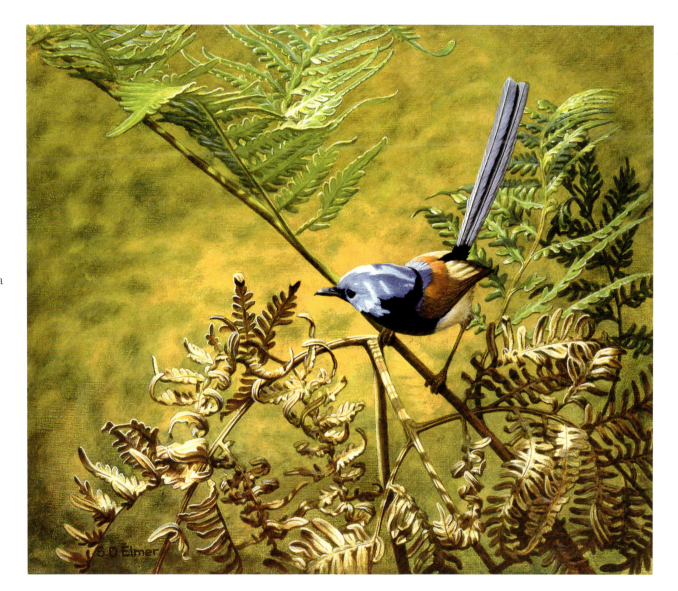

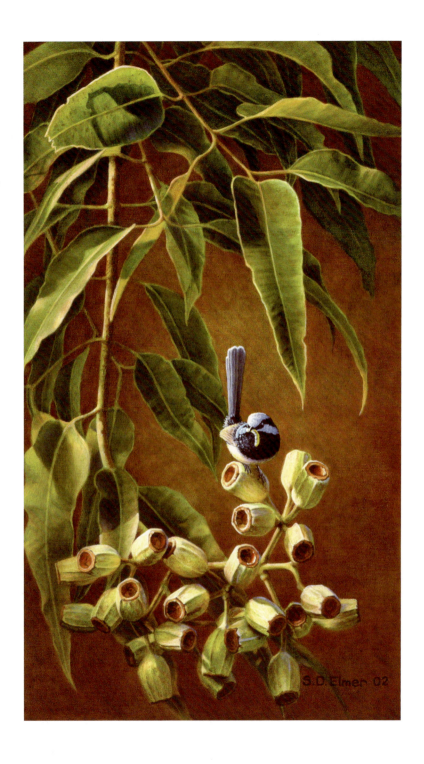

SUPERB FAIRY-WREN

VARIEGATED FAIRY-WREN

As far as I know, Neville W Cayley was the first to use the term 'Fairy Wren', in an illustrated article in the *National Geographic* magazine in 1945. Later he published a book, *The Fairy Wrens of Australia*, using the same illustrations. To my eye these are the best paintings that Cayley did, and I would welcome a new edition of the book if the originals could be found for modern techniques of image scanning. Unfortunately, reproduction of subtle variations in blue colours is a weakness of colour printing. Without getting too technical the printing process uses three colours, cyan, magenta and yellow, as well as black. For most colours the application of these four inks, one at a time in overlapping layers, is satisfactory, but blues are a bit difficult. Each of the male fairy-wren species has a different shade of blue, from purplish-azure in the western Splendid Fairy-wren to silvery-blue in the Red-winged Fairy-wren. The Superb Fairy-wren (left) has a rather pale blue, which is richer in Tasmanian birds, while in good light the Variegated Fairy-wren (right) is seen to have three subtly different shades of cobalt blue.

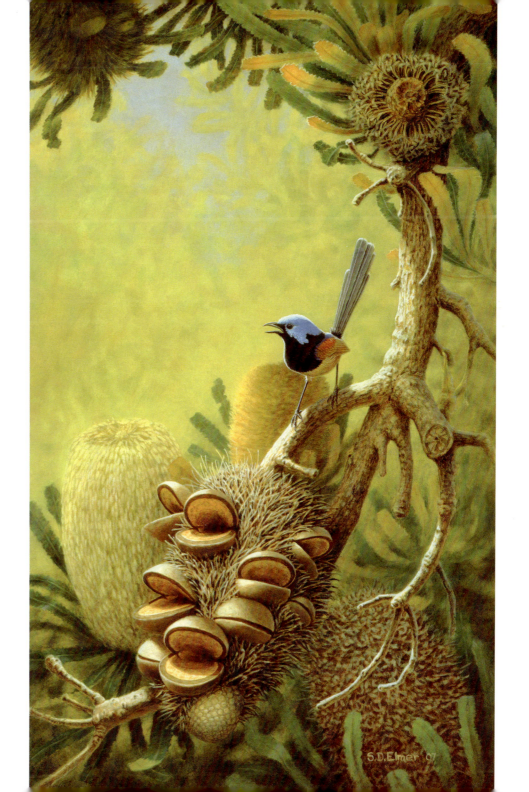

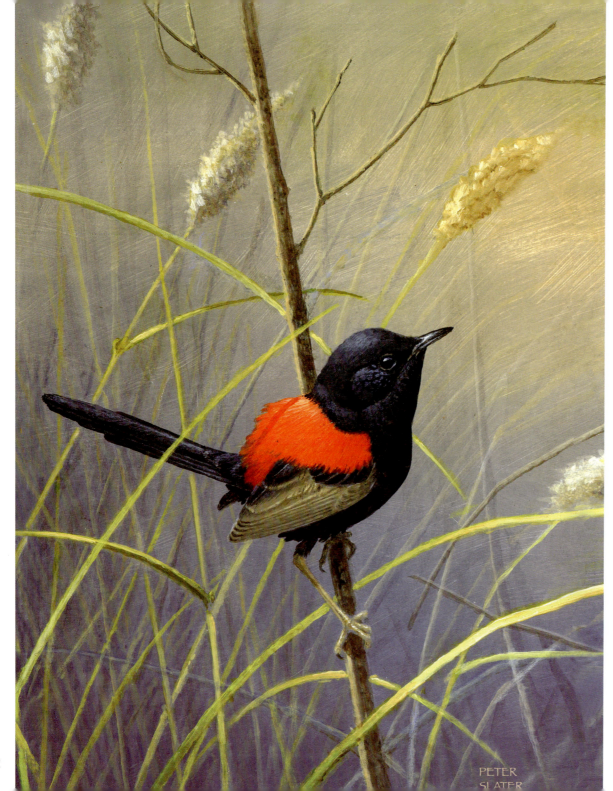

RED-BACKED FAIRY-WREN

One of the glorious sights of the Australian bush is a male Red-backed Fairy-wren displaying. The crimson saddle of feathers on the back is normally tucked away neatly, but during display it is fluffed up and expanded into a fiery ball; the effect is heightened by black surrounding feathers. Sometimes a male holds a red flower petal in its bill, apparently while intruding into the territory of a neighbouring male. I once saw, through our kitchen window, a male pick a fragment from the red portion of a Tropical Milkweed flower, and commence displaying towards a female. Each territory contains at least a pair, but often there are as many as six individuals, possibly immature birds from the previous season, most of them brown females or young males; sometimes there are two fully-coloured males in the family party. One female is dominant and does most, if not all, of the nest-building and lays the eggs. The other birds assist in feeding the young once they hatch, but at nests we have watched, the dominant female seems to be the most active.

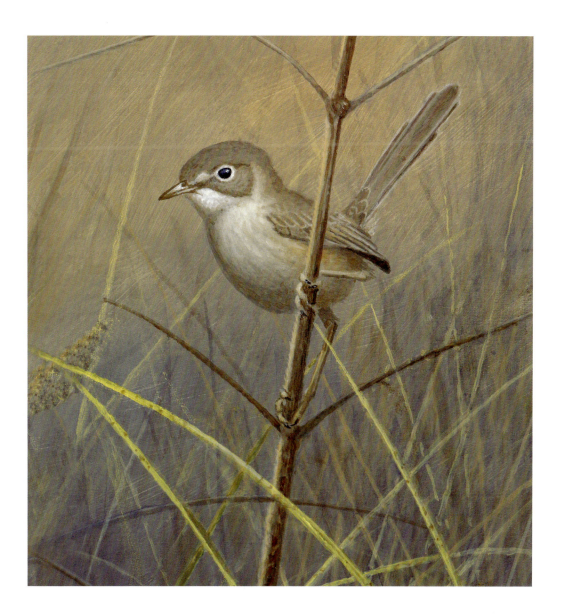

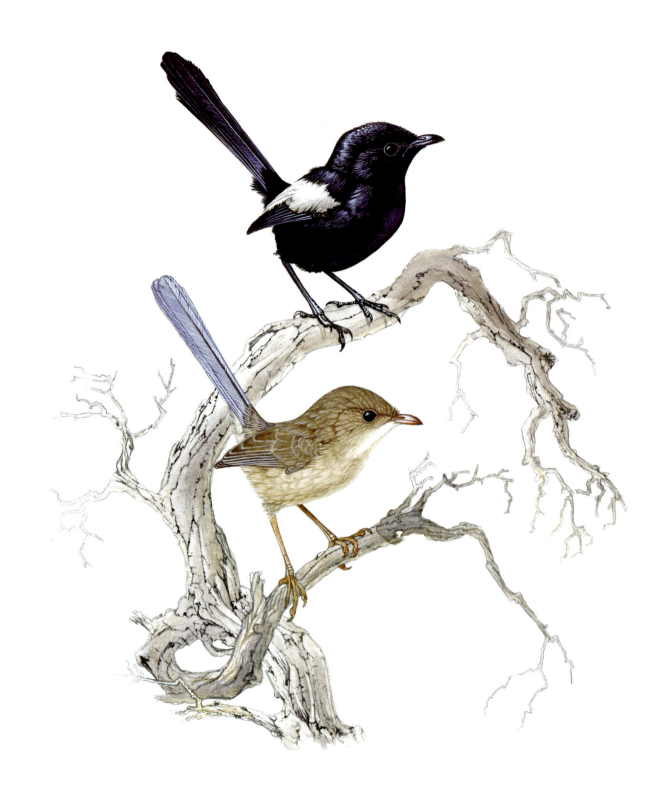

WHITE-WINGED FAIRY-WREN
LILAC-CROWNED FAIRY-WREN

The White-winged Fairy-wren is basically a bird of the arid interior, but in the west extends onto several islands off the coast, where it was discovered by the Baudin expedition in 1801. Unlike the mainland birds, the blue of the male plumage on the islands is so intense it appears to be black, so for a long time it was thought to be a different species, the 'Black-and-white Wren'. The Lilac-crowned Fairy-wren of the tropical riverine thickets was discovered by Joseph Elsey, a young doctor who travelled with the expedition in search of the missing explorer, Ludwig Leichhardt, collecting birds and other specimens along the way. He died a few years later at the age of 24. Elsey Station, the locale of the book *We of the Never-Never*, was named after him, as was a genus of snapping-turtles. The grasses and pandanus thickets that the western subspecies of the fairy-wren inhabits, along the tropical creeks and rivers, have been degraded by cattle, particularly in the Kimberley, where it is listed as endangered.

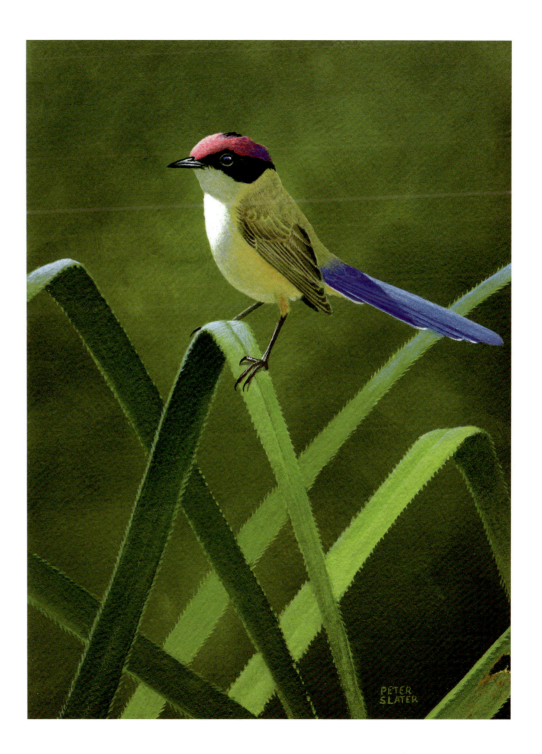

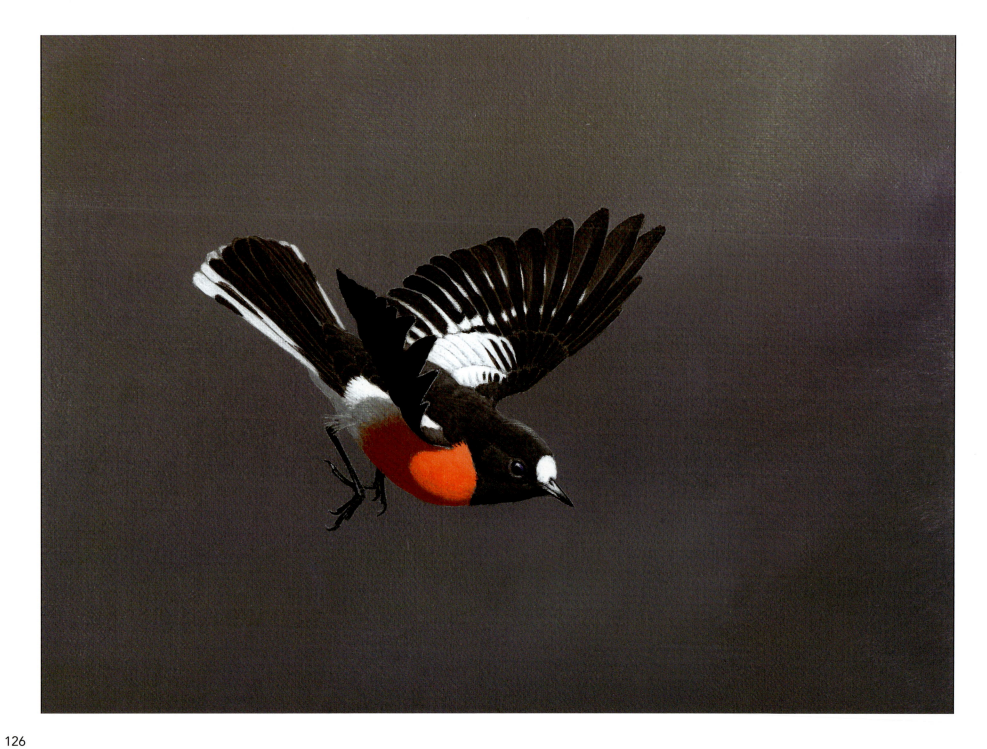

PACIFIC ROBIN
SCARLET ROBIN

It doesn't snow all that often in Queensland so when we heard it was falling at Girraween on the Granite Belt, Raoul and I headed up to have a look. We'd never seen snow before, so we spent a few magical hours wandering around, snapping photographs like any old tourist. The sight that most entranced me was a Scarlet Robin, a vision in red and black against a grey and white background. Naturally it made its way into a painting. I believed for many years that Georg Forster was the first artist to portray the robin, a bird he encountered on Norfolk Island while travelling with Captain James Cook's second expedition to Australia. But recent research suggests the Norfolk Island bird is a different species to the one on the mainland, so it is now called the Pacific Robin, *Petroica multicolor* (left), and the Australian bird is now the Scarlet Robin, *Petroica boodang* (right), one of only three birds having an aboriginal specific name. The others are the Brown Falcon, *Falco berigora* and the Southern Boobook, *Ninox boobook*.

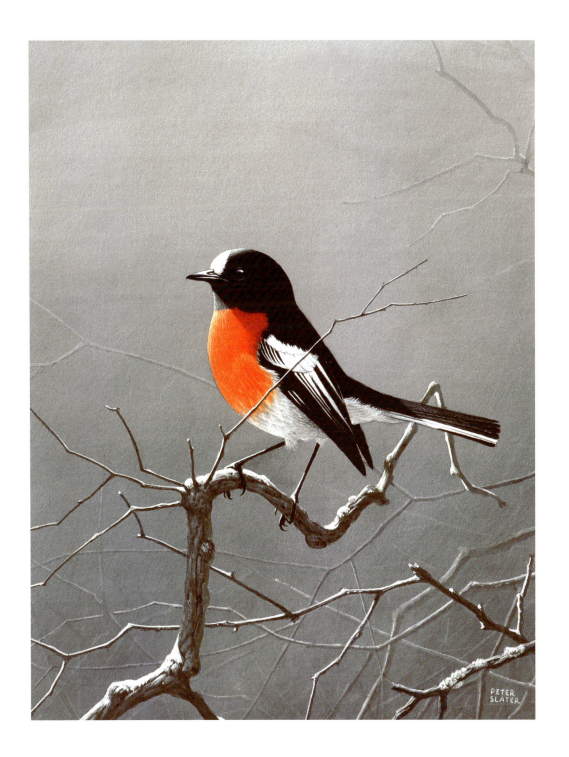

RED-CAPPED ROBIN

FLAME ROBIN

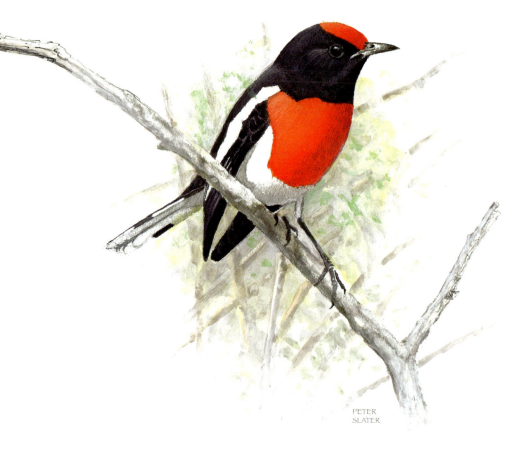

Robert Brown was a botanist who sailed with Matthew Flinders on his circumnavigation of Australia. While ashore in South Australia looking for specimens he discovered the Red-capped Robin. I don't know if artist Ferdinand Bauer, who was accompanying Brown and beautifully illustrating botanical and other specimens, painted the robin. It is such a striking bird that he probably did, but I can't find any reference to it. He did paint a Ringneck while there, probably collected at the same locality. The Flame Robin inhabits more open country than other robins. John Gould showed a specimen at a meeting of the Zoological Society of London in 1836, and published a description in the society's journal, but neglected to say who had discovered it. He observed it himself a few years later while domiciled in Tasmania, and noted its tameness around human habitations.

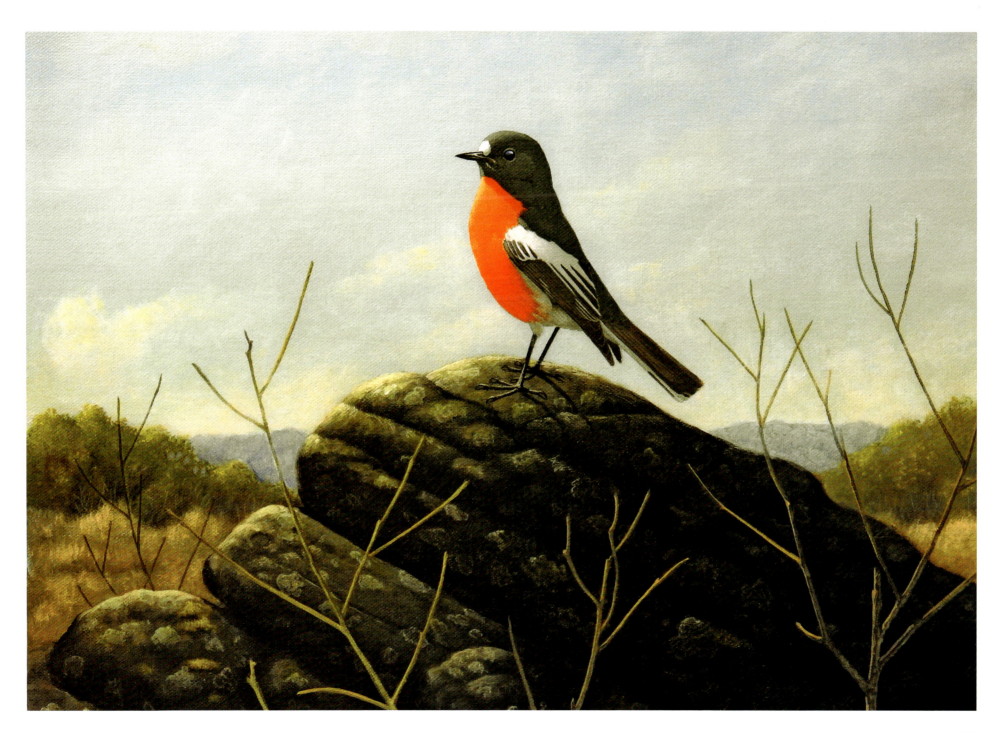

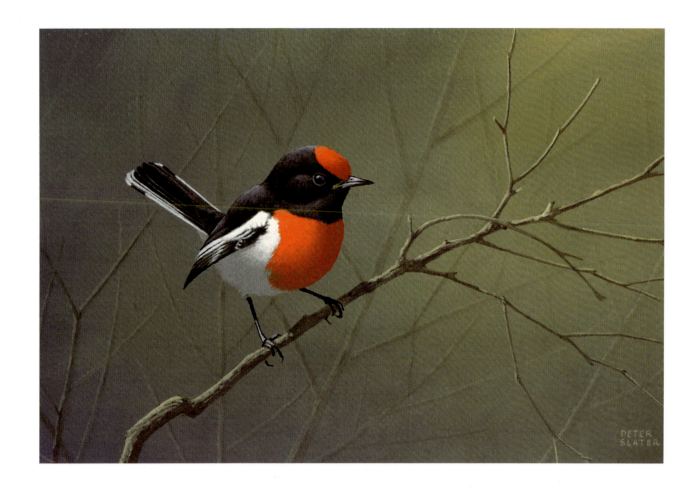

RED-CAPPED ROBIN

In the early 1970s my favourite birdwatching site was in a seven-hectare patch of mulga beside a small lake between Bollon and Cunnamulla, Queensland. There I found as many as 13 pairs of Red-capped Robins holding territories. We usually visited in August when the robins and numerous other birds were nesting and I did a number of paintings of obliging males.

Many years later, in 2014, I took Sally there, telling her it was a fabulous spot for robins. We found only one pair, building a nest in a dead tree. When we returned a fortnight later, the nest had been torn out and there was no sign of any robins. The paintings record what once was there, but I'd rather have the birds.

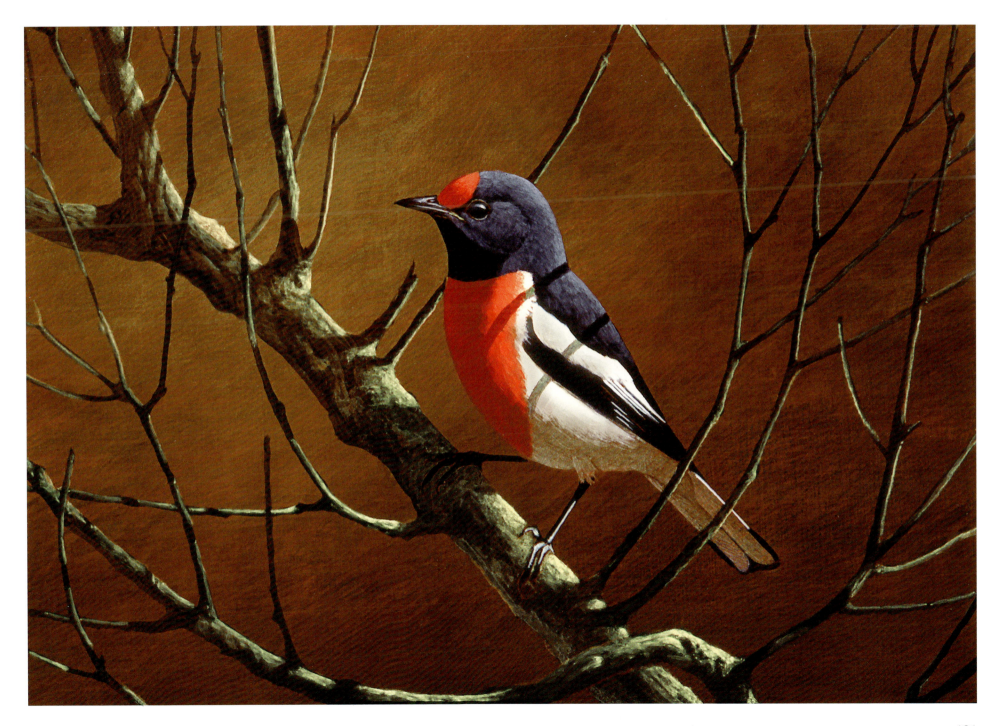

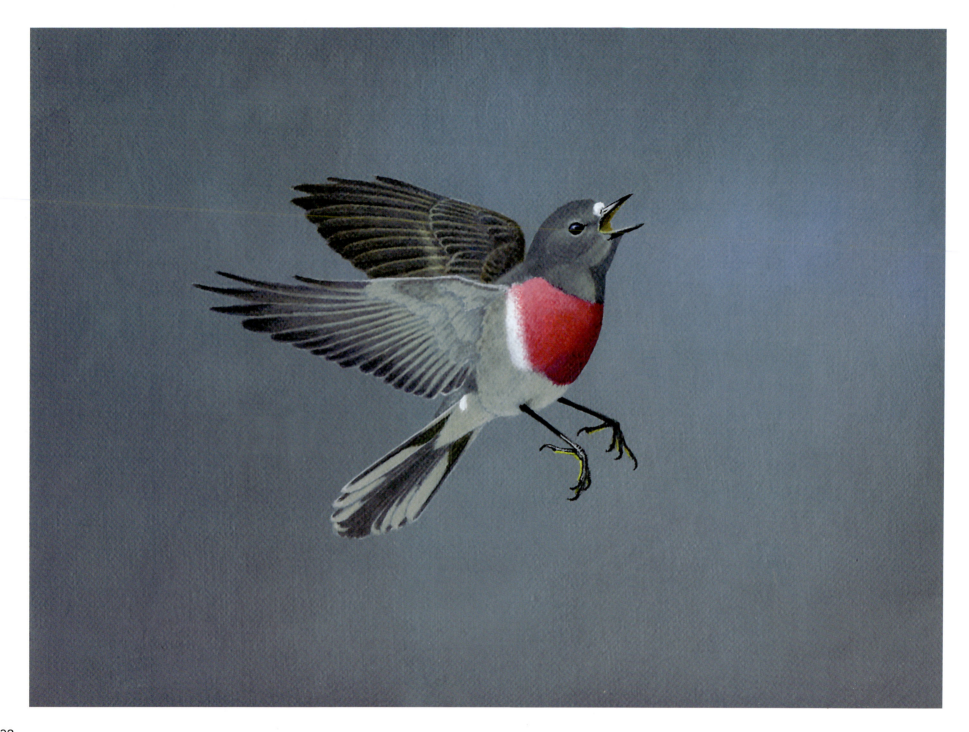

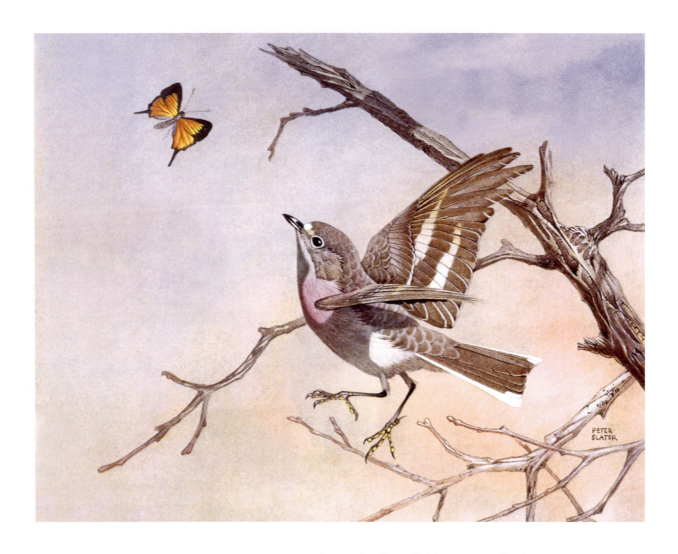

ROSE ROBIN

Every winter a few Rose Robins came to live in our garden, turning up and leaving on approximately the same dates each year. Their quiet contact call was a feature of our backyard. Early in August the males would begin singing their sepulchral songs; within a week they would all be gone and we would look forward to their arrival the following year. Then Noisy Miners moved into our neighbourhood and we haven't seen a Rose Robin here since.

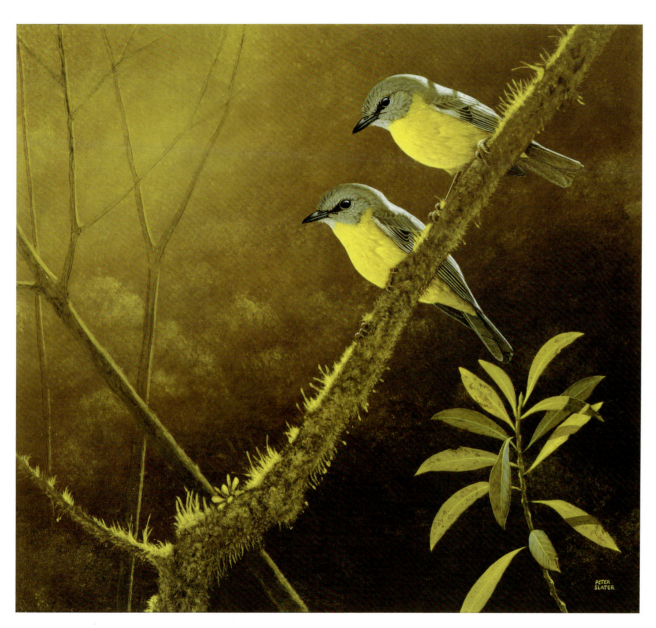

EASTERN YELLOW ROBIN

Roy Wheeler was a legendary and much-loved birdwatcher, the first to see 600 Australian species in one year. If he didn't inaugurate the Bird Observers Club he certainly ran it effectively for many, many years. In retirement he went to live at O'Reilly's Guest House in his favourite birding spot, the Lamington National Park. I came to know him well on the annual O'Reilly's Bird Weeks. Roy's greatest enjoyment was to take a party of birdwatchers out for the dawn chorus. At 3am precisely would come a knock on the door and we would stumble into the rainforest to listen as each species began to call. Invariably, after we had settled, the first songsters, the Eastern Yellow Robins, began their bisyllabic salute to the dawn. One often encounters yellow robins in the bush, but it is only when listening to the dawn chorus that one realises how many there are. It is not unusual to hear ten within earshot. Each year fewer birdwatchers turned out until, on my last visit to Bird Week, Roy and I were the only ones to make the effort. Long after he died, Roy's beloved Bird Observers Club amalgamated with Birds Australia. I imagine the look on his face when he heard the news would have been similar to the one I saw when no-one turned up for the dawn chorus. But he would probably have been happy eventually at how the amalgamation has turned out.

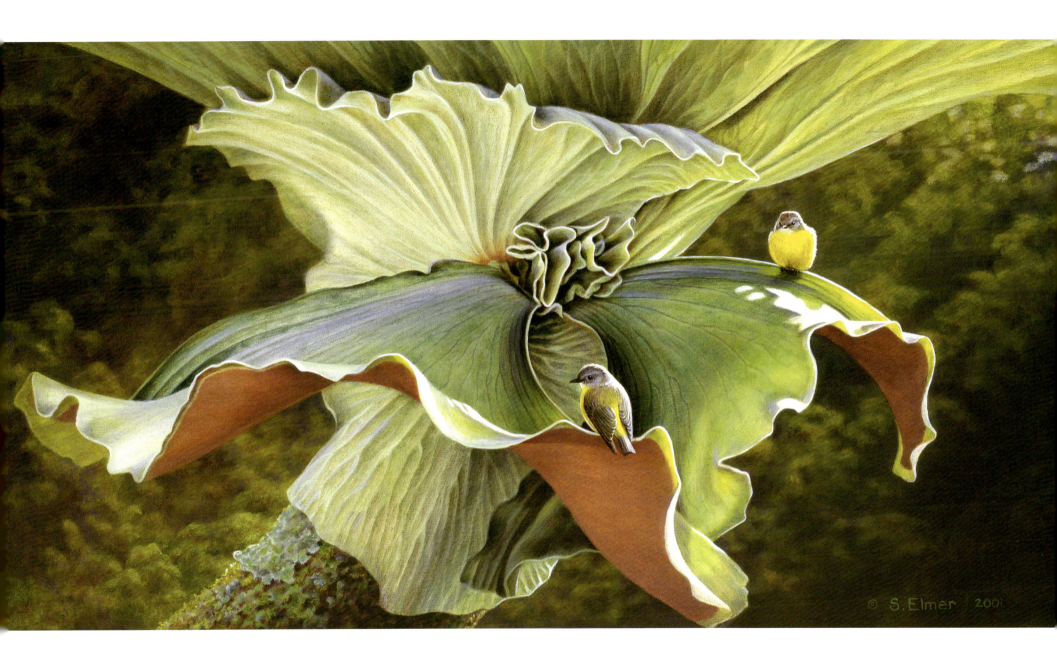

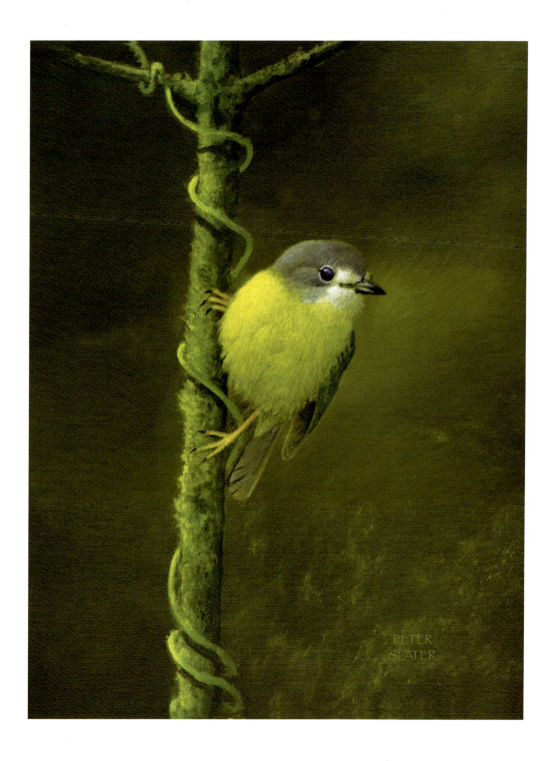

PALE-YELLOW ROBIN

FAIRY GERYGONE

It's not unusual to see Eastern Yellow Robins sharing the same patch of rainforest as Pale-yellow Robins (left). Presumably the two species seek sufficiently different items of prey so that they don't compete. We see Eastern Yellows well out into the arid interior at places like Idalia National Park, but never the Pale-yellows. They are restricted entirely to rainforests; their large eyes are probably an adaptation to their gloomy surroundings. In north Queensland the robins are replaced by the White-faced Robin, which seems to have an even bigger eye. Also in north Queensland rainforests, as well as in mangroves, occurs the Fairy Gerygone (right). At the southern edge of its range the males have only a reduced patch of black on the chin; to the north the black extends progressively further onto the throat and breast. The females have pale throats, rather like White-throated Gerygones, but not as clear-cut. These birds in my painting were as far north as the species occurs, in the Lockerbie Scrub, in this case only 200m from the tip of Cape York. I found a nest there, as usual built near a paper wasp colony, and got too close. The pain subsided after a day or two.

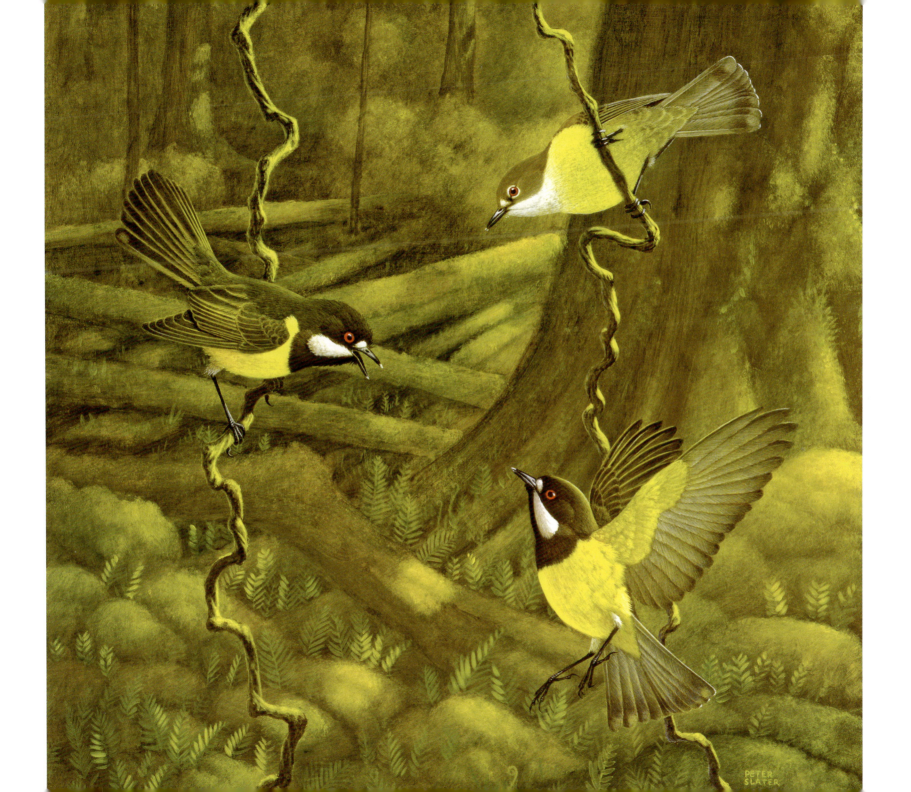

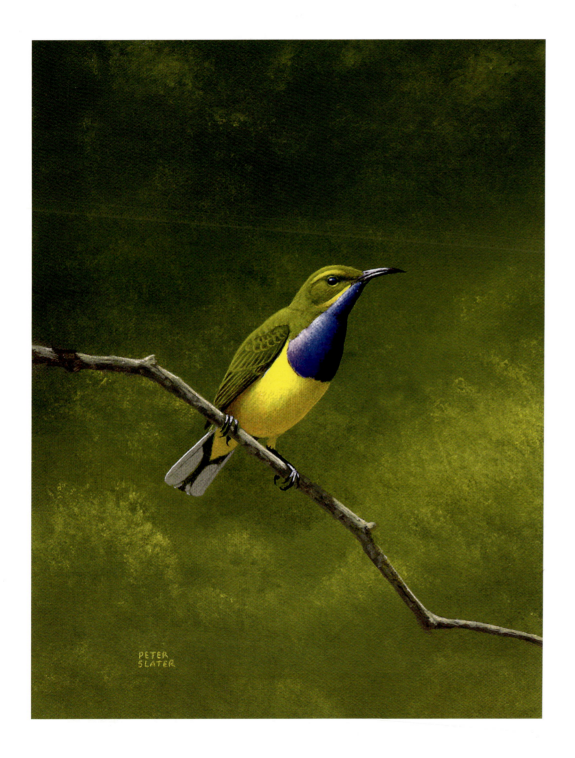

OLIVE-BACKED SUNBIRD

LEMON-BREASTED BOATBILL

These are two north Queensland specials. The brilliant iridescent gorget of the male sunbird changes colour according to the angle, or it can appear just black if the light is unsympathetic. The female lacks the gorget, its place being taken by yellow feathering. Where we lived near Innisfail, a pair of sunbirds flew into our home on a daily basis, searching for spiders and other small creatures. We had a large mirror on the dressing table in the bedroom and each sex often attacked its reflection, perceiving itself as a rival. The boatbill is not so easy to see in the gloomy rainforests where it lives, being rather reclusive in habit. I found the best way to locate one was by listening for its melancholy five-note song, which is reminiscent of that of a Rose Robin. The robin often cocks its tail and so does the boatbill. The bill that gives the bird its name is flat, so I have painted the head tilted slightly to give an idea of the shape.

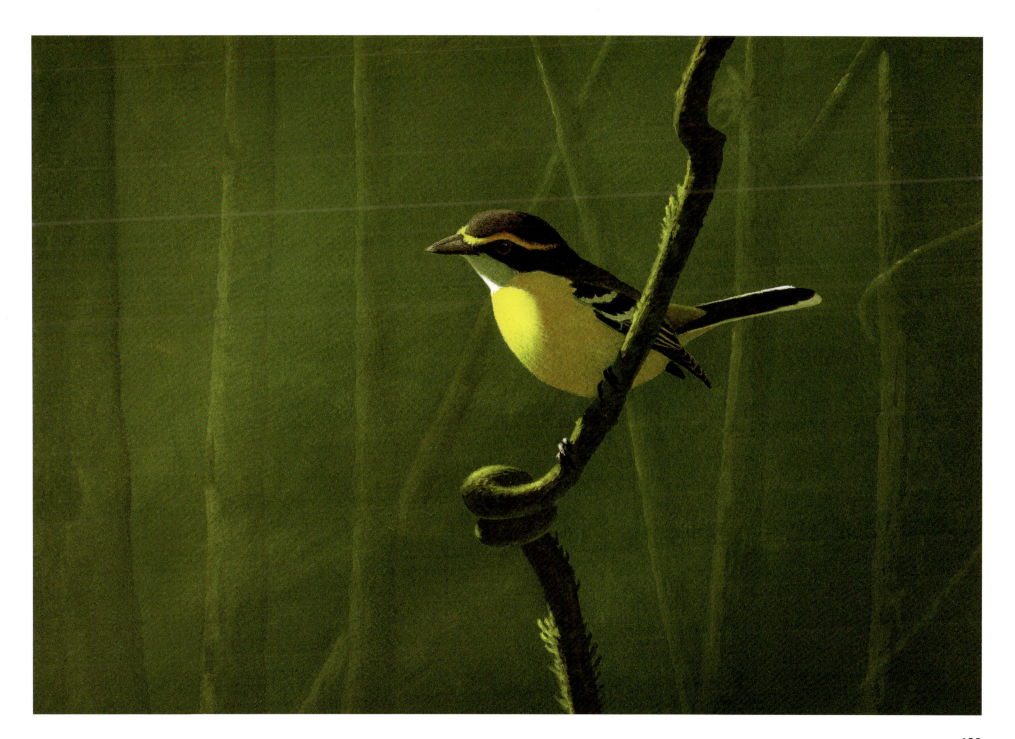

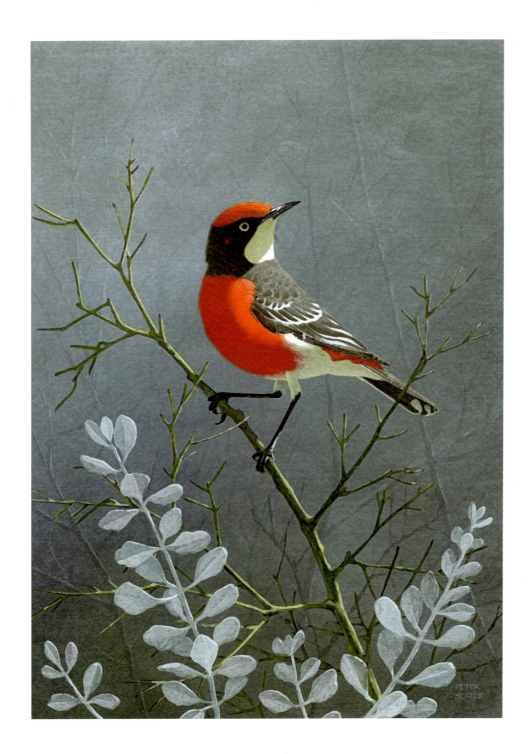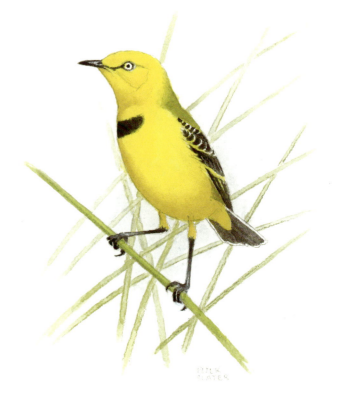

CRIMSON CHAT
YELLOW CHAT
ORANGE CHAT

Australian chats are not chats at all but basically terrestrial honeyeaters, feeding on arthropods fossicked from the ground as well as nectar in low shrubbery. The Crimson Chat (far left) often occurs in flocks in the inland, and occasionally nests in small colonies with much aggressive interaction between the brightly coloured males. Usually though nests are well apart and territories are larger. The Yellow Chat (near left) has a range unique among Australian birds, basically confined to rushes in widely isolated localities around the periphery of northern Australia from the Fitzroy River in Queensland to the Fitzroy River in Western Australia as well as along bore-drains in the interior. To me the intense yellow of a freshly moulted male is almost too painful to look at, and impossible to reproduce in a painting, but I find the juxtaposition of Orange Chats and salt-bush/blue-bush foliage the most harmonious sight in the Australian outback, worth travelling a thousand kilometres to see (right).

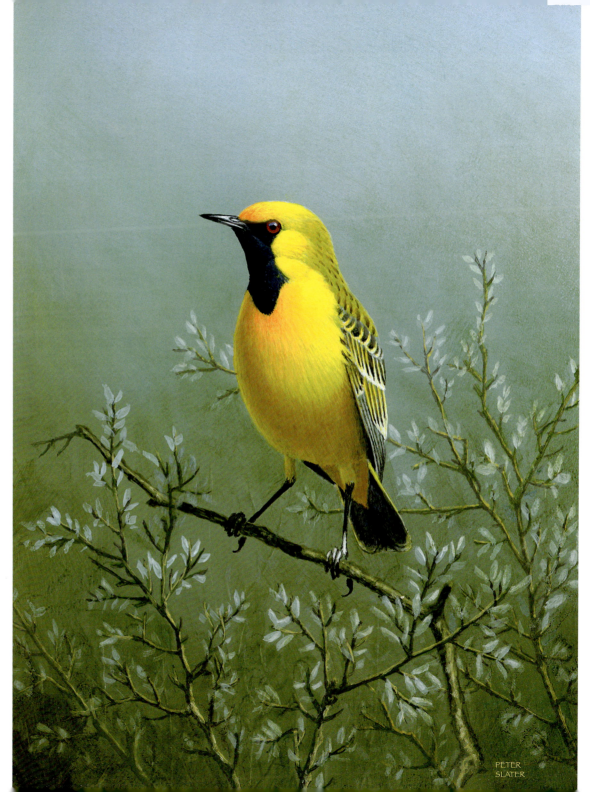

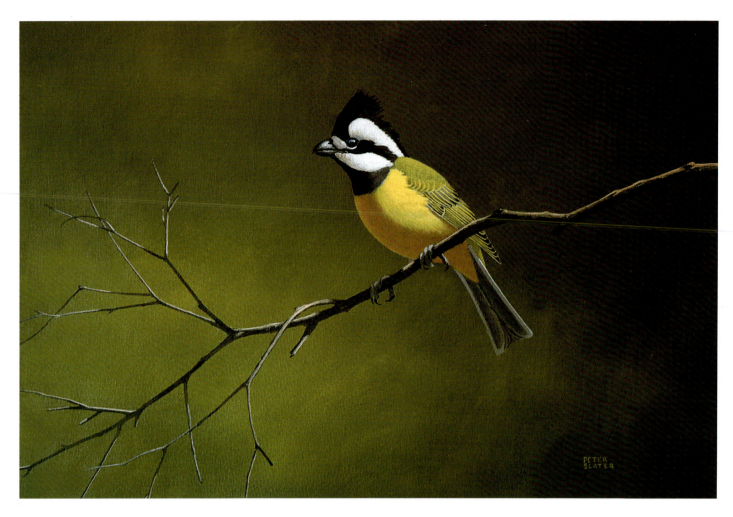

NORTHERN SHRIKE-TIT
WESTERN WHIPBIRD

There was a time when the Northern Shrike-tit was considered to be very rare, even endangered, but access to recordings of the calls gave observers a better idea of how to go about finding them in the woodlands of the Top End and Kimberley. Knowledge of calls is also essential for tracking down the critically endangered Western Whipbird in the dense heaths of the south-west. Perhaps it's not such a good idea to go chasing it anyway – what is more important: to tick it off or to leave such a vulnerable bird undisturbed?

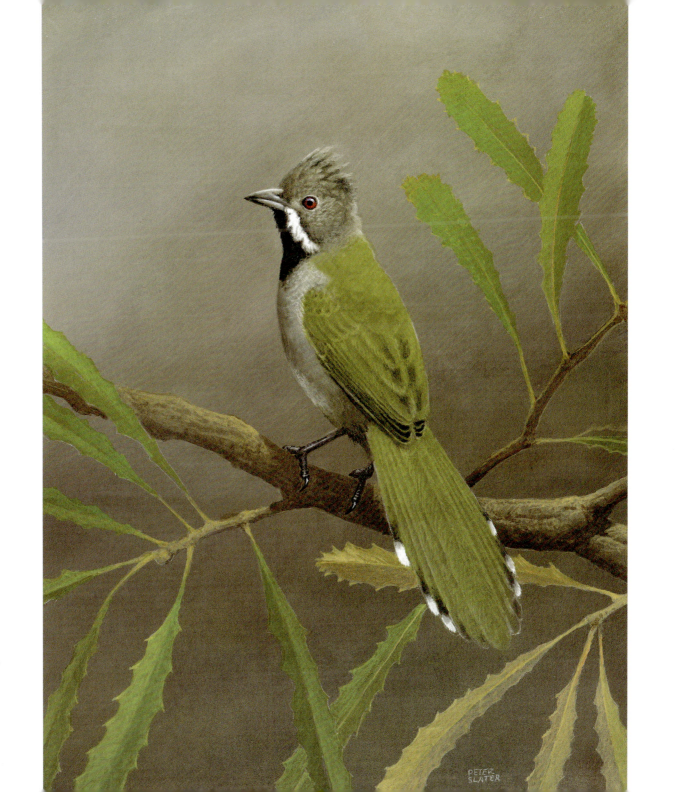

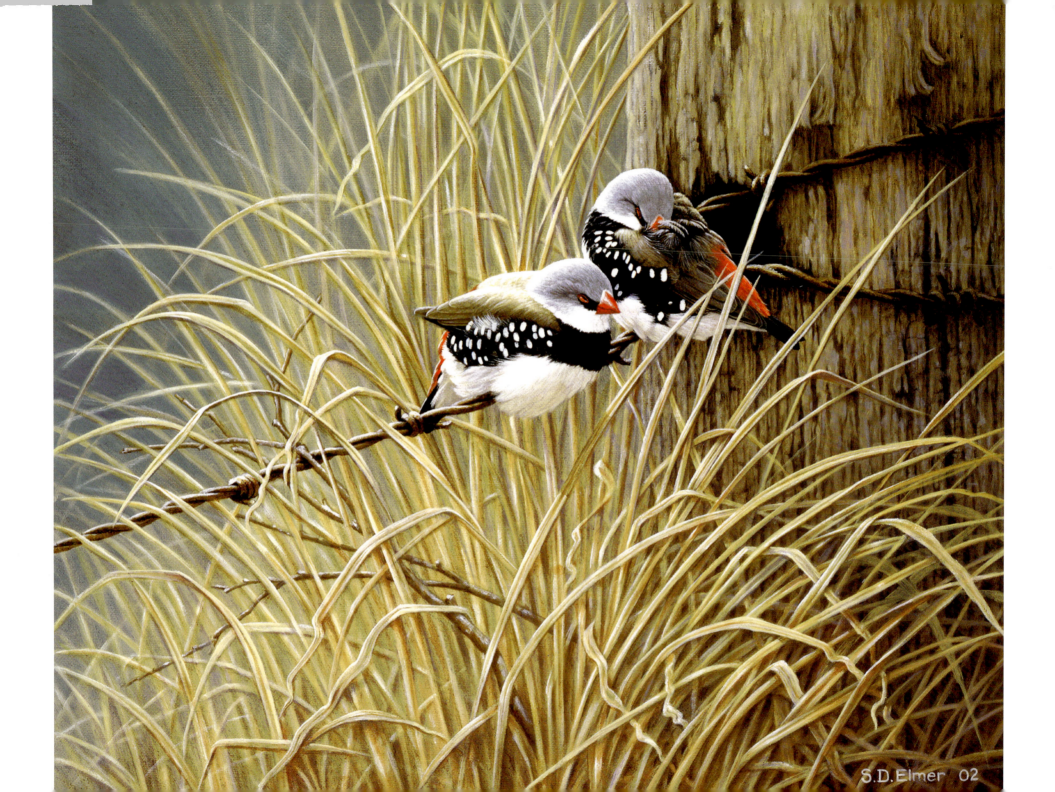

DIAMOND FIRETAIL

PAINTED FINCH

I heard about firetails at a very early age and the magical name evoked in my mind all sorts of phantasmagorical phoenix-like imaginings, yet I wasn't at all disappointed when, at the age of five or six, I actually saw one. Because it flew down and began fossicking within a metre of where I sat in my hideaway under an old drooping fig tree, I had an ideal opportunity to study its red markings and profusely spotted sides and decided the reality was better. It inspired one of my first attempts at drawing a bird, lost alas like so many drawings and paintings done in the following 80 years.

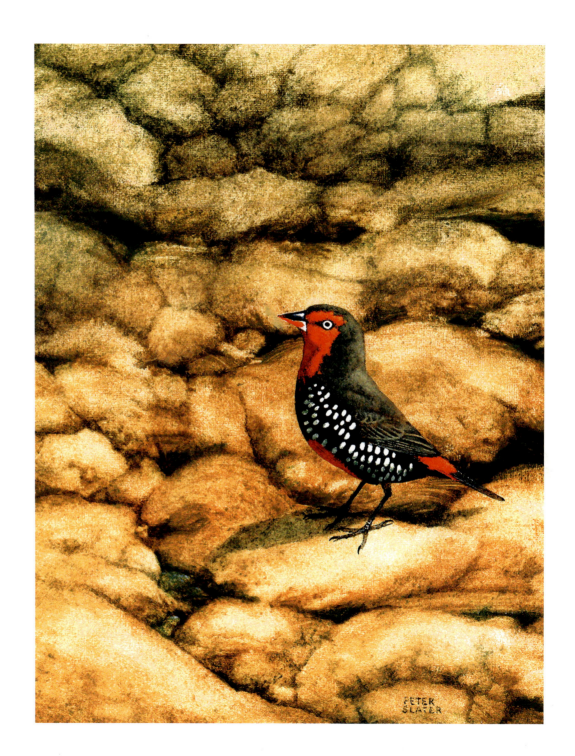

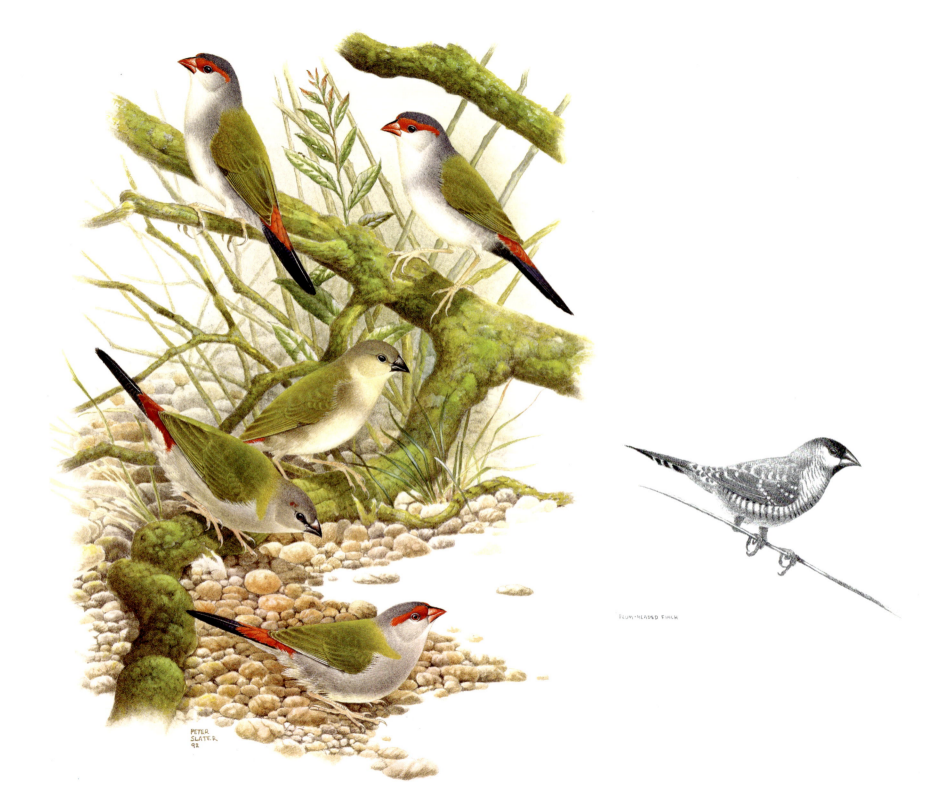

PLUM-HEADED FINCH

146

RED-BROWED FINCH
PLUM-HEADED FINCH
LONG-TAILED FINCH

Every once in a while I have been asked to supply sample paintings for proposed books. Some projects have proceeded but others have been abandoned. Joseph Forshaw sought my participation in a book about Australian finches. These are two of the paintings I prepared. For one reason or another I was unable to proceed, so Joe eventually asked Tony Pridham to provide the artwork, resulting in a beautiful book. My painting of the Red-browed Finch shows the two subspecies; the three lower birds are adult, immature and juvenile birds of the southern race *temporalis*, while the upper two are from the Cape York Peninsula race *minor*. The Long-tailed Finch is a northern species; birds in the Kimberley have yellow bills (race *acuticauda*) while those in Northern Territory and north-western Queensland have red bills (race *hecki*). The Plum-headed Finch of mid-eastern Australia is one of my favourite small birds. John Gould named it the Plain-coloured Finch, *Aidemosyne modesta*, which is an absolute insult to a very beautiful bird. Unfortunately I can't locate any of the paintings I have made of it, showing the beautiful plum-colouring of the crown, so must be content with a small sketch from Bladensburg National Park, Queensland.

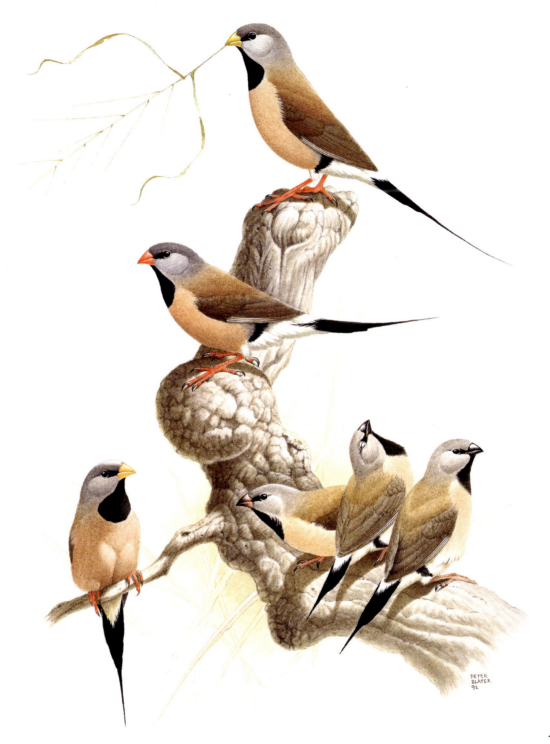

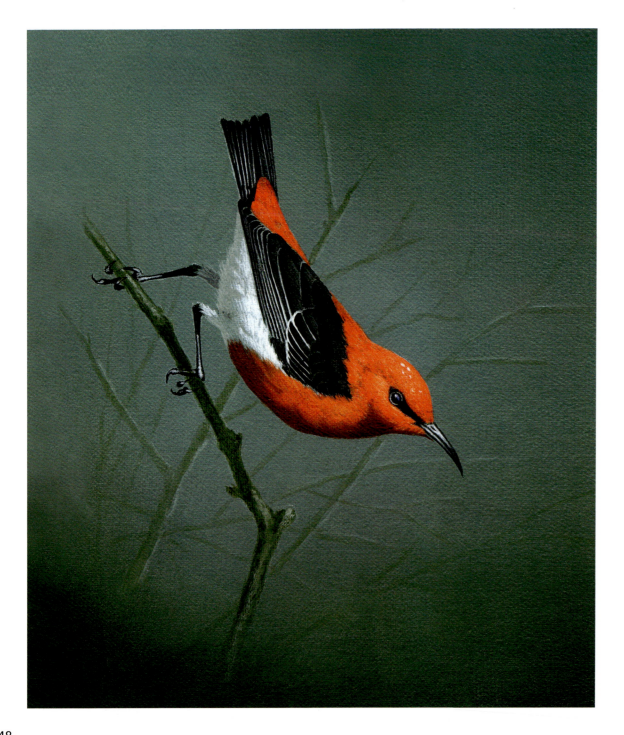

SCARLET HONEYEATER

Among the things I have planted around my home are callistemons, evodias, banksias and kangaroo paws. In some years dozens of Scarlet Honeyeaters arrive to feed on the nectar from the flowers. Other years there are few, or even none at all. In the years of plenty, Peter and I stand on a scaffolding near the evodias and happily photograph the birds as they busily forage for their food. There is a lot of chasing to and fro as choice blossoms are competed for. At Peter's place he used to see the Scarlets, even finding them nesting in his garden, but he hasn't seen one for about ten years. Possibly the arrival of Noisy Miners is responsible, because the vegetation hasn't changed much.

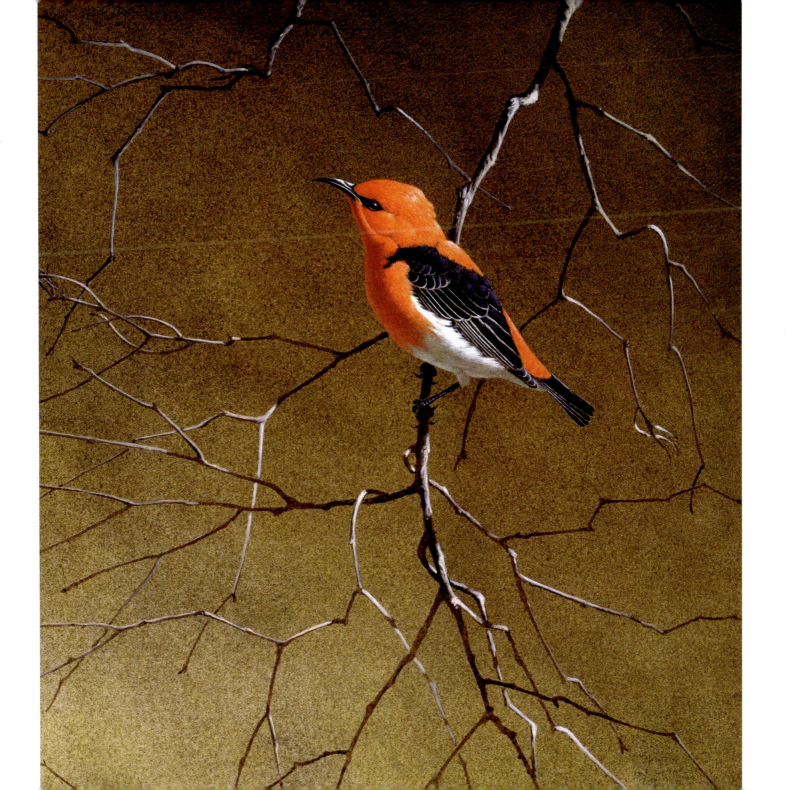

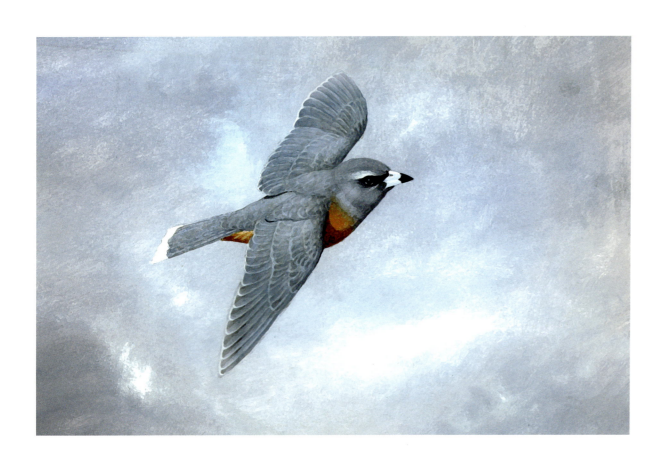

WHITE-BROWED WOODSWALLOW

Whenever we travel in the inland we watch for White-browed Woodswallows, because they are a good indicator of productive birding. Being highly nomadic, they move in sometimes large flocks until they detect a good patch, green from recent rain, then settle for a while, the length of their stay determined by the availability of food, either insects or nectar-rich plants like the desert bloodwoods and eremophilas. Usually we also find other nomads such as Crimson Chat, Pied Honeyeater, songlarks and White-winged Trillers in the same area. Twice I have been camped at particularly good spots when a flock suddenly appeared. Within a day on each occasion, pairs began selecting nest sites, usually behind detached bark, in a knot-hole or on a horizontal branch, often within a metre of the ground. A week later nests were completed and the breeding cycle begun.

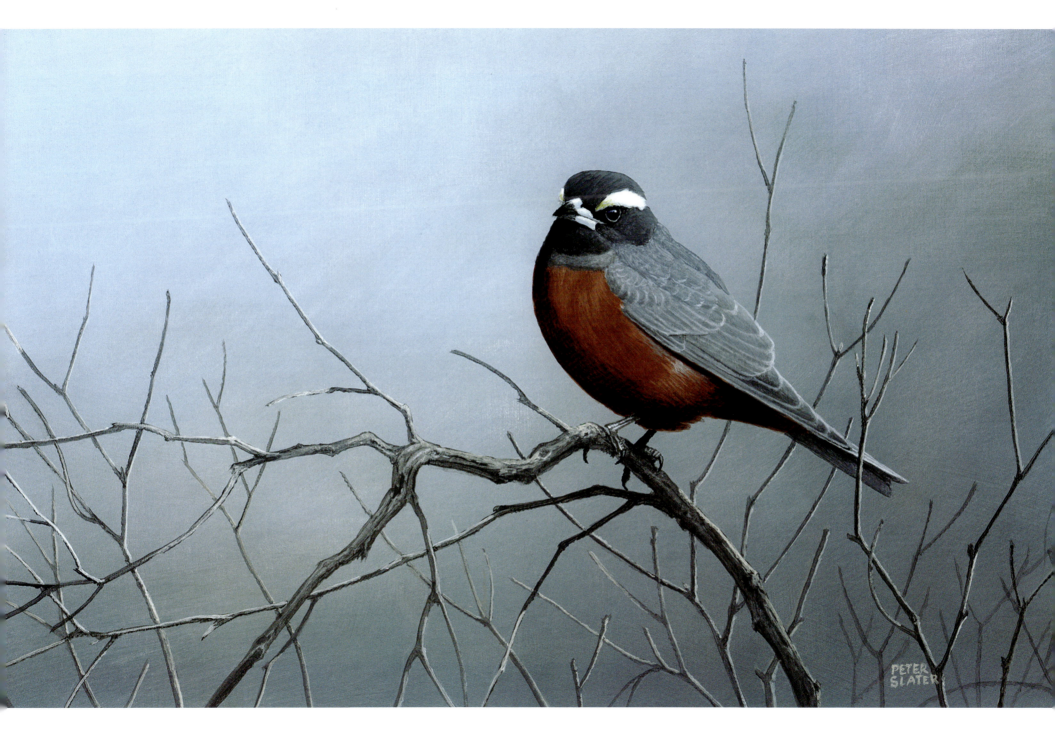

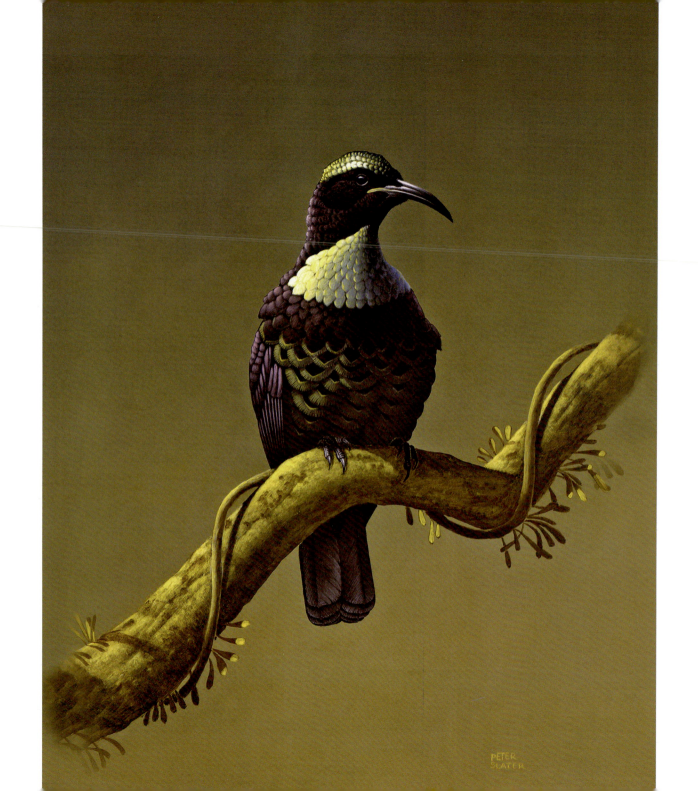

PARADISE RIFLEBIRD
VICTORIA'S RIFLEBIRD

Usually the metallic breast-plate and crown of riflebirds is seen as iridescent blue or violet, but on one occasion in the McPherson Range some benign ray of light lit up the feathers of a male Paradise Riflebird I was watching with a golden glow which I tried to recreate in this painting (left). When Swainson described the bird in 1825 he was unsure whether it was allied to honeyeaters or sickle-billed birds-of-paradise, although he suspected probably the latter, suggesting it might represent a bridge between the two. Nowadays it is confirmed as being allied to the birds-of-paradise. Like Victoria's Riflebird (right) it is generally confined to rainforest, but I was surprised to find one in the open woodland near my home near Brisbane. I was walking through the bush when I was struck by a rain of bark debris. On looking up I detected a female busily chipping away into the bark like a woodpecker. It's the only one I've seen outside rainforest.

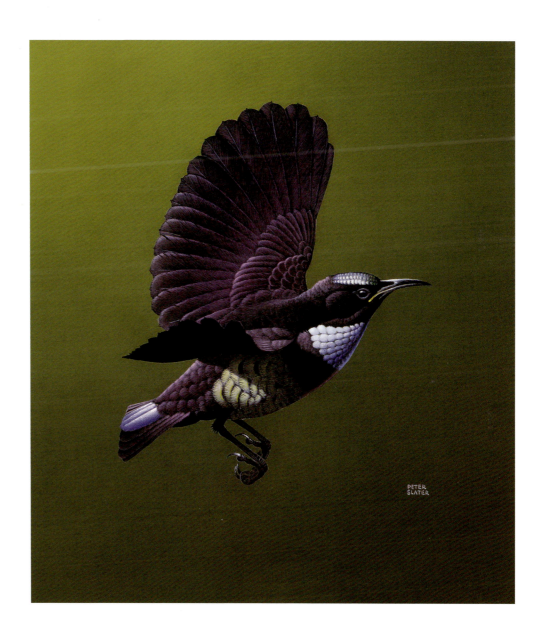

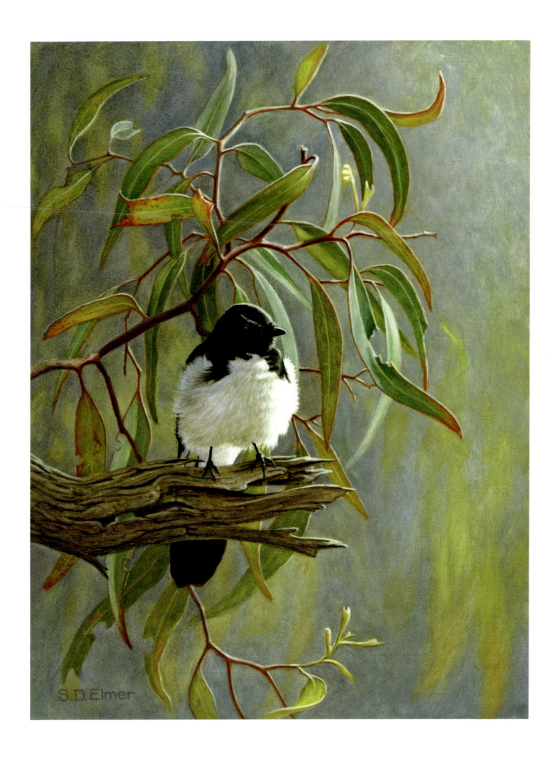

WILLY WAGTAIL

PIED BUTCHERBIRD

Where I reside, on a hectare of land, Pied Butcherbirds live on one side of my home and Grey Butcherbirds on the other, almost never venturing over the clearly defined line that in their eyes bisects the house. In 40 years I have only seen one interaction between these two normally aggressive species, when a Grey ventured into the Pieds' territory and absolutely routed the larger birds. Both have nested in the yard on occasions, usually well apart, but once within 30m. It is interesting that Willy Wagtails often build close to one or the other. Often pairs of wagtails nest in my yard; one year most of the nests were failing due to pierced eggs and I suspected Noisy Miners, but I eventually saw a Blue-faced Honeyeater at a nest feeding on egg-yolk.

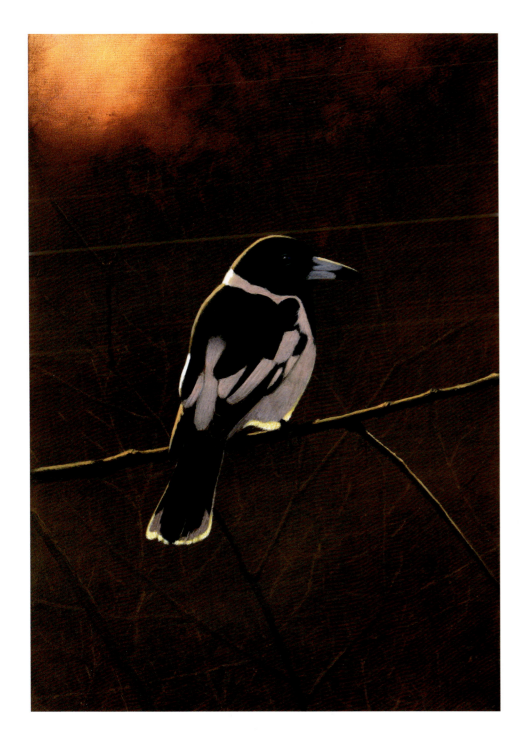
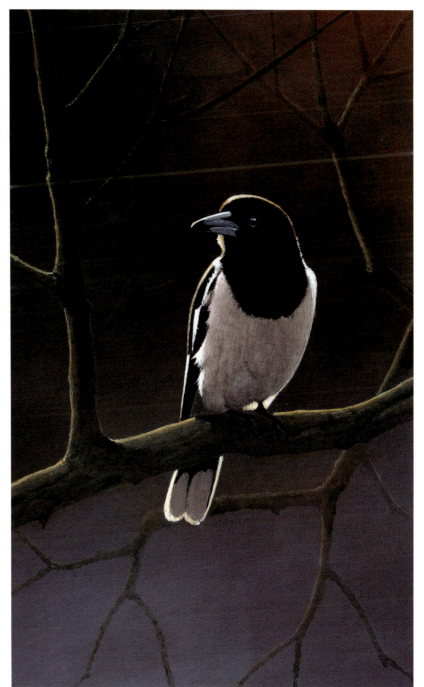

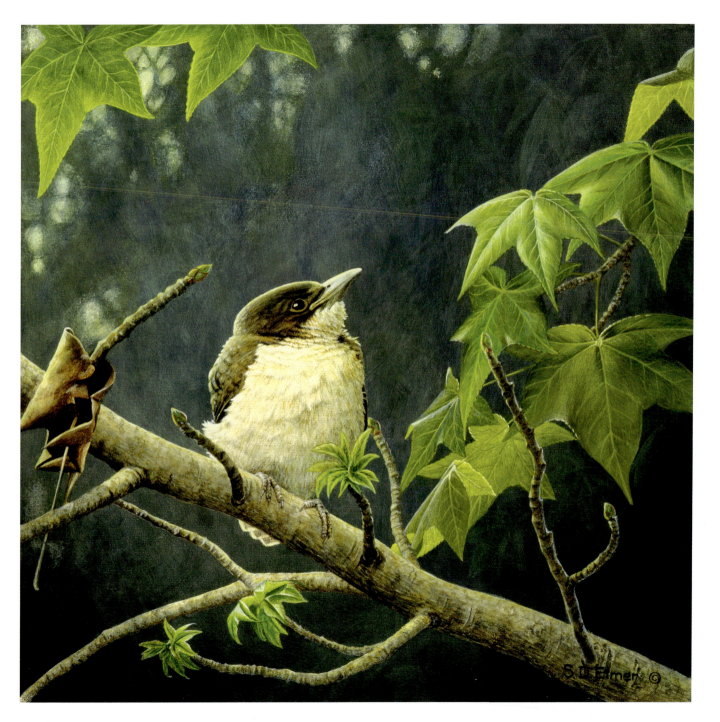

GREY BUTCHERBIRD

SILVER-BACKED BUTCHERBIRD

Sally's painting (left) shows a young butcherbird waiting to be fed by its parents. Even at this age it will often sing away to itself, a quiet 'whisper song' that may include mimicry of other bird calls. If it survives it will retain its brown plumage until about a year old, when it will moult into the grey, black and white adult plumage (far right). It may stay to help its parents raise the next brood, or move away to find a vacant territory and a mate to rear its own chicks. Near right is a Silver-backed Butcherbird I saw in the East Kimberley. The little black patch under its chin is also found in the Black-backed Butcherbird of Cape York Peninsula and New Guinea, which is very similar but its mantle is black, not grey.

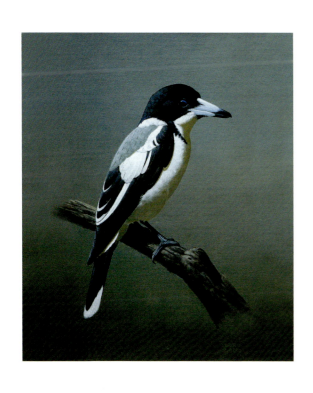
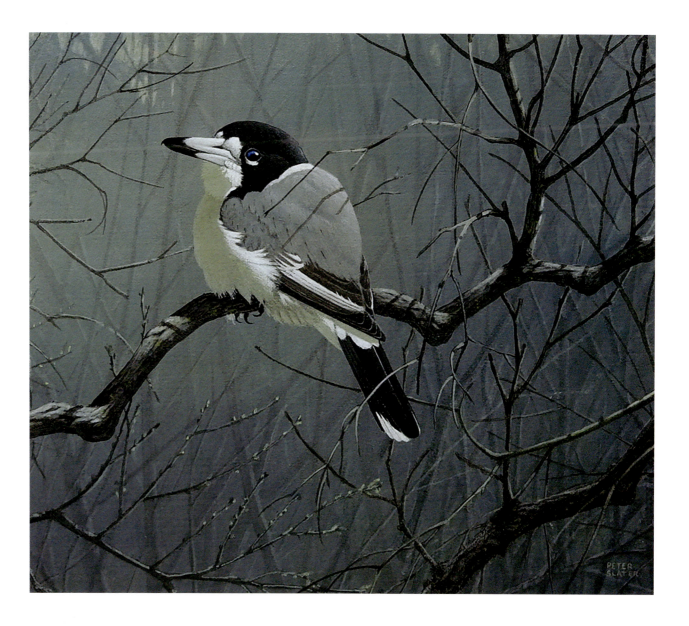

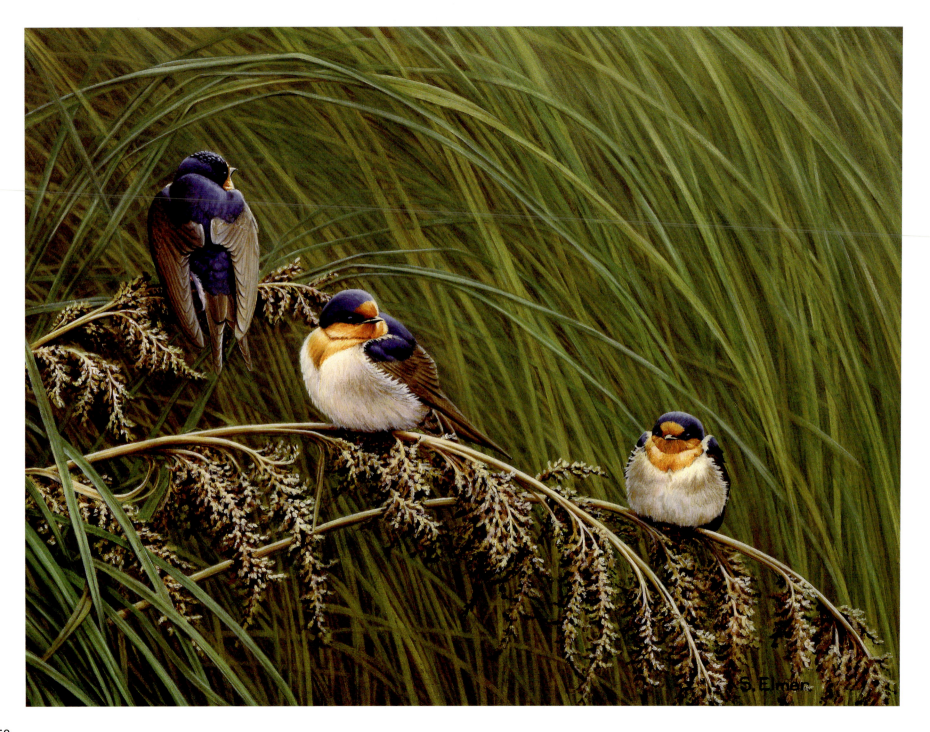

WELCOME SWALLOW

I don't usually read reviews of my books, but one rather malevolent example was brought to my attention by a well-meaning friend. Among other nasty things, the reviewer suggested that my backgrounds were mud, the birds were blobs of colour and were occasionally anatomically impossible. Anyway I got a bit cross (which is why I don't read reviews) so when we were in Melbourne I fronted the reviewer. Pat held me back so physical altercation was avoided; the culprit claimed he had been having a bad time when he wrote it and promised to publish a retraction. I'm still waiting. When I arrived back home I sat down and worked on a swallow flying to its nest in our garage (right). I painted a poster on the wall behind the bird, like one of those seen in cowboy films, with a caption: 'Wanted Dead or Alive, For Malicious Misrepresentation', featuring a portrait of the miscreant and a huge reward. Pat persuaded me that it wasn't a good idea and suggested he would probably be offended that I only offered $250,000 as a reward, so I decided to scrape it back to bare canvas and repaint the background. Sally doesn't get too upset by reviews of her books, so there is nothing hidden in the grasses behind her swallows (left).

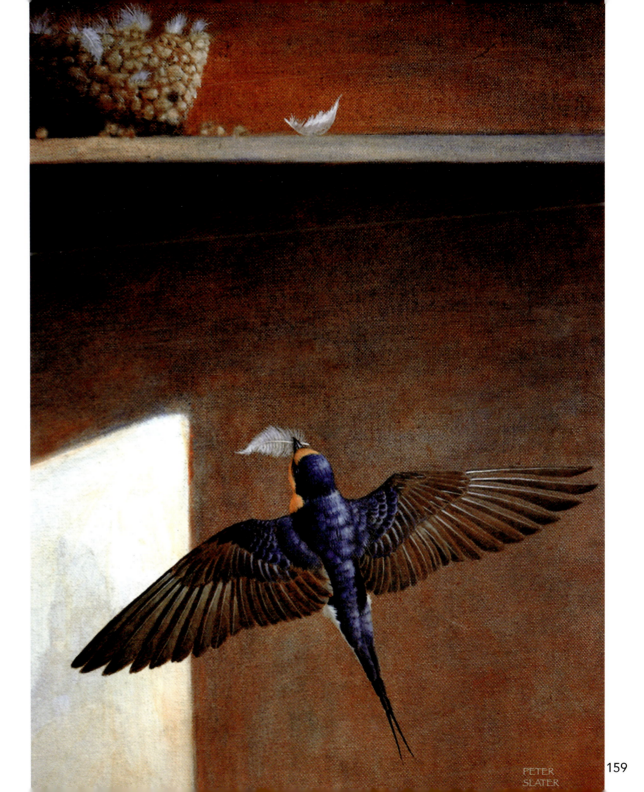

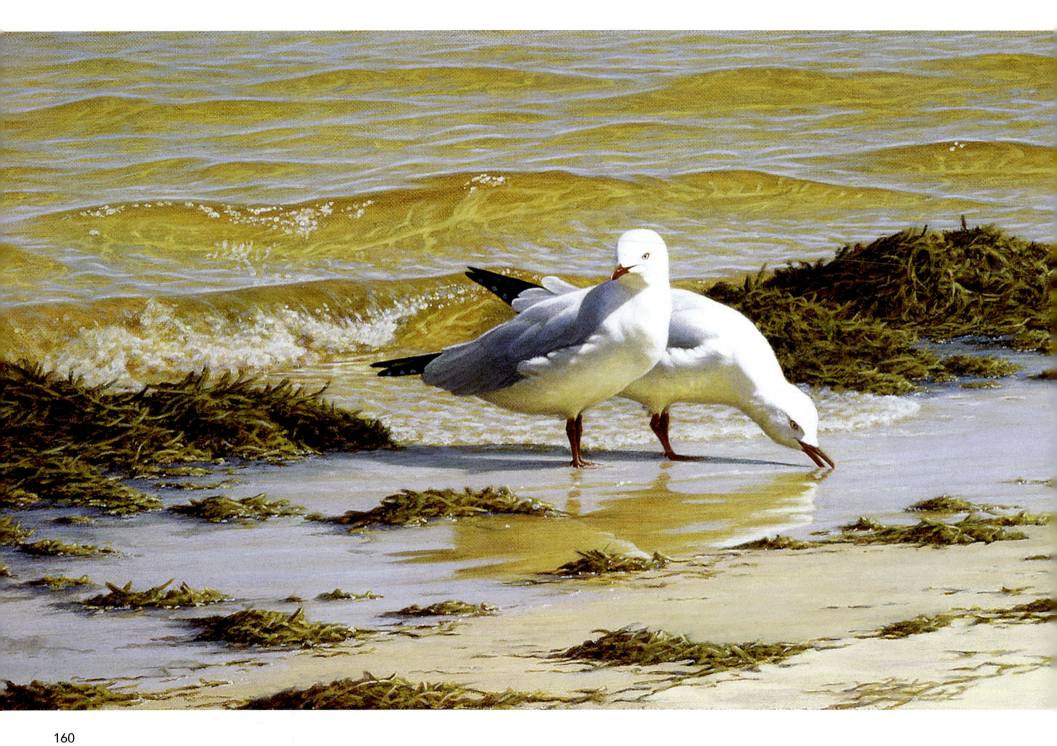

SILVER GULL

Gulls have proliferated in Australia and Tasmania since the by-products of the Caucasian invasion have provided convenient hampers. I'm not sure if anyone knows how many there are on the mainland but there is an annual tally in Tasmania, the longest running bird-count in Australia, currently standing at about 16,000 in the area covered. A familiar sight around picnic tables is a ring of gulls waiting and squabbling over scraps. My dear son Raoul invented a game called Chip Snooker, where each participant in turn designates a particular gull in a flock, throws a chip and scores if it catches the offering. If successful, the player proceeds until some other gull intervenes, then the other competitors take their turns. Raoul always wins because he goes first, when there are only a few gulls; numbers quickly build up and by the time he has dipped out there are hundreds. So subsequent players have no chance. Raoul wrote a story about Chip Snooker for an international literary competition and won it of course; the prize was a fortnight for two in Zambia, where we didn't see any gulls so unfortunately had to make do with Red Bishops, Southern Carmine Bee-eaters, Bateleurs, Malachite Kingfishers and other avian wonders. By the way, I hope the game doesn't catch on. So if you read this, stick to beach cricket, and the gulls can watch; they love cricket.

AUSTRALIAN PELICAN

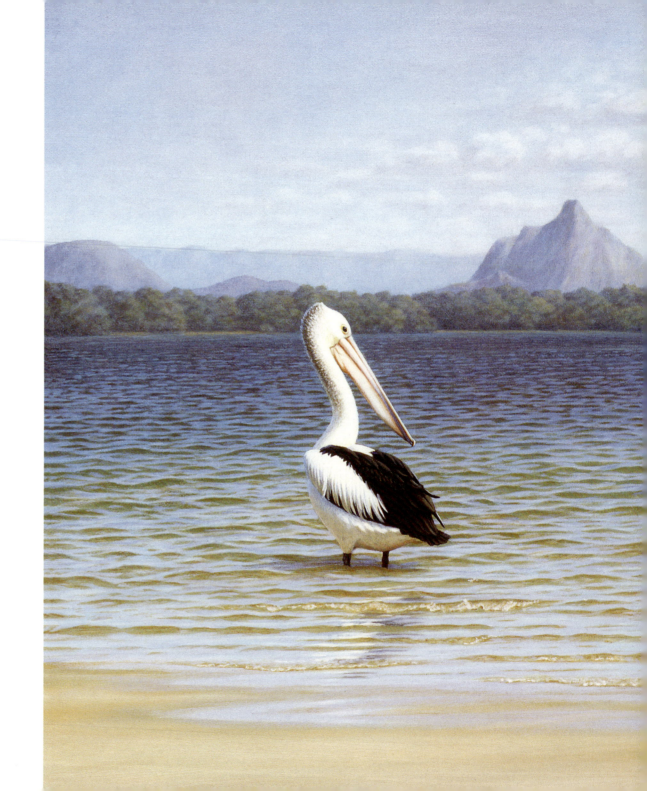

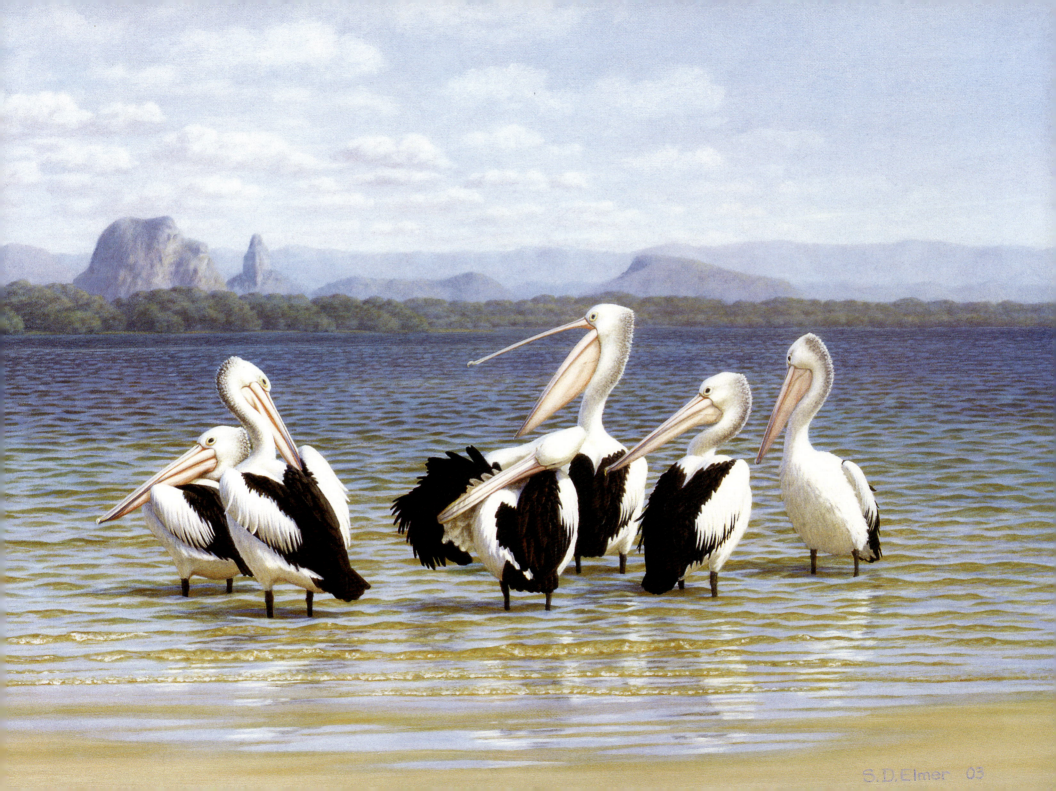

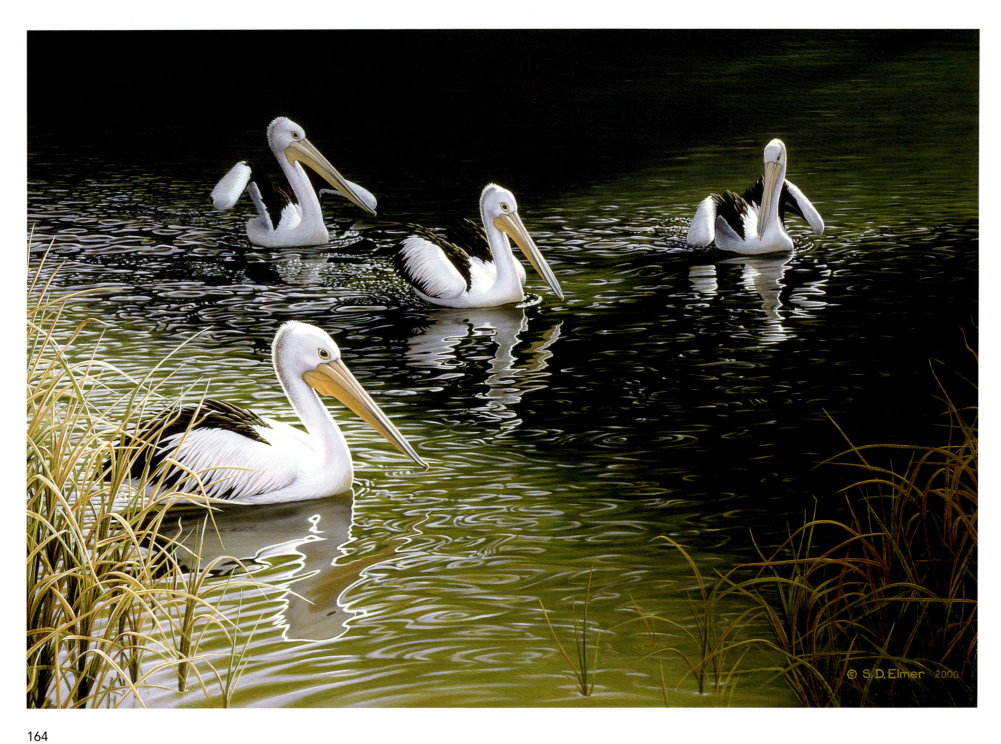

AUSTRALIAN PELICAN

We spent a week or so one September at Cookawinchica Creek, just south of Bedourie in far-western Queensland. The creek was barely flowing and was backed up against the road causeway. Multitudes of fish trying to swim upstream to spawn could not proceed any further and provided a feast for egrets, herons, cormorants, terns and a raft of a hundred or more pelicans. Each time a road-train crossed the causeway the pelicans laboriously took off to circle a while and then return, touching down with a huge 'whoosh' on outstretched feet. They must have taken off dozens of times each day, at a huge cost of energy, but the easily caught fish probably made it worthwhile. Most likely they came from the breeding colony on Lake Machattie, 30km to the south-east, where diminishing numbers of fish in the lake were forcing them further afield.

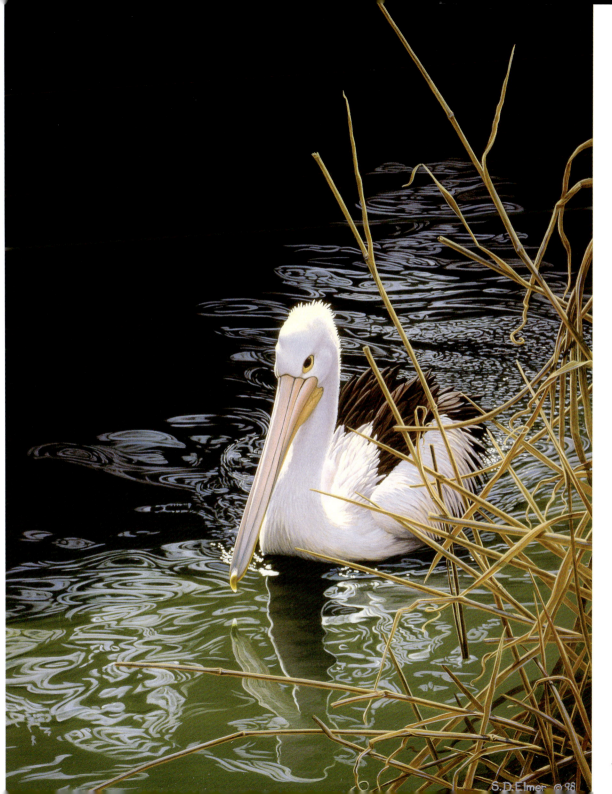

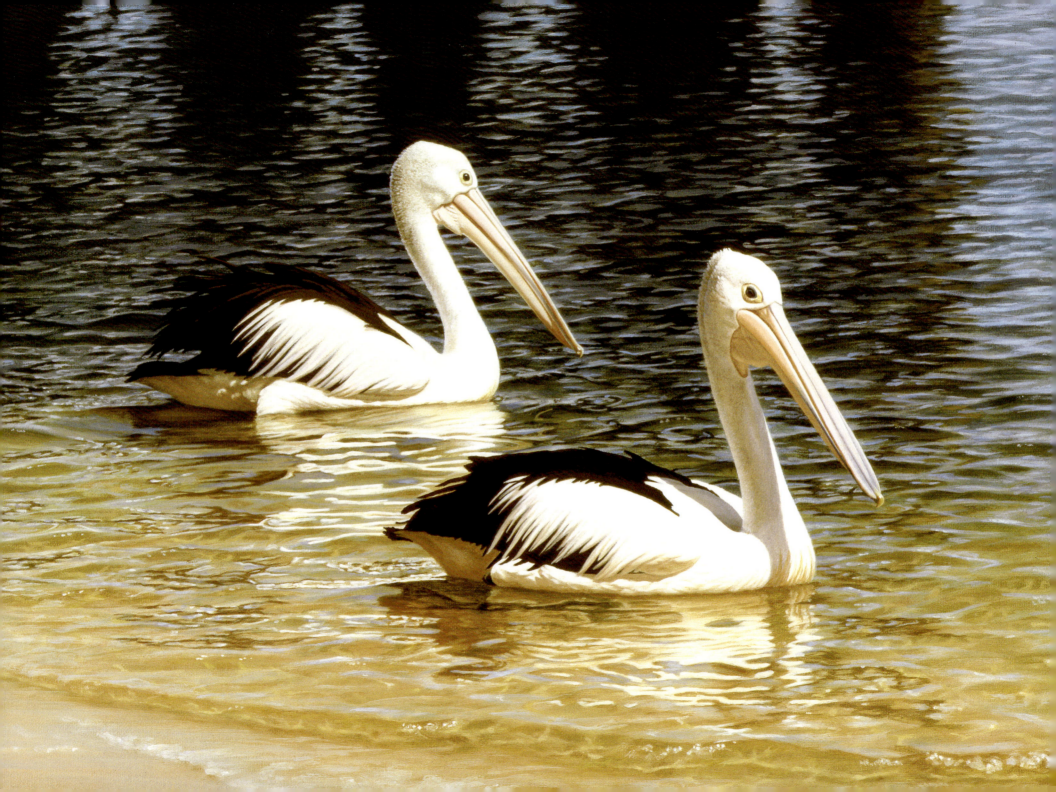

AUSTRALIAN PELICAN

Sally can't resist pelicans and has probably painted more of them than any other bird. Even as I write she is drawing up yet another – it will be too late to include in these pages, but we have selected a fair sample anyway. I've only painted the odd pelican, none of them good enough, but when I was nine or ten years old, before I'd even seen one, I was inspired to go searching for their nesting places. It happened this way: my teacher read us a poem, *Where the Pelican Builds its Nest*, by Mary Hannay Foott. It was about two bushmen who never returned from a trip into the interior, and our teacher explained that the poet used the analogy of the pelicans because no one knows where they nest. My passion for birds was already all-consuming so I determined that I would be the one to find the nesting place. Actually I did find some breeding ten years later, not in the far-distant inland but on an island in the Peel-Harvey Estuary, not too far from home. I remember picking up a chick that had wandered away from the colony, planning to return it; the youngster was squishy like an eider-down pillow filled with olive-oil. By that time I realised I'd been misled by the teacher, but I still believed that no-one knew where Banded Stilts nested, so determined I would find them. But that's another story.

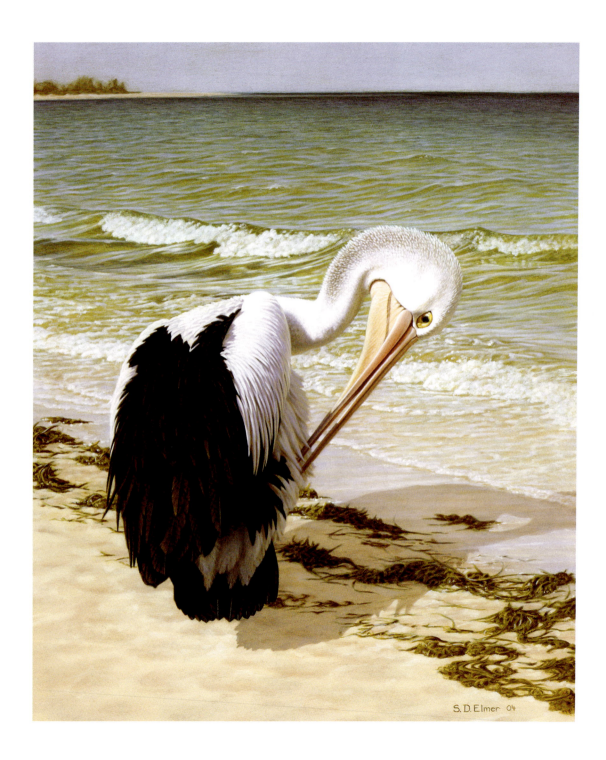

AUSTRALIAN PELICAN

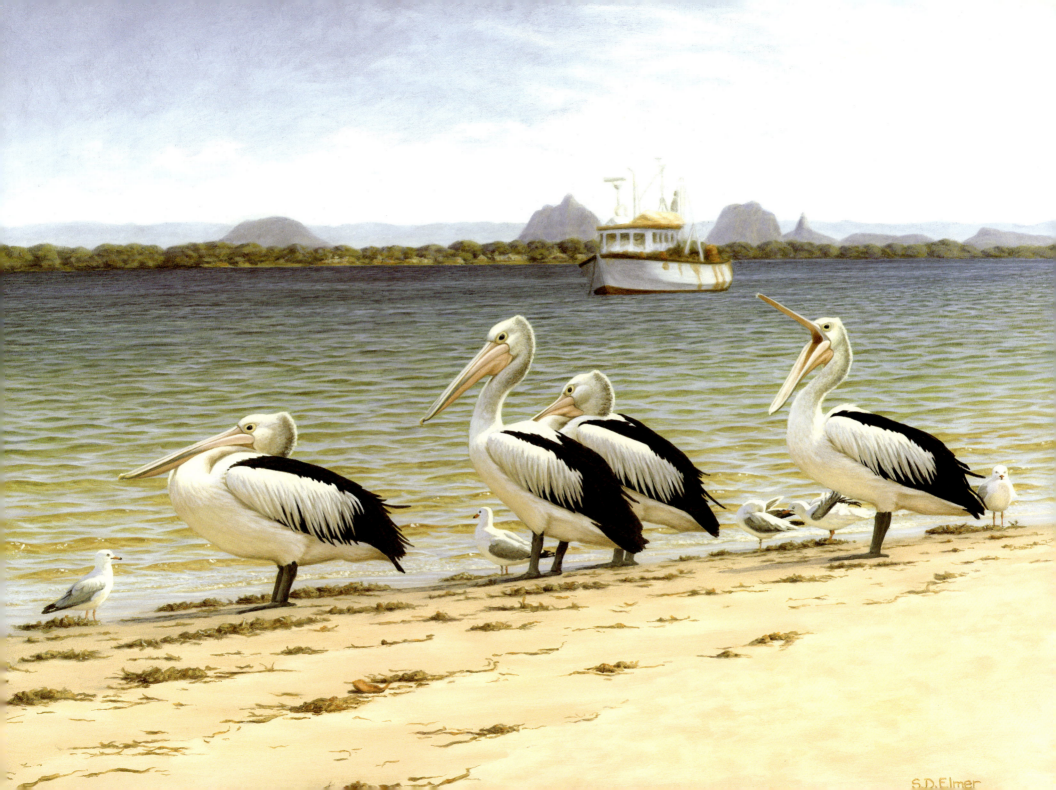

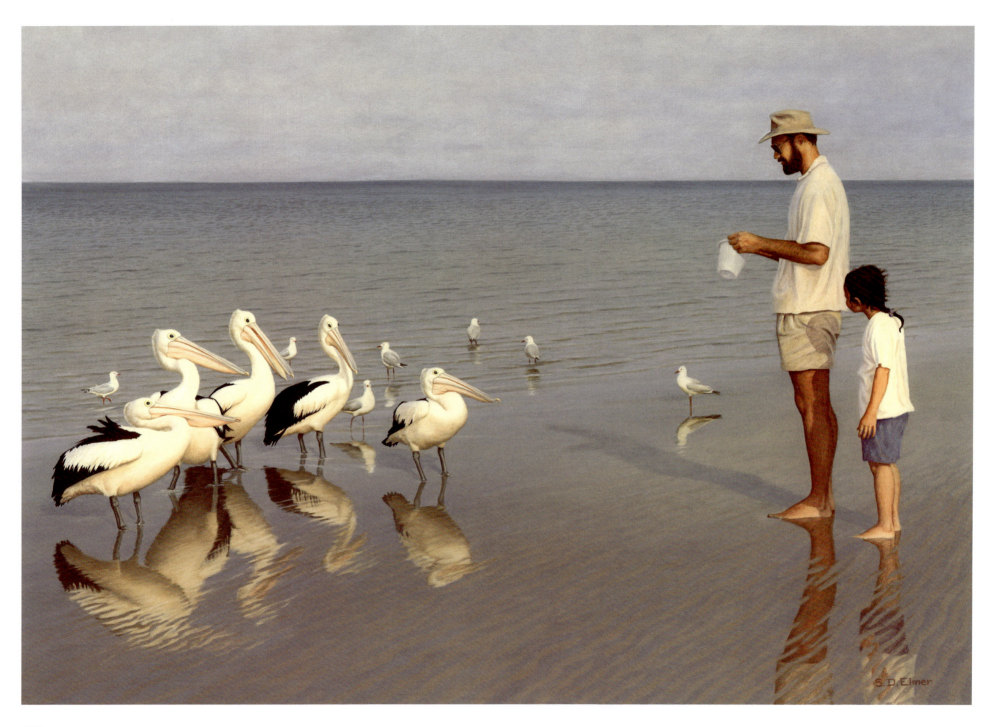

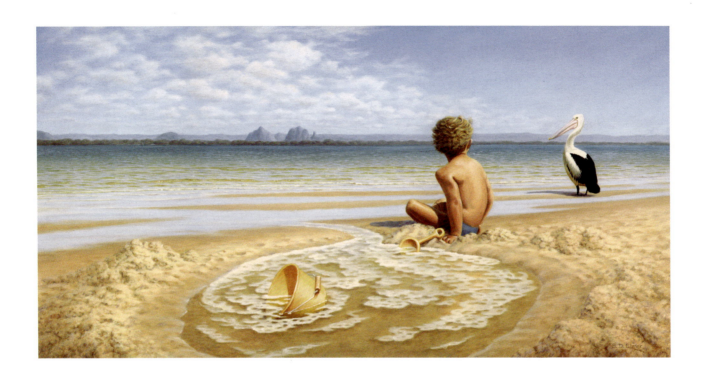

AUSTRALIAN PELICAN

Unlike most birds, pelicans don't mind people and often line up to be fed with fish scraps. One of the mysteries surrounding these large birds is how they know when the lakes in the desert, so far away, fill up, enabling huge numbers of fish to build up. Then the pelicans take off, head into the interior and congregate in large densely packed nesting colonies on islands in the lakes. They don't always need to head off inland; as mentioned on a previous page we found a colony in Peel Inlet on the coast in Western Australia, another on an island in Wivenhoe Dam, not far from Brisbane, and a small colony on one of the Lacepede Islands north-west of Broome.

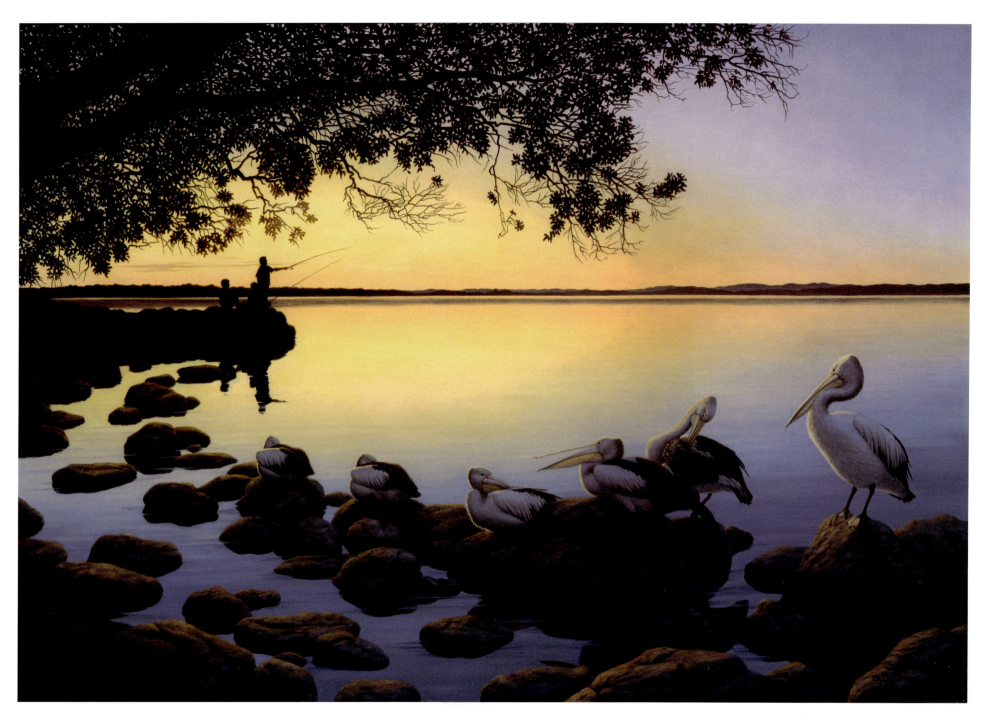

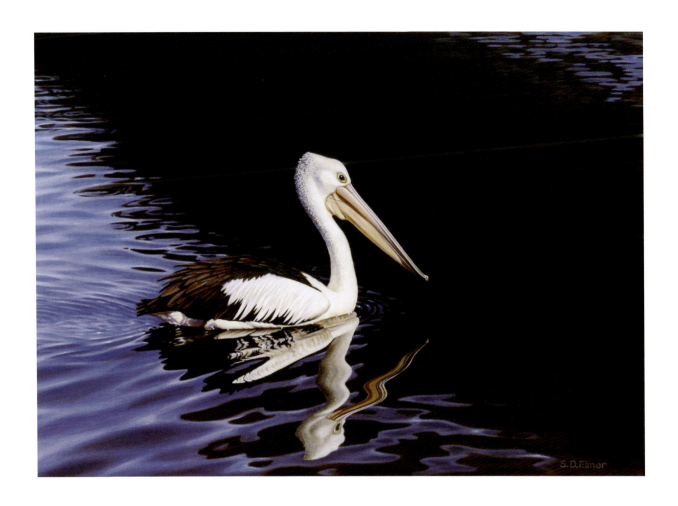

AUSTRALIAN PELICAN

laughing fishermen
on sun-kissed rocks do not hear
screams of dying fish

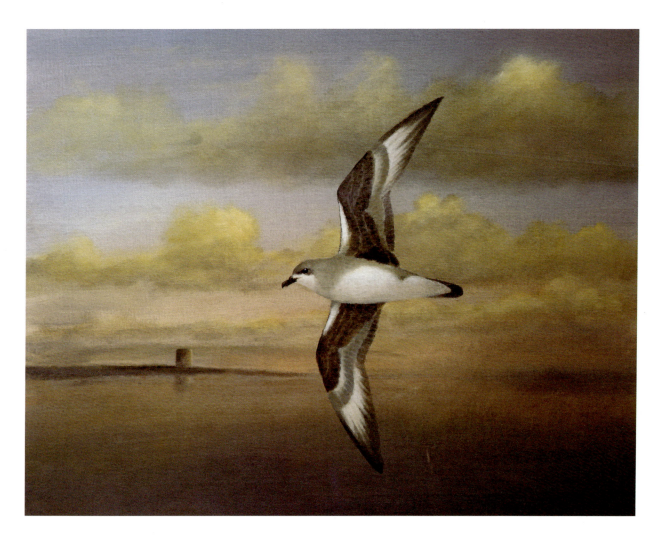

HERALD PETREL
SOFT-PLUMAGED PETREL

In 1845 HMS *Rattlesnake* landed a workforce of convicts on Raine Island at the northern end of the Great Barrier Reef to build a tower; it still stands but has been repaired over the years. More than a century later my mentor John Warham visited the island and discovered Herald Petrels breeding (left), so far the only known locality in Australian waters. My painting shows a petrel returning to the island at sunset; most other petrel species don't return to their nests until after dark. A bird banded on Raine was observed on Round Island near Mauritius in the Indian Ocean. The Soft-plumaged Petrel (right) breeds in very small numbers on Maatsuyker Island, Tasmania, so as an Australian breeding bird it is regarded as endangered. However, elsewhere it is not uncommon, and I picked up beach-washed examples after storms on the west coast. I can remember thinking that the plumage didn't seem to be unusually soft.

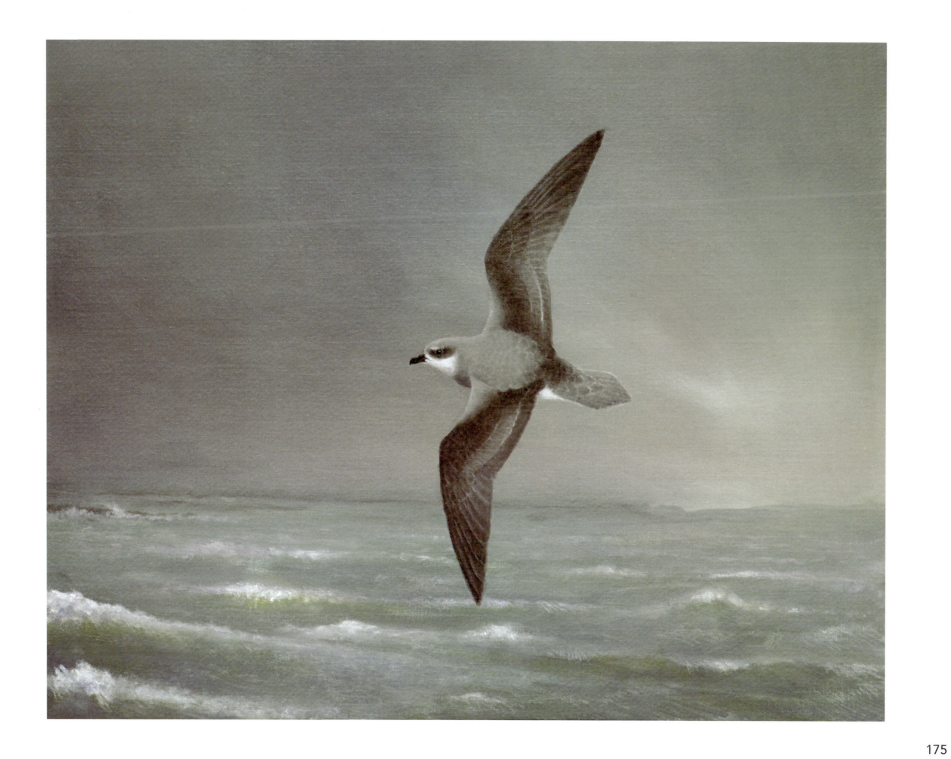

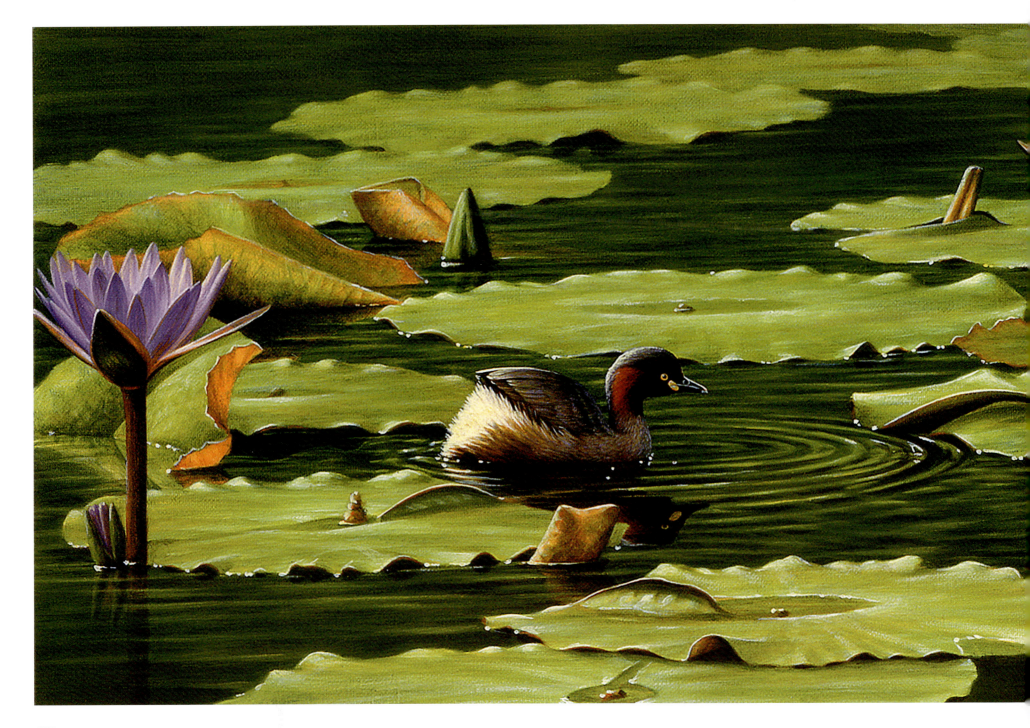

AUSTRALASIAN
GREBE

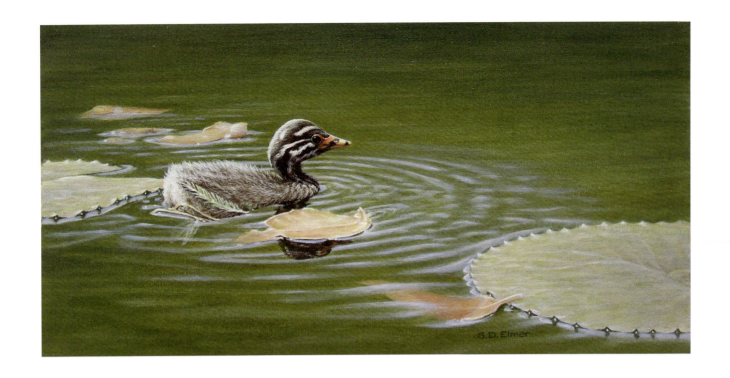

AUSTRALASIAN GREBE

As children, we used to call these birds 'dabchicks', an old English name meaning 'diving chick'. We fervently believed that, if fired on, they could dive before the bullet reached them, so quick were their reflexes. The name grebe is said to derive from an old French word 'krib' which refers to the crests of some species. Chicks of all of the world's 20 or so grebe species have striped patterns on their heads, and many have coloured patches on the beak like the bird above. They are able to swim and dive soon after hatching, but tire quickly and clamber onto a parent's back for a free ride. Sally's painting of an adult (opposite) is housed in the permanent bird art collection of the Leigh Yawkey Woodson Art Museum in Wausau, Wisconsin, USA.

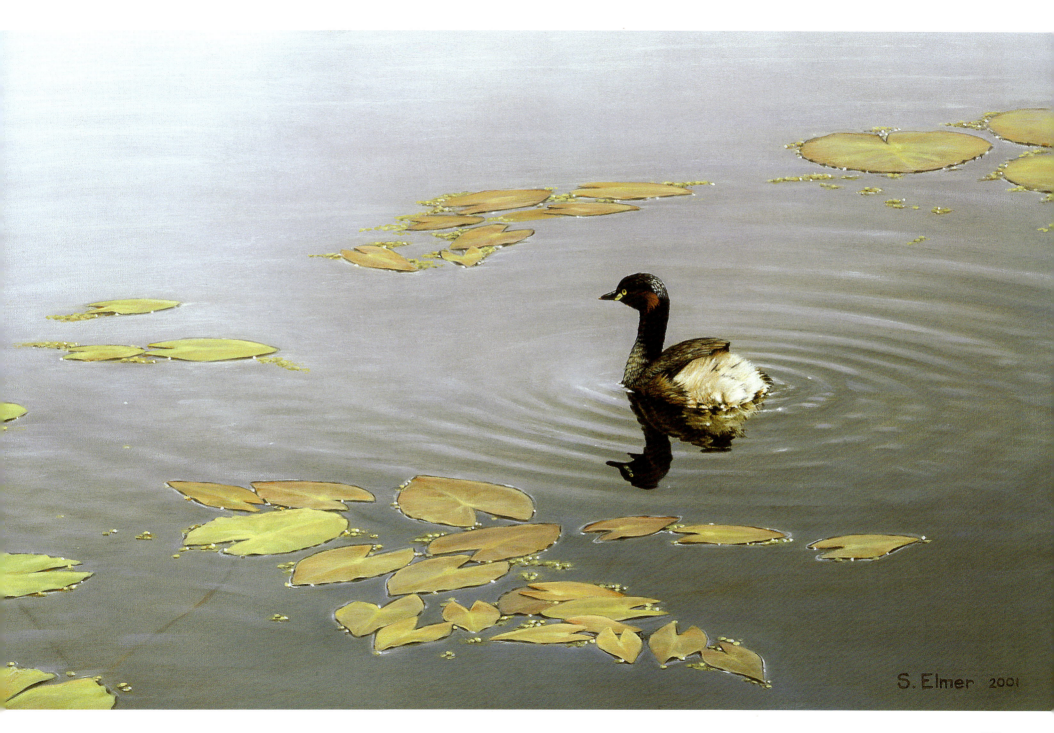

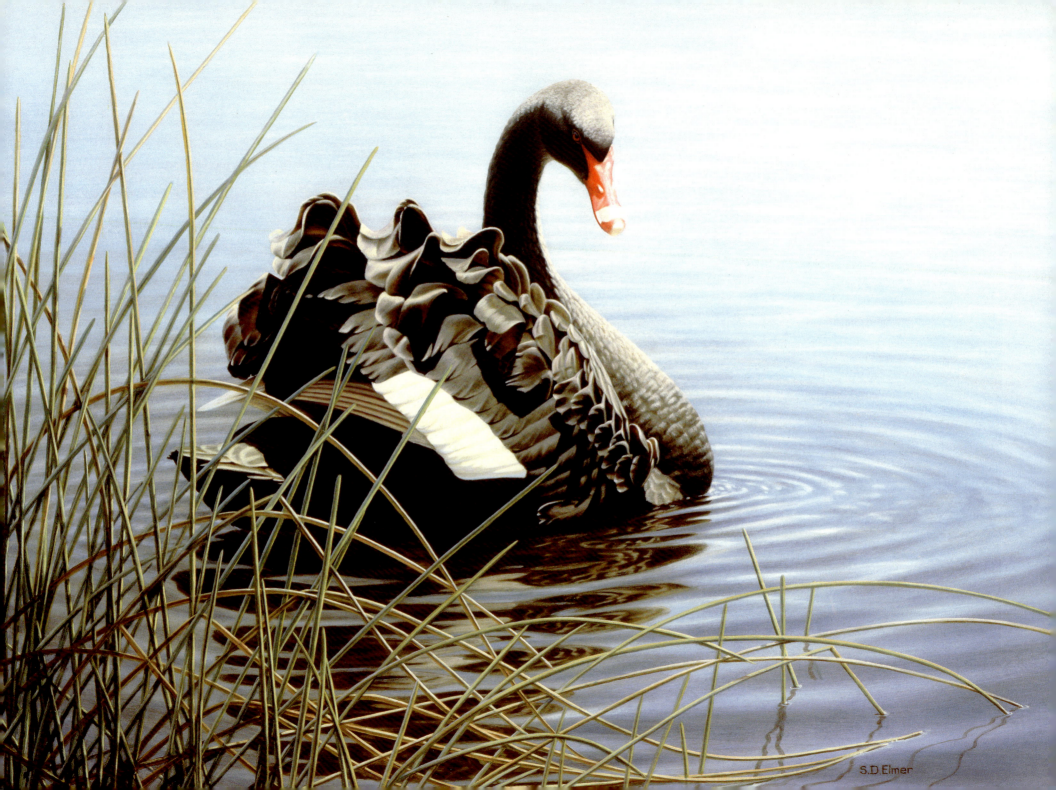

BLACK SWAN

I came across a vast colony of nesting swans on an island in Lake Bindegolly. This island must have been used for aeons because half-buried in the dunes near the island I found hundreds of aboriginal artefacts, stone cutting implements as well as bird bones. I sat on the dune watching the incubating swans and the extended flotilla of their waiting mates, listening to the incessant fluting and bugling, and imagined a time before we came: the wanderers gathering for the feast, the laughter, the fires, the children racing and screaming, the heaps of swans to be roasted and eaten; later, decorating bodies with down from the nests, then the dancing, here, *here* on *this* dune, with never a thought that it could ever end.

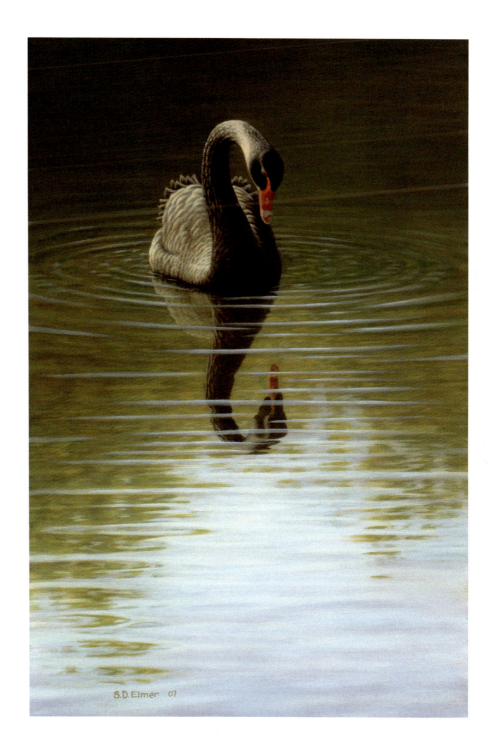

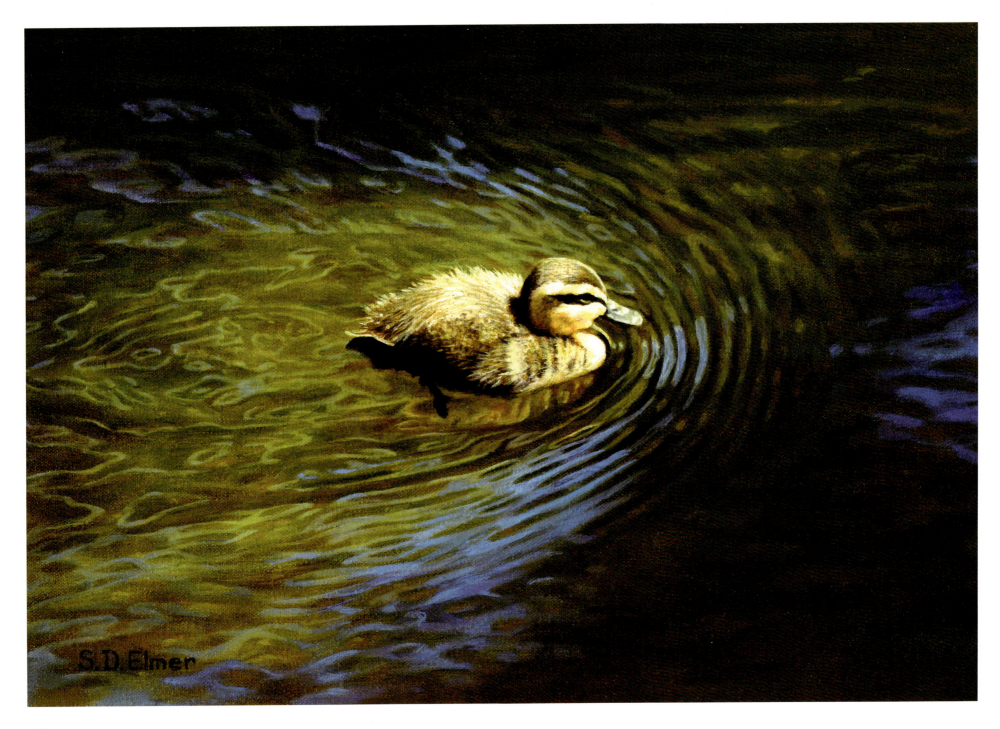

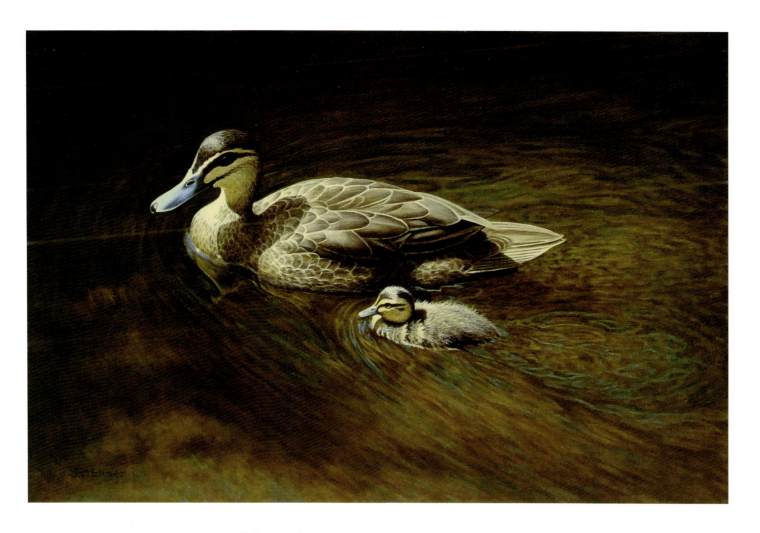

PACIFIC BLACK DUCK

I remember staying with Auntie Ida in Perth before the war when I was young. She would pack a hamper of most delicious ham sandwiches, fill a bag with stale bread and take me on a number 13 tram to head off to Queens Gardens to feed the ducks. I would spend the day there happily while Auntie Ida did her crocheting, sitting near a statue of Peter Pan. The birds I remember were Pacific Black Ducks and Silver Gulls. I tried to throw bread to the ducklings but the adults and the gulls kept getting all the food.

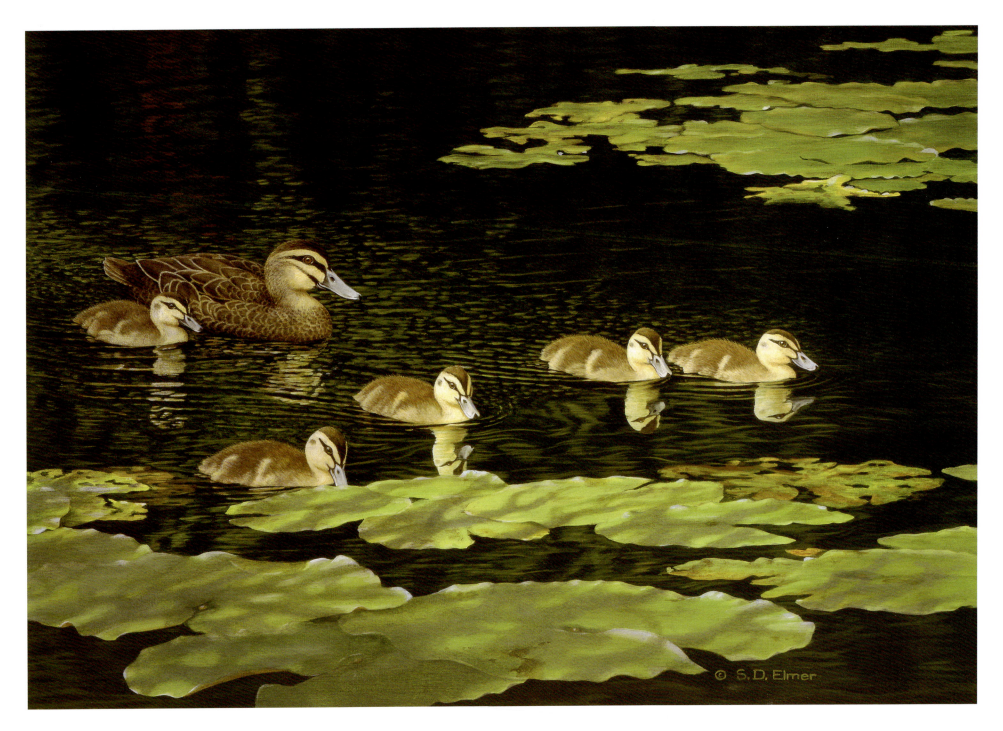

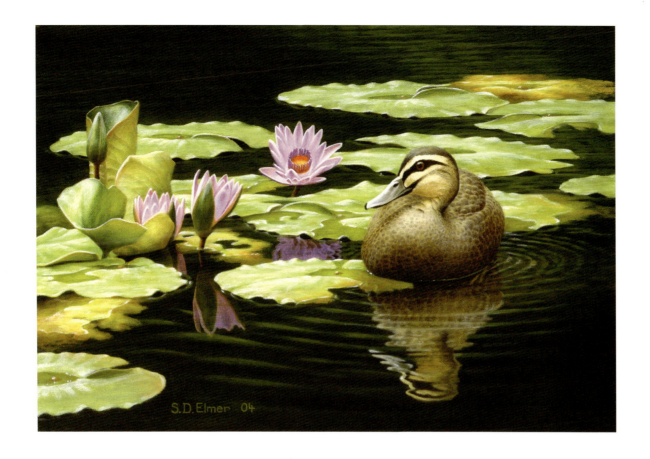

PACIFIC BLACK DUCK

There are several species of 'black ducks' besides ours – one in America, one in Africa and another, the Eastern Spot-billed Duck, in South-East Asia. They are closely related to the Mallard and hybrids are not uncommon. The Mallard was introduced into Australia as early as 1862, and is found on suitable wetlands throughout the south-east and Tasmania, with a small population in the south-west. Hybrids are usually identifiable in the first generation; in subsequent generations the appearance is similar to normal Pacific Black Ducks. There are those who fear that this genetic pollution may affect the Pacific Black Duck's rate of survival in times of increasing aridity.

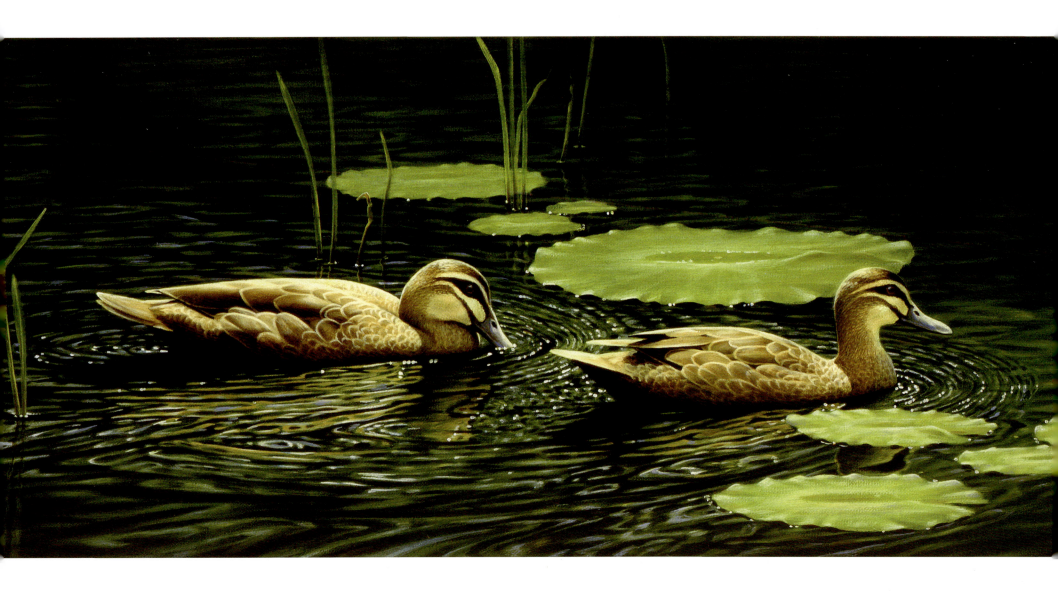

PACIFIC BLACK DUCK

Praise is something I am wary of. Usually the most effusive compliments come from those with no knowledge of painting or birds: the more knowledgeable are likely to pretend a feather is out of place, screw up one eye, caress the chin thoughtfully and say in a hesitant, querying, patronising tone, 'Ye-e-e-s?' Sally and I went to William T Cooper's last exhibition, where the praise from aficionados and novices alike was fulsome and heartfelt in response to 20 or more works of sheer genius. One of the paintings was a pair of Pacific Black Ducks among lilies. Next day we showed Bill some images of our paintings. When he came across Sally's duck painting (left) he remarked 'That's better than mine'. Praise doesn't come any higher than that!

AUSTRALASIAN SHOVELER

Shovelers are named for the shape of their bills, which are lined with fine lamellae used to strain small invertebrates, algae and plants from the water. There are four species, two of which occur in Australia; one, the Northern Shoveler, is a rare visitor from the Northern Hemisphere. The Australasian Shoveler inhabits the southern two-thirds of Australia as well as Tasmania and New Zealand. We don't come across them all that often, but had our best views at Gould's Lagoon in Tasmania where they were numerous and confiding. We saw plenty of Freckled Ducks there as well, and a New Zealand Scaup, so we found it a great place to spend a week or so. It wasn't named after John Gould as we had thought before we arrived – he spent time in Tasmania, staying with Sir John and Lady Jane Franklin while he and his wife Elizabeth were gathering material for their monumental books on Australian birds and mammals. No, the lagoon is named after Arthur Gould, on whose land it lay. He was a forward-thinking man who realised its potential as a wildlife sanctuary.

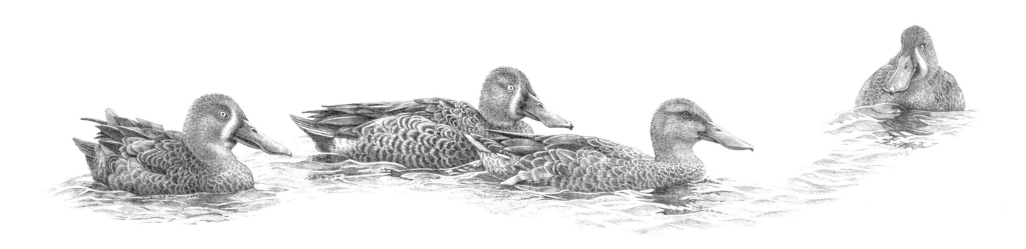

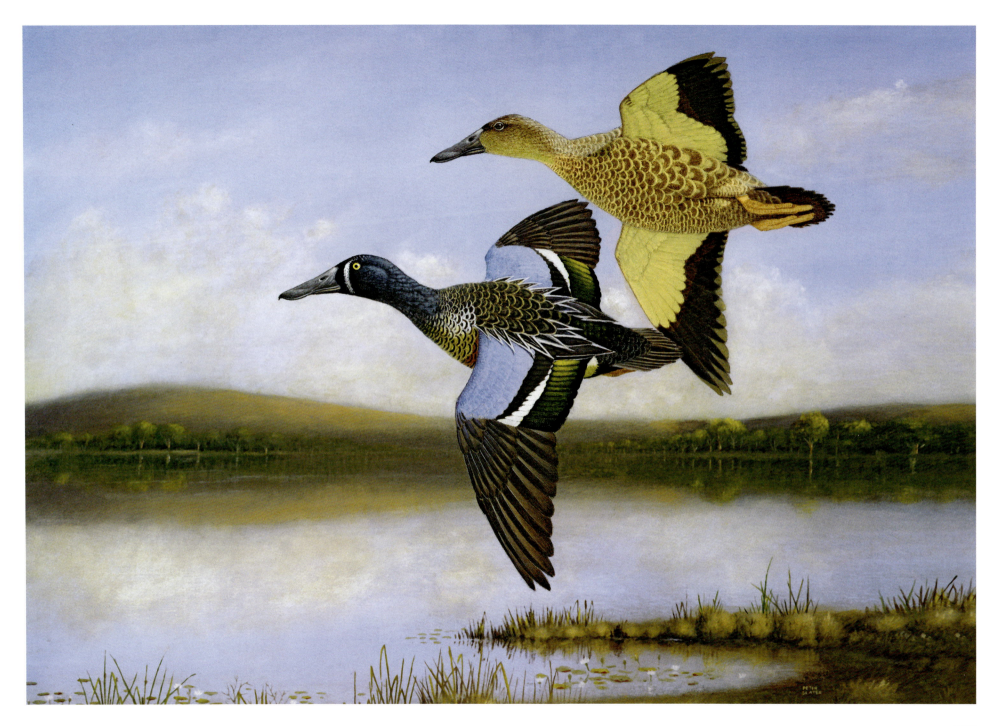

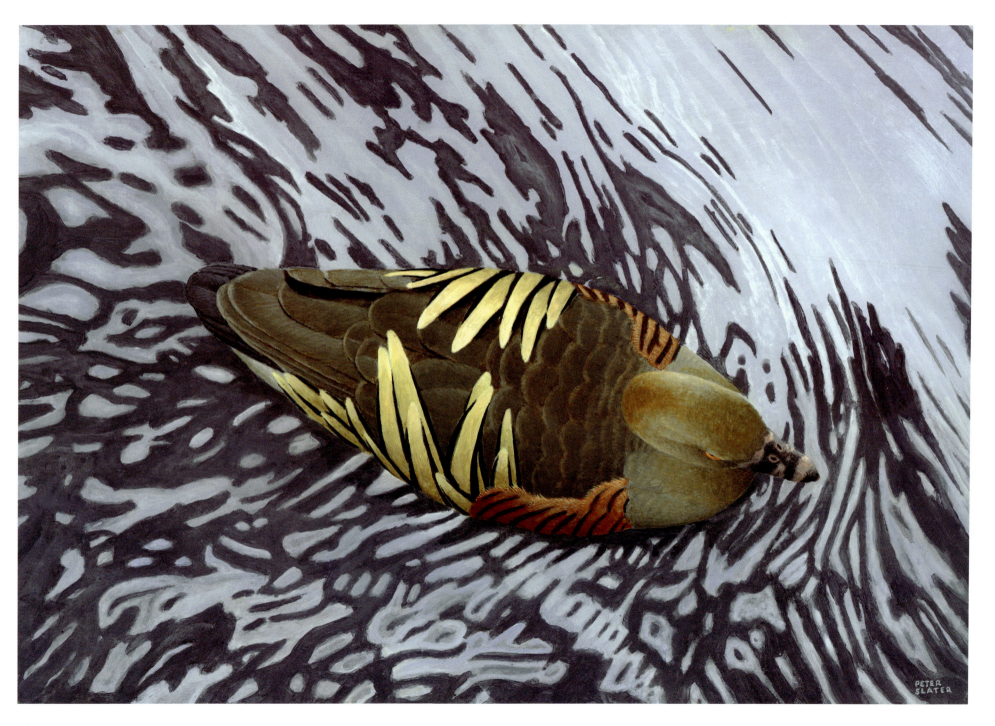

PLUMED WHISTLING-DUCK
AUSTRALIAN WOOD-DUCK

I remember being very excited when I saw my first wood-ducks, some time in the 1940s, because I thought at the time that they were very rare. We knew them as Maned Geese back then; they have the stately air of geese about them. Now, on the other side of the continent, I see some every day in my garden where they feed on the weeds that look just like lawn if I half-close my eyes and squint a bit. They are very efficient as weed-mowers. I like watching them potter about on their dainty feet, which are quite unlike the very large feet of whistling-ducks. I don't see any of *them* in my yard but there are usually quite a number at a pond just down the road, and I hear them whistling away as they fly over at night. I find the Plumed Whistling-Duck with its long flank-feathers very attractive; and I have painted quite a few, always unsuccessfully, so when I was seeking a better way, the idea of looking down suddenly zapped into my mind. The result (left) joined a road-trip around the US with a travelling exhibition of bird-paintings, and made it safely back home, whistling all the way.

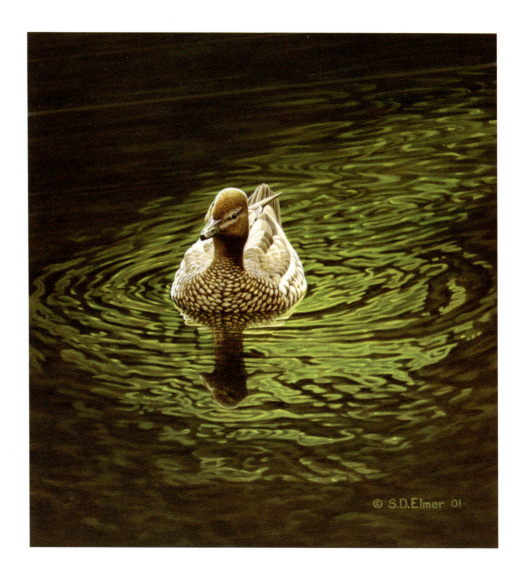

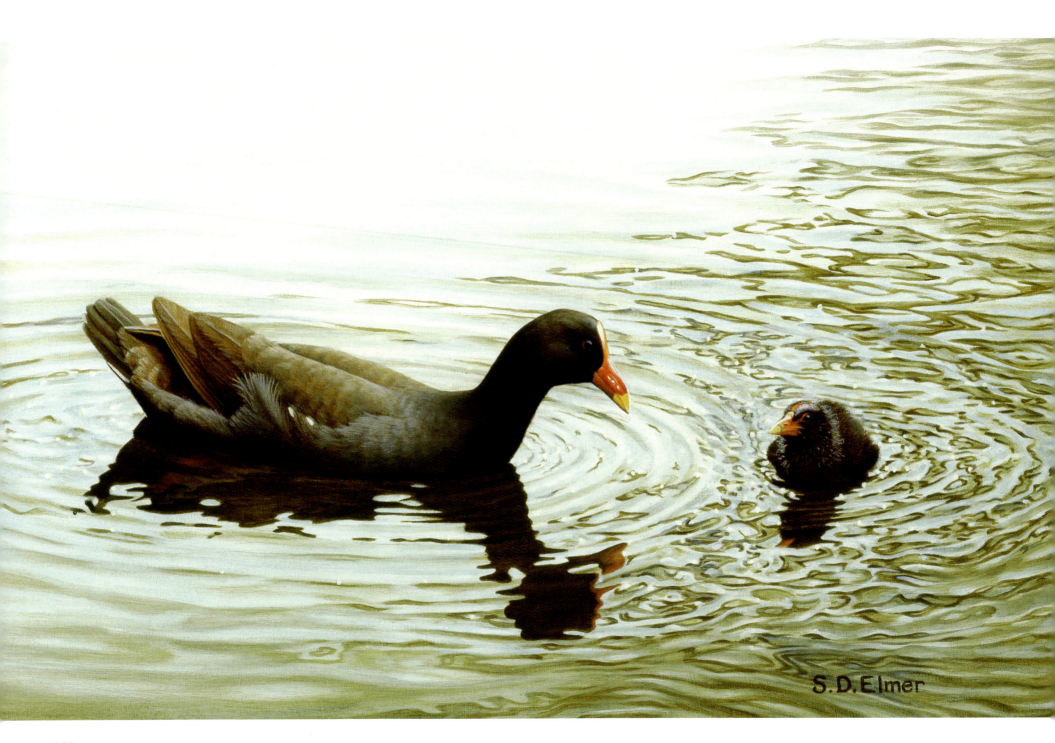

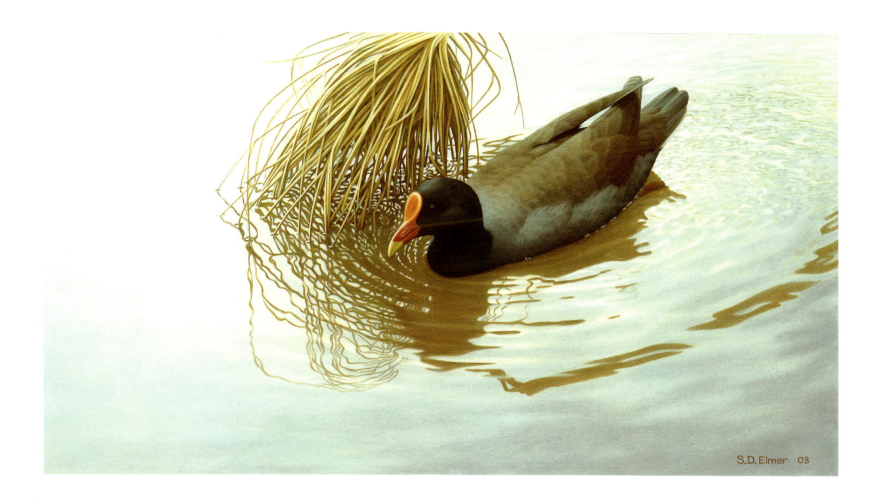

DUSKY MOORHEN

Dusky Moorhens are so common they are generally overlooked as very attractive and interesting birds. Recently the similar Common Moorhen from Eurasia was added to the Australian bird list as a vagrant; it has white spots on the flanks and yellow-green rather than red legs. Very occasionally we see Dusky Moorhens with white flank-spots, such as the one Sally painted on the left, which is probably a relic of the ancestor of both species.

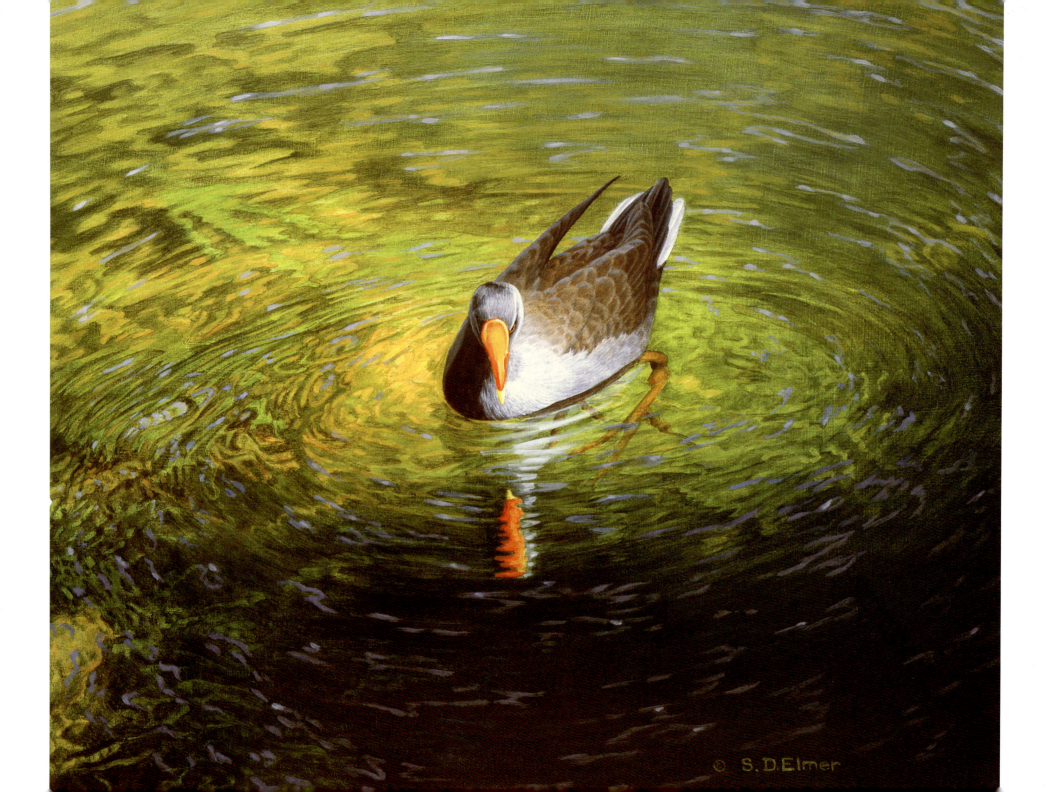

DUSKY MOORHEN

One of the moorhens Sally painted years ago at the Mt Coottha Gardens (left) looks like a lovely mutation we have seen recently at the same locality. It lacks eumelanin in the plumage, resulting in blue-grey feathers, obviously a recessive mutation, so is likely to turn up very occasionally in future generations in the Gardens and perhaps elsewhere. On the right is a more typical bird. It could be carrying the mutated gene, so if it mated with another bird carrying the gene, one in four of their progeny are likely be pale like the one opposite.

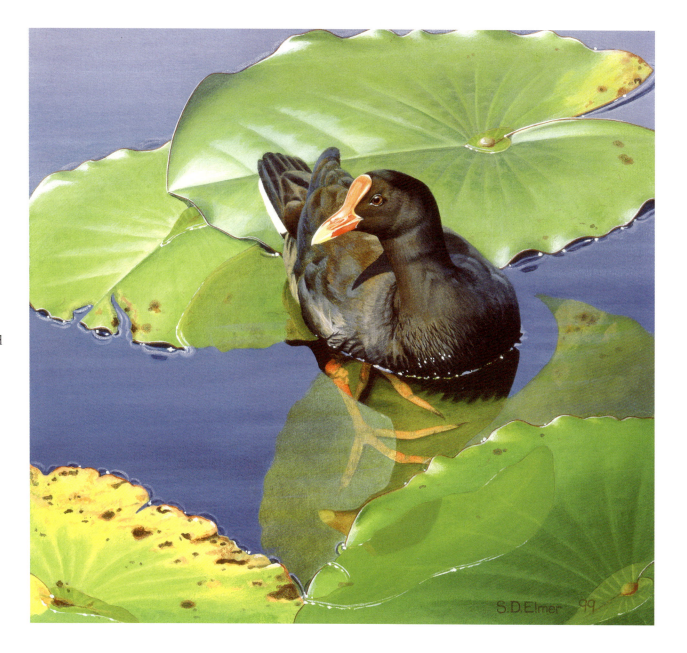

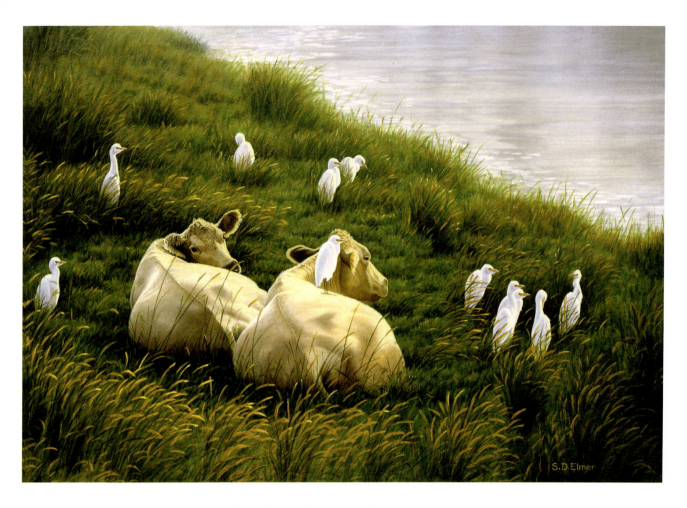

CATTLE EGRET

LITTLE EGRET

When I was quite young, living in Manjimup, Western Australia, I often visited Alfie Glew's farm at Middlesex. Years later I was driving past on a nostalgia trip and saw some Cattle Egrets with a few cows in one of the paddocks. Cattle Egrets at that time were unknown outside of the Top End. So I took photos and raced back to Perth to alert the world. Alas, there was a photo on the front page of the *West Australian*. Someone had beaten me to it. Curses! Nowadays the egrets are to be seen wherever there are cattle, and often in our back paddock when Pat had horses.

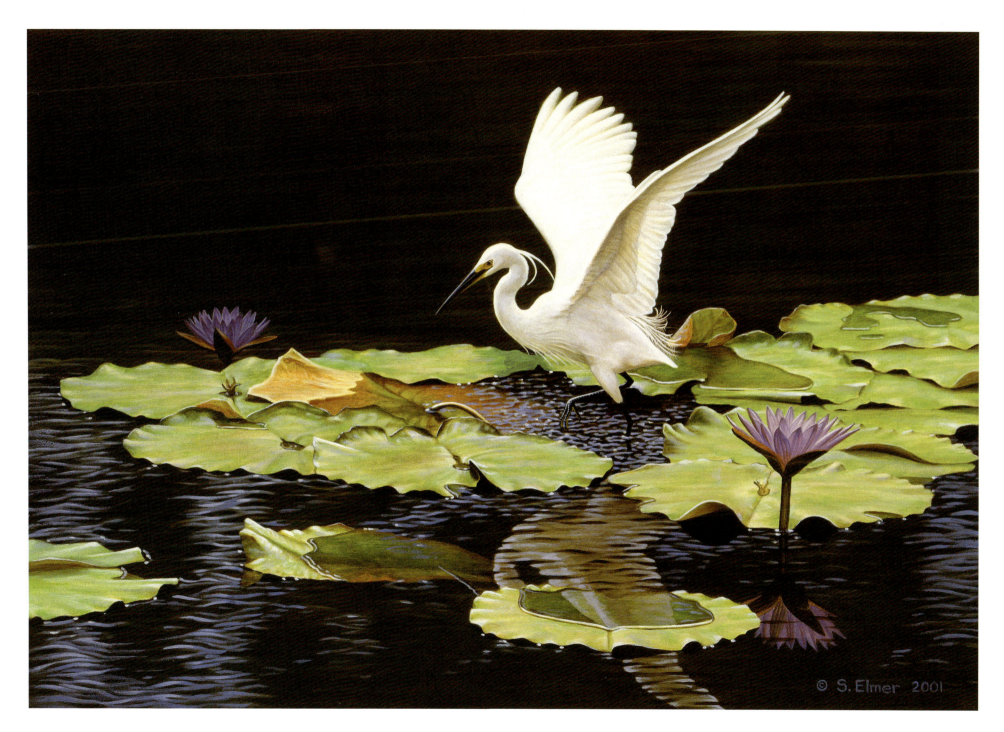

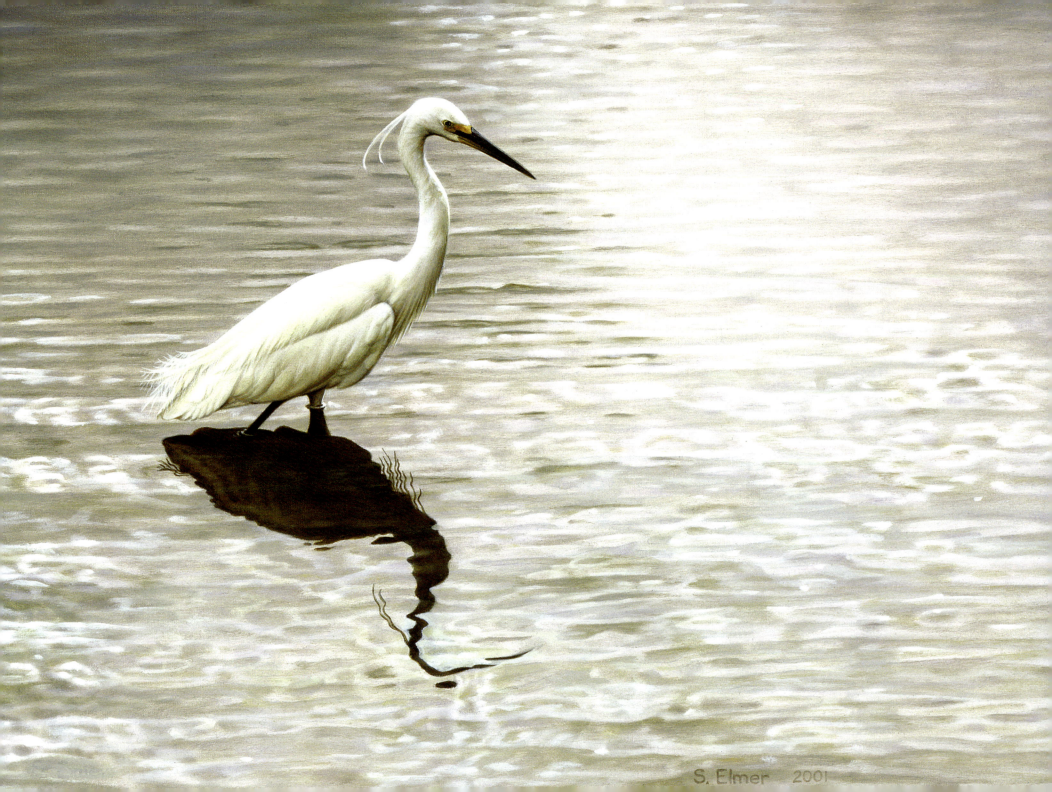

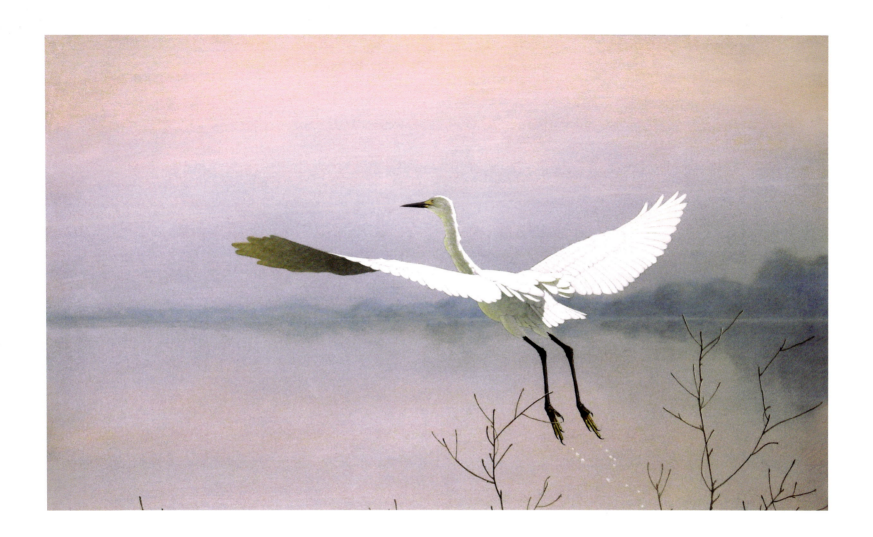

LITTLE EGRET

Egrets were made to be painted. Their images are often seen in Chinese and Japanese art, and Brancusi's sensuous forms have something of the egret about them. Sally's painting opposite reminds me of a poem I love, by the revered Buddhist monk Basho:

egret's legs
grow shorter
after summer rains

INTERMEDIATE EGRET
EASTERN GREAT EGRET

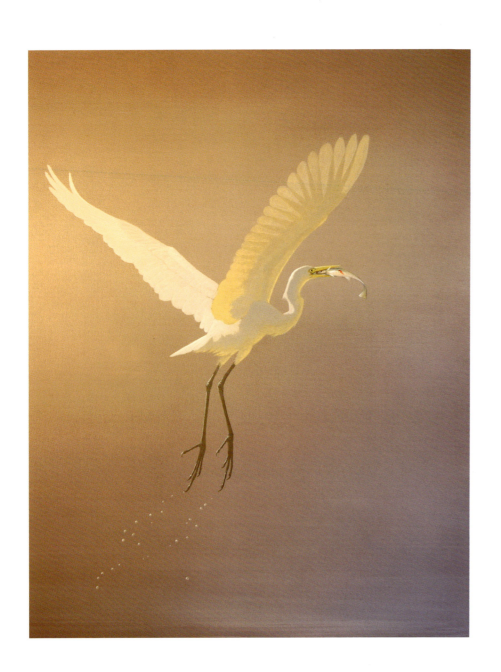
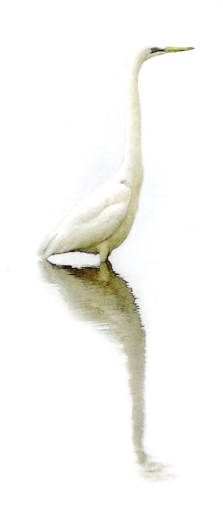

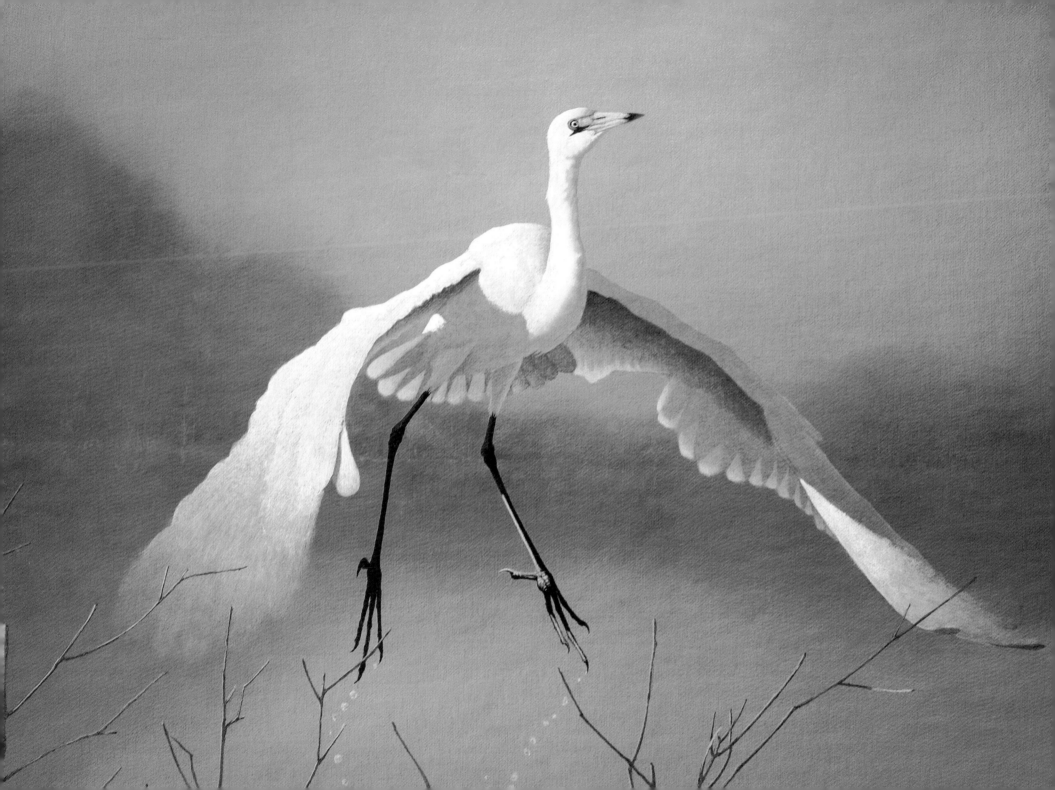

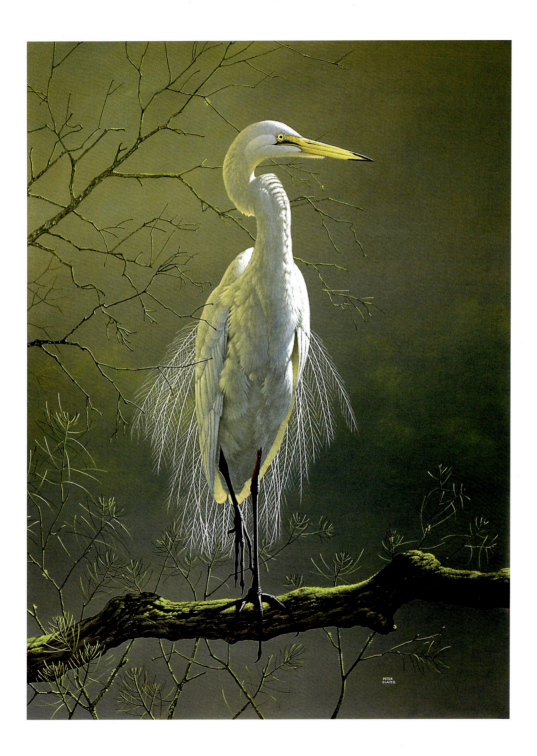

EASTERN GREAT EGRET

Among the highlights of my life were the days I spent watching a nesting colony of Eastern Great Egrets from a concealed hide. A large number of pairs chose a grove of casuarinas in the middle of an ephemeral freshwater lake to build their stick nests. We built the hide in a tree outside the colony to avoid disturbance, but three pairs of latecomers chose to construct their nests alongside the structure, within a few metres. Over the next two months I was able to watch them, firstly in courtship displays emphasising the beautiful plumes, then incubating the three or four pale blue eggs, and finally feeding the young ones on regurgitated tadpoles and fish. Incubation started when the first or second egg was laid, so nests often had chicks of different sizes; the larger ones in a brood tended to get more food than smaller youngsters. At first they were covered with down, with a wispy haircut; when fully grown the young egrets were white like their parents but lacked any plumes. The time spent sitting hidden passed too quickly: magical days in a magical place.

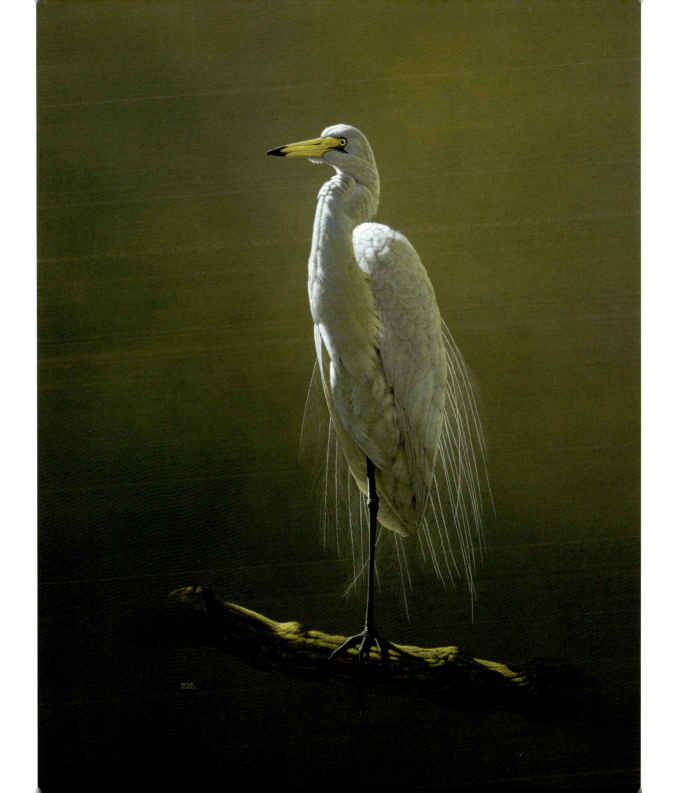

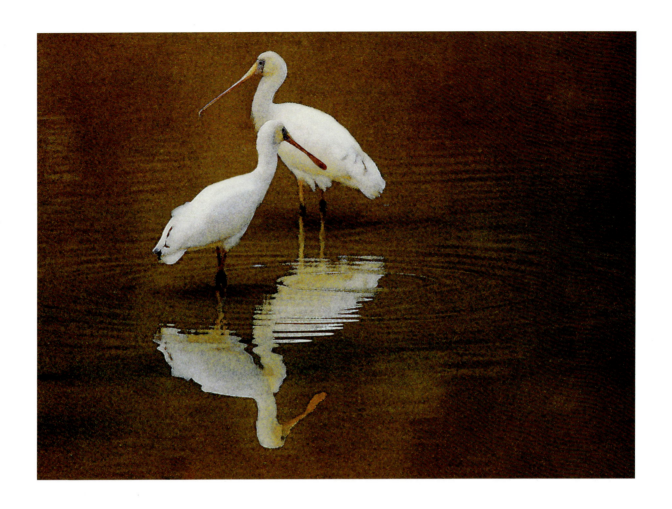

YELLOW-BILLED SPOONBILL

ROYAL SPOONBILL

Spoonbills are very efficient at hunting in muddy water, swishing their spatulate beaks from side to side, snapping up any fish or tadpole they touch with lightning reflexes. At the nest they are very affectionate; adults preen each other as well as their chicks, and we have also seen chicks preening each other – something we have never seen chicks of other birds do. Indeed from a hide in the West Kimberley I saw two White-necked Heron chicks consistently trample over a smaller sibling whenever a parent arrived at the nest with food. I don't think it survived.

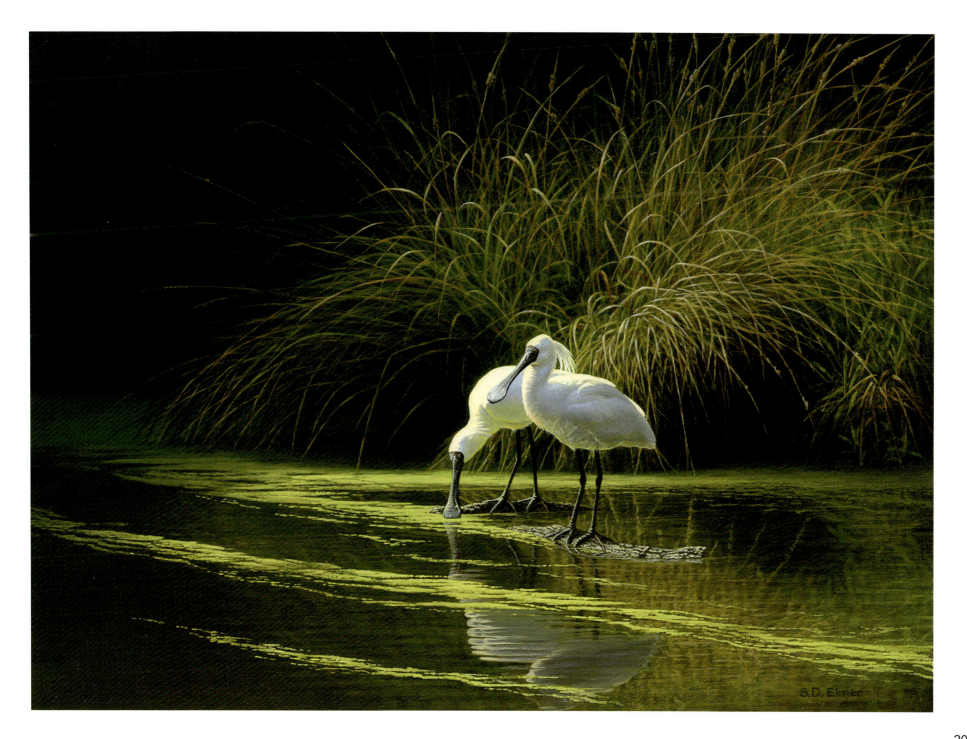

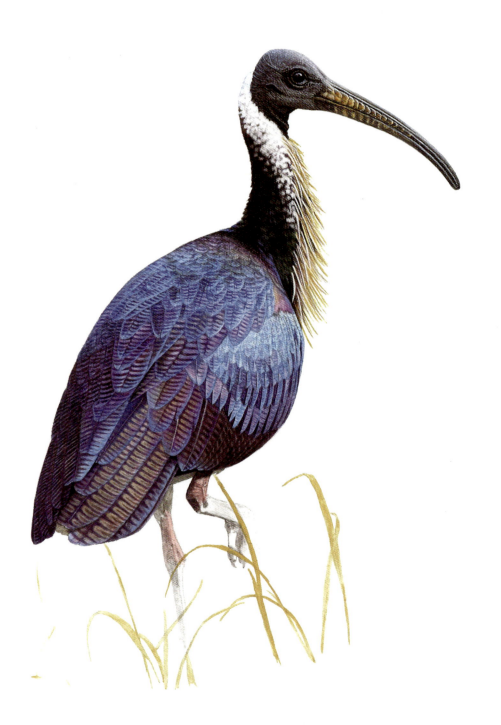

STRAW-NECKED IBIS
AUSTRALIAN WHITE IBIS

In the study of the Straw-necked Ibis, I chose the position to compliment the painting on the right, and also so that I could enjoy painting those delicious, stunning colours. At first glance from afar, they may appear to be a black and white bird, but as they move, the sunlight brings out the ever changing blues, greens, purples and hints of deep golds. Not so easy to imply in paint, as each time the bird moves, the colours change and trying to work out how to portray its iridescence was a challenge. I mainly see the Straw-necked Ibis at a distance, feeding in small flocks on open pastures. They are far more wary than the Australian White Ibis, which will scavenge around your feet at outdoor eating areas. One of my old photos showed a white ibis in a position I really liked, but with no good information for its legs and feet. I knew I would find them around the ponds at our local botanic gardens, so went and promptly found a young bird preening itself on an isolated rock. Just as I was settling to watch, an older bird chased off the youngster and posed in exactly the position I wanted! Could it read my mind? I went home very elated and with fantastic information.

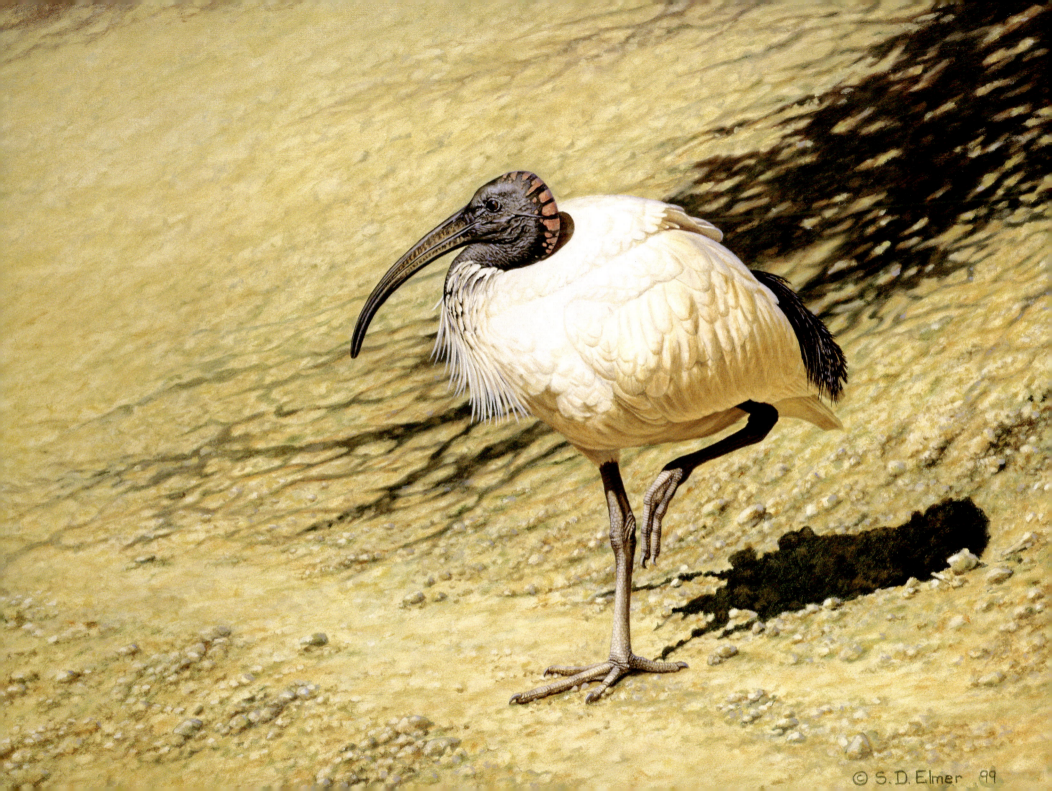

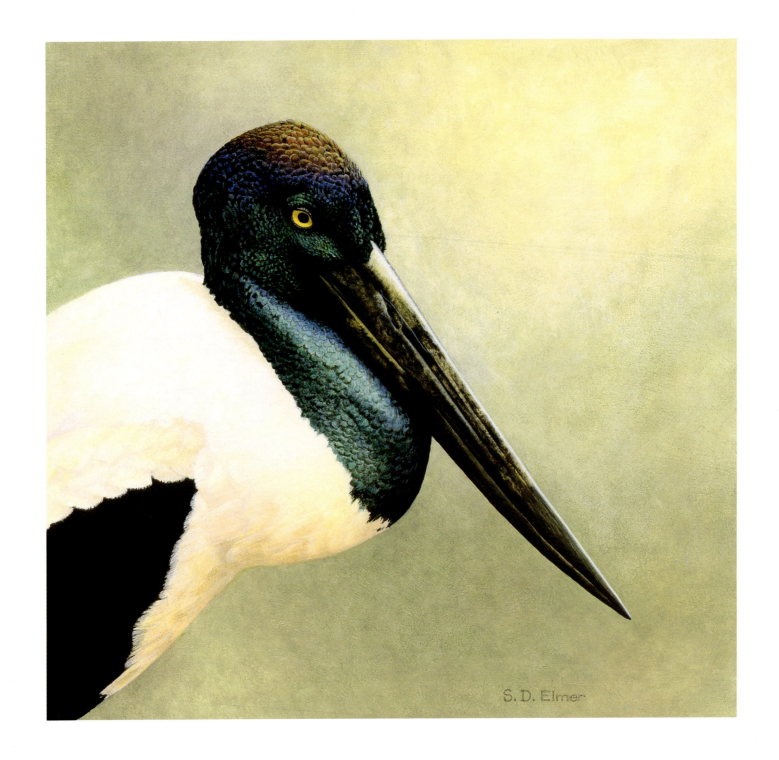

JABIRU

Jabiru is a name given to a rather grotesque-looking South American stork by the local inhabitants in Brazil, and hi-jacked by John Gould when he wrote about this Australian species, which should more properly be thought of as a Black-necked Stork. Being proper is not a particularly Australian characteristic, so Jabiru it will remain. It is much more pleasing to the eye than the South American bird. To the tongue it is not so pleasant, as the explorer A C Gregory wrote: 'The colour of its skin and flesh is of a rich salmon tint; the flavour of the latter has a fishy flavour, too over-powerful to admit of its being eaten by anyone but a hungry explorer'. Presumably he spoke from experience, having shot one while exploring the Gascoyne River in 1848. You have been warned.

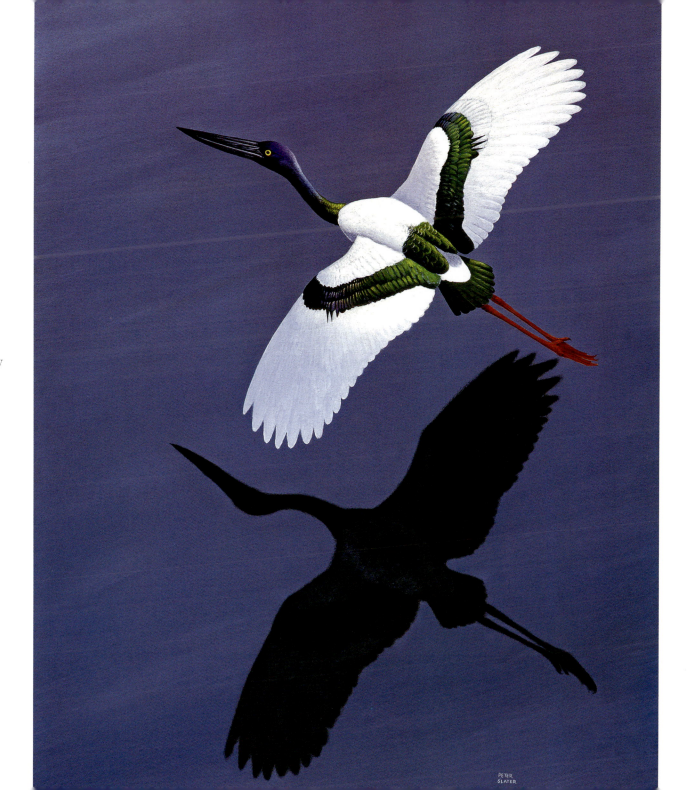

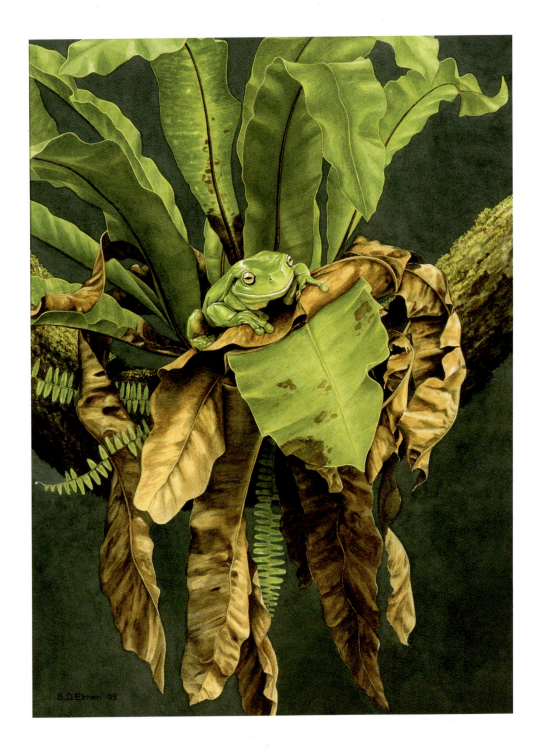
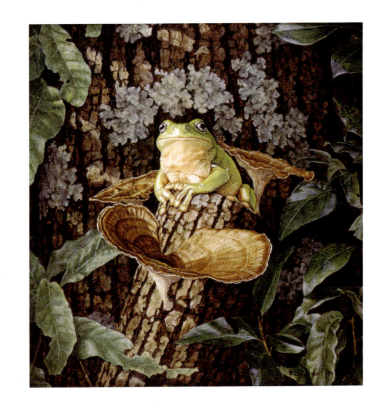

GREEN TREE FROG

Green Tree Frogs appear to be everybody's favourite. Perhaps it is due to the large eyes and smiling faces. I don't think it has anything to do with the call. In times past at our place we have been blessed with one in every downpipe as well as in dozens of upright galvanised pipes that support the fences. The frogs love these locations because when they utter their territorial calls, the reverberations amplify the sound to make its source seem far bigger and more important than it really is – like those businessmen who speak very loudly into their mobile phones in public places. The cacophony at our place when it rained was awesome – 30 or 40 frogs in unison at full blast. Nowadays I only hear one or two. Our neighbour Julie had a 'pet' tree frog that lived in her toilet cistern. She was extremely devoted to it and left the window above the cistern open so it could go outside to feed. She would often sit watching TV with the frog on her hand, its buccal pump vibrating contentedly as she stroked its back. One night she appeared at our door in great distress, holding the frog upside down on her palm. She had heard it squarking loudly and on investigation found it being swallowed by a Green Tree Snake. The frog was rescued and appeared to be in a bad way so Julie tried to revive it by trickling brandy down its throat, then carried it over to our place. Pat eventually calmed her down and proclaimed 'Julie, this frog is drunk!' So it proved to be; I removed the snake from Julie's toilet and the frog lived happily ever after. Despite Julie's best efforts no handsome prince ever appeared, but the kind gentleman who came to snake-proof the cistern proved to be an adequate alternative.

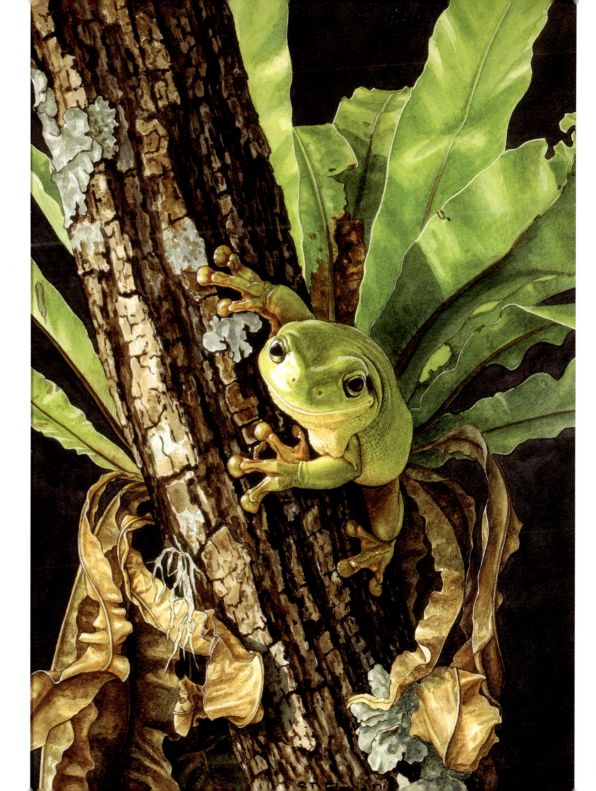

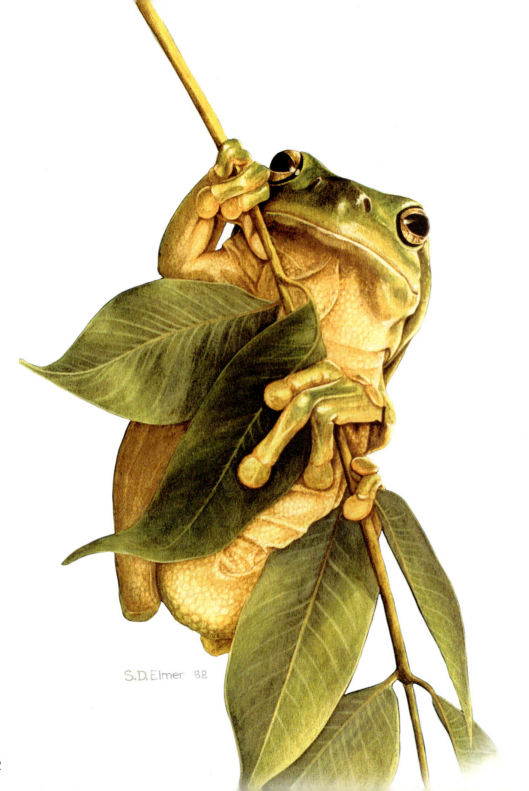

GREEN TREE FROG

RED-EYED TREE FROG

To my eye the Red-eyed Tree Frog is much more attractive than its large green cousin, and it is certainly more elegant in its movements. During the day it sits immobile on a green leaf, hiding the brightly coloured underparts, and so effective is its camouflage that it is difficult for humans to detect. However, Pacific Bazas have no trouble finding them, and together with other small frogs such as the Dainty Tree Frog, they form a large part of that raptor's diet. Perhaps the baza is able to see further into the spectrum of ultra-violet light than we can, thus detecting its victims more easily against the leafy hiding place.

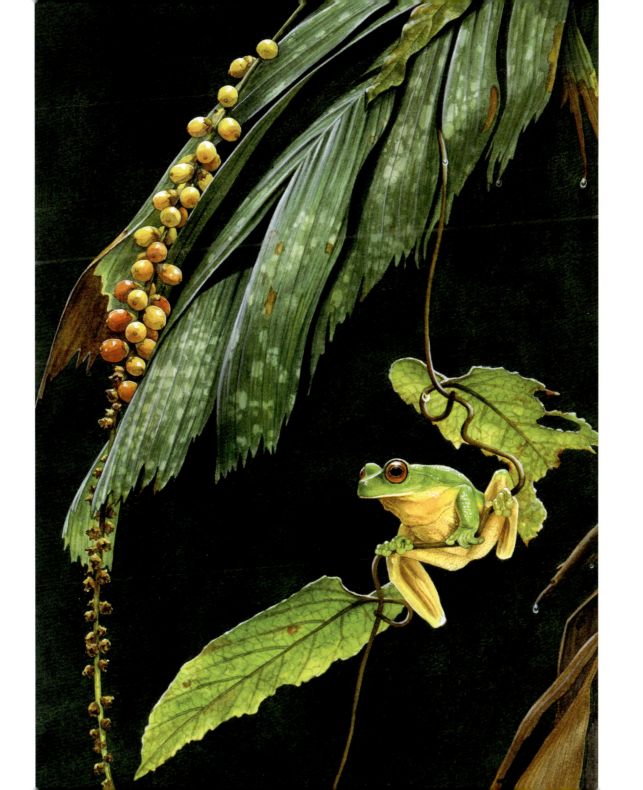

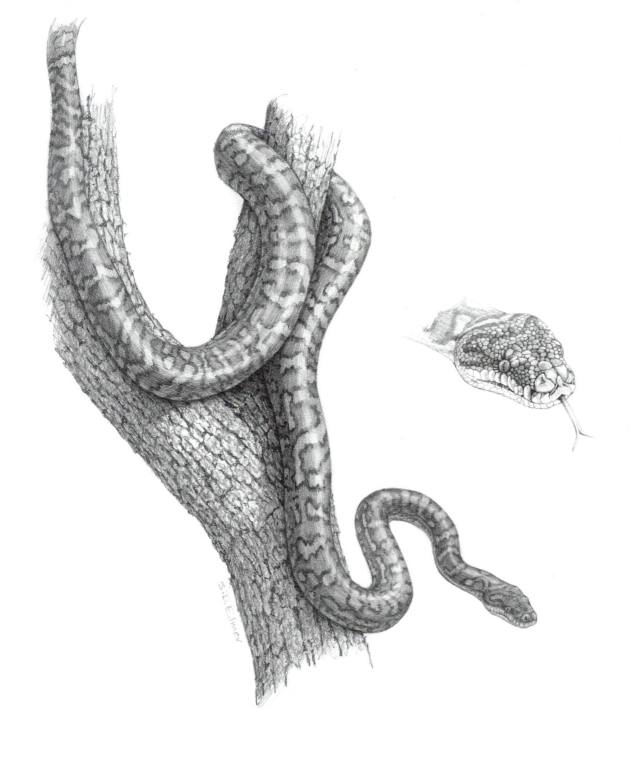

CARPET PYTHON

Carpet? I don't know when the name originated, but I suppose the patterns can look like oriental carpets as some people suggest, and the texture of the scales contributes to that impression. In the drawing on the left, I have concentrated on just the patterning, leaving out the scale definition. These snakes have a variety of colours and patterns, as well as habitats, over most of Australia, including urban areas where possums, rats and chickens form their diet, much to the dismay of many chicken lovers. The painting on the right was created for *The Magic of Mary Cairncross Scenic Reserve: A Celebration of Art and Nature*, a book produced by local artists and naturalists to celebrate and explore a very special reserve in the Sunshine Coast Hinterland. I have never really 'taken' to acrylics, not liking the feel of them, but for this painting I thought I might experiment by using them a bit like I use watercolour – thin washes building up layers of colour to create the composition, patterns and lighting, then finer brushes to develop the details. Using acrylics this way I could paint over and change elements I didn't like, unlike true transparent watercolours.

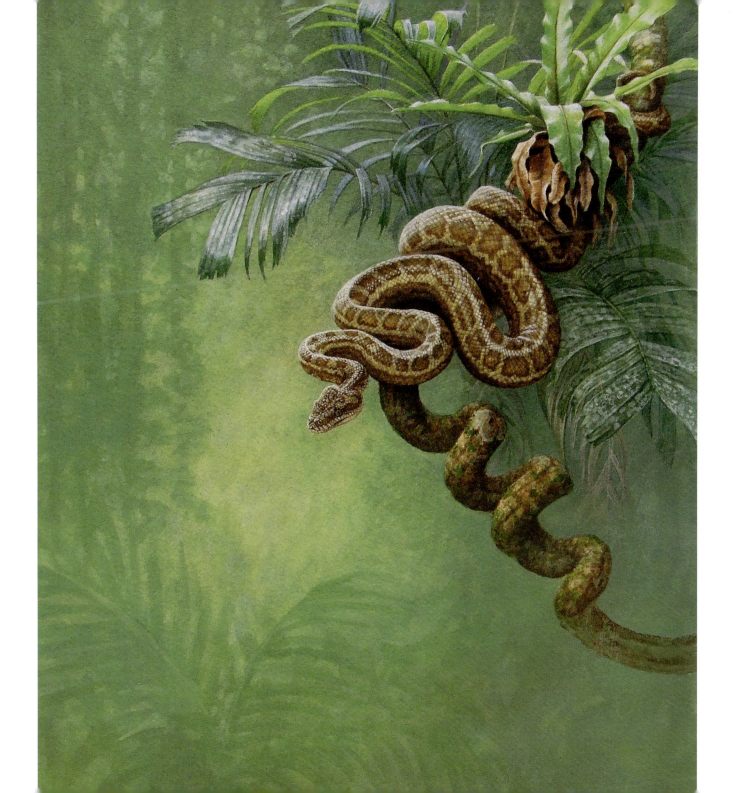

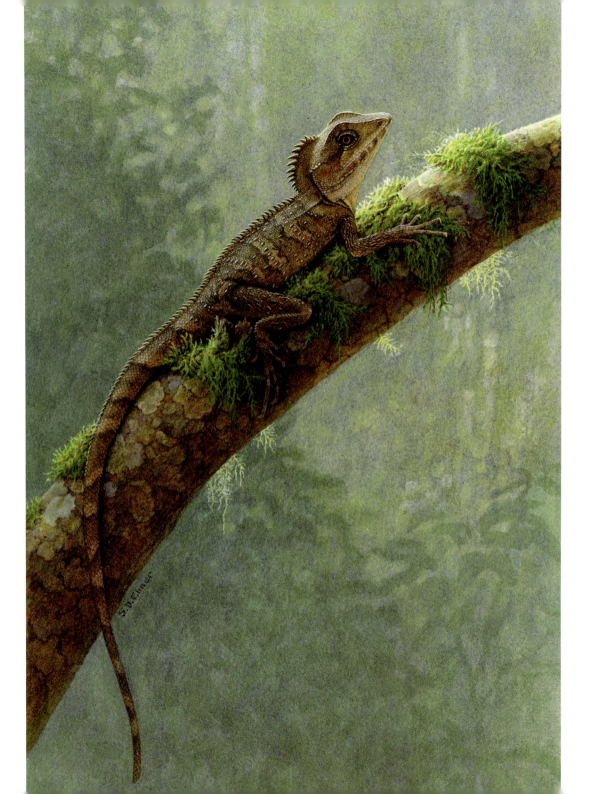

SOUTHERN ANGLE-HEADED DRAGON

EASTERN WATER DRAGON

I first became aware of the Southern Angle-headed Dragon while planting trees on our property, when I came across a tiny wobbly lizard with a huge head. It was obviously a baby, and after going through my reptile book, I worked out it was this species, which is also known as Southern Forest Dragon. They are rarely seen as they are well camouflaged and always move around to the other side of a branch or tree-trunk when approached. Some years later when again planting, I dug up a small cluster of eggs and was curious to know if they were dragons, due to their size. I kept them in a glass tank until they hatched and yes, seven tiny little dragons emerged, some patterned, some plain, possibly either male or female. After I photographed them, they were released into the rainforest near my house, in the hope that I may see them again. In 30 years I've only seen one. The Eastern Water Dragon (right) is a lot larger and sturdier with stronger markings than the angle-headed, reaching a total length of 1m, as compared to 30 cm, two-thirds of which is tail. These dragons are often seen in public parks and gardens and are not at all timid, to the extent that they don't get out of your way, making you walk around them!

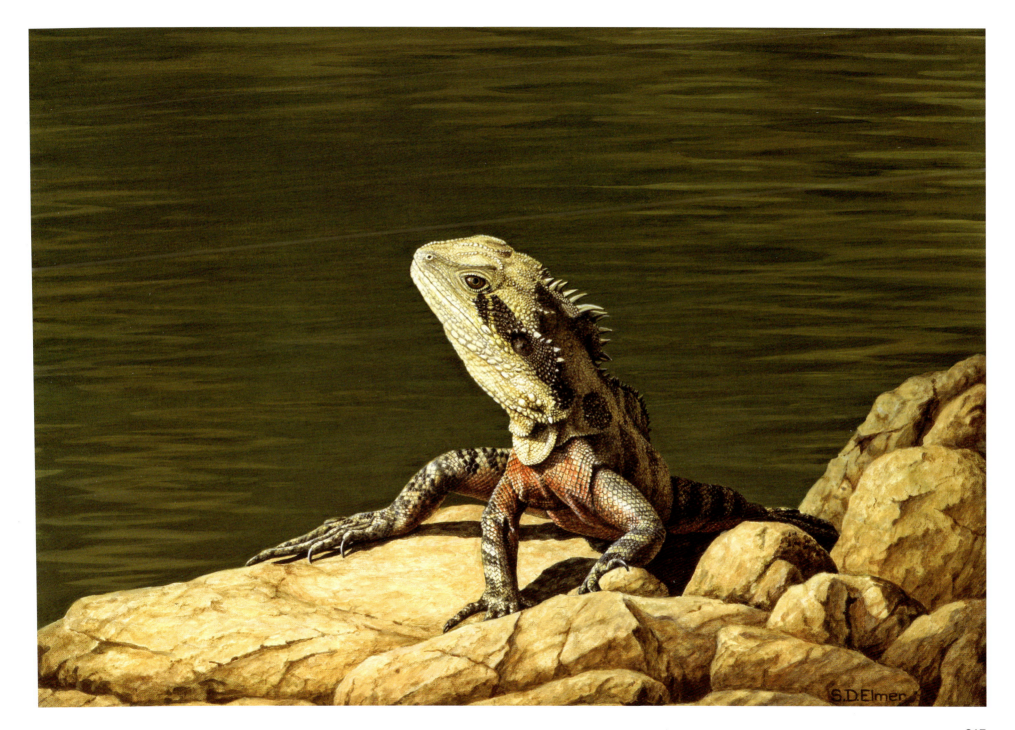

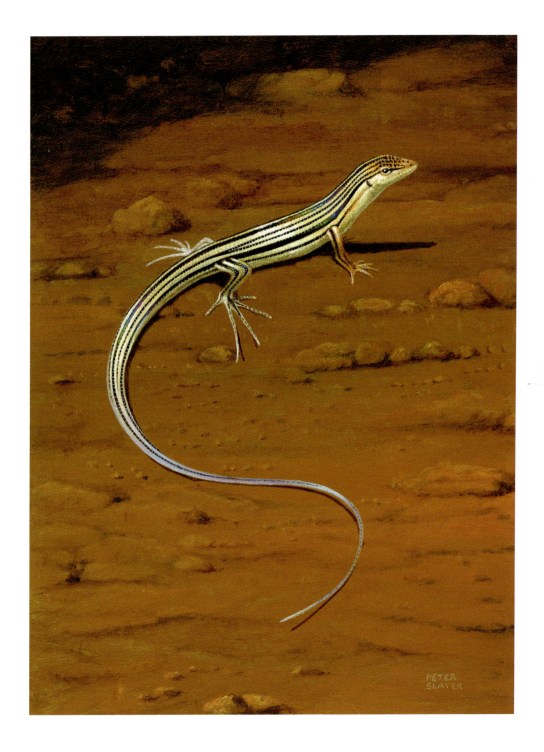

BLUE-TAILED CTENOTUS

KAKADU CTENOTUS

If there were no such thing as birds, I would probably have spent my life studying and painting reptiles. My particular favourites are the comb-eared skinks of the genus *Ctenotus*. It is a very large genus with more than 100 species described so far; new species are being discovered at regular intervals, so there are probably at least 120 all told in a wide variety of habitats. I illustrated some of the multi-striped species (near left) for a proposed field guide to Australian reptiles that never eventuated. Most enthusiasts use scientific names instead of common names when discussing various species. Everybody's favourite is the Fourteen-lined Ctenotus, *C. quattuordecimlineatus*, probably because they can pronounce it, but I prefer the Blue-tailed Ctenotus, *C. calurus*, of the western deserts (left), an elegant multi-striped racer found on sand dunes. A single dune in the desert can support up to 13 ctenotus species including *calurus*, each exploiting a different micro-habitat so finely tuned that even time of day can be involved. Some emerge from their burrows early in the morning, others later in the day; some live near the top of the dune, others down close to or in the swale, all in all a master-class in evolutionary ecology. I have painted the Kakadu Ctenotus, *C. gagadju* (right), on a rock because that is the way I first saw it, but it is more at home in grasses.

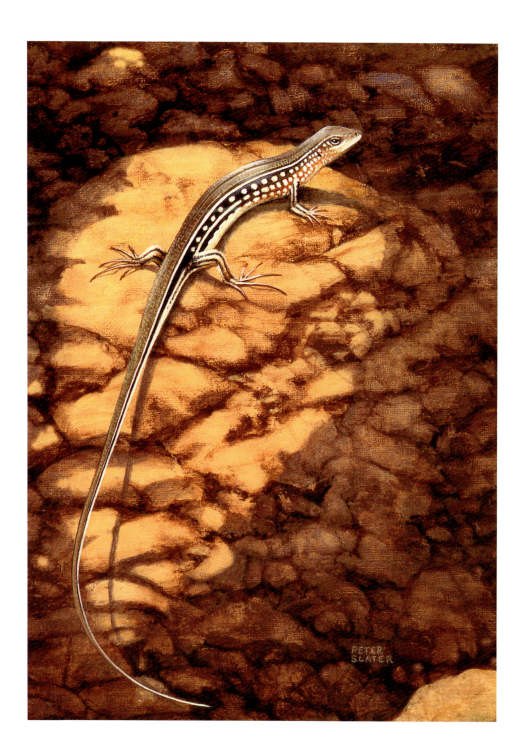

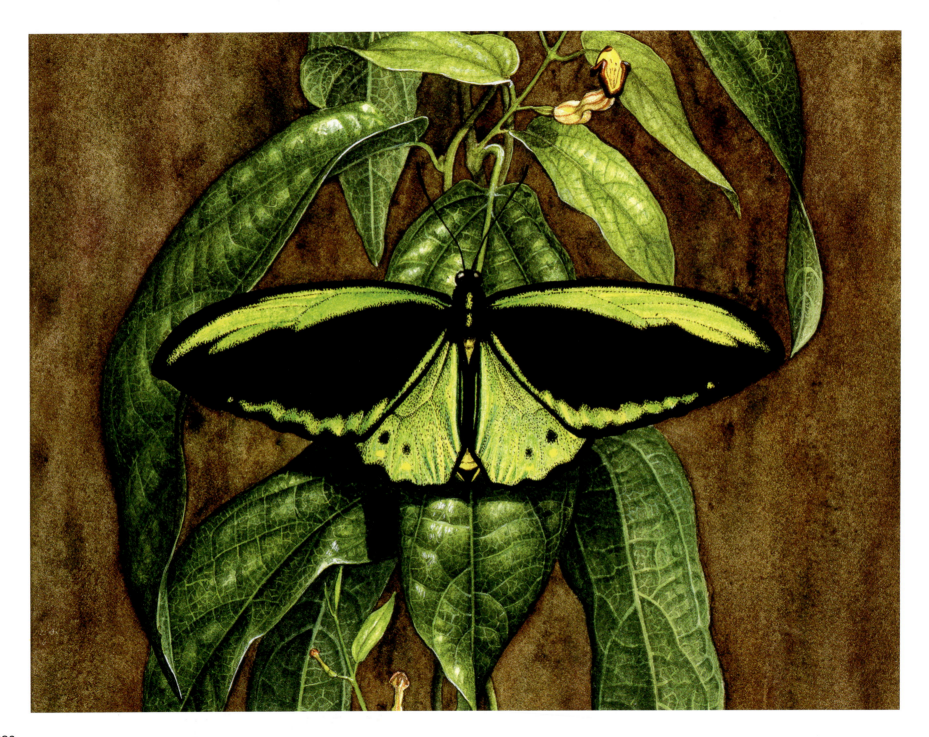

RICHMOND BIRDWING

On one of our explorations through the bush, dad and I discovered a birdwing and its vine, *Pararistolochia praevenosa,* with a ripe seedpod. We germinated the seeds and planted them out in our rainforest property, and soon had tiny caterpillars. We had to remove them before they ate the young vines down to the ground, relocating them to a large old vine we had recently discovered. Over the years the vines have proliferated and now I regularly see the birdwings around my home through the summer months. When Peter visits he often spends hours waiting near a vine hoping for a good view and he is never disappointed. This painting (right) shows the lifecycle of the butterfly as well as growth stages of the vine leaves, flowers and seed pods, and was created for reproduction in the book *The Magic Of Mary Cairncross Scenic Reserve: A Celebration of Art And Nature*. I didn't have far to go for live models.

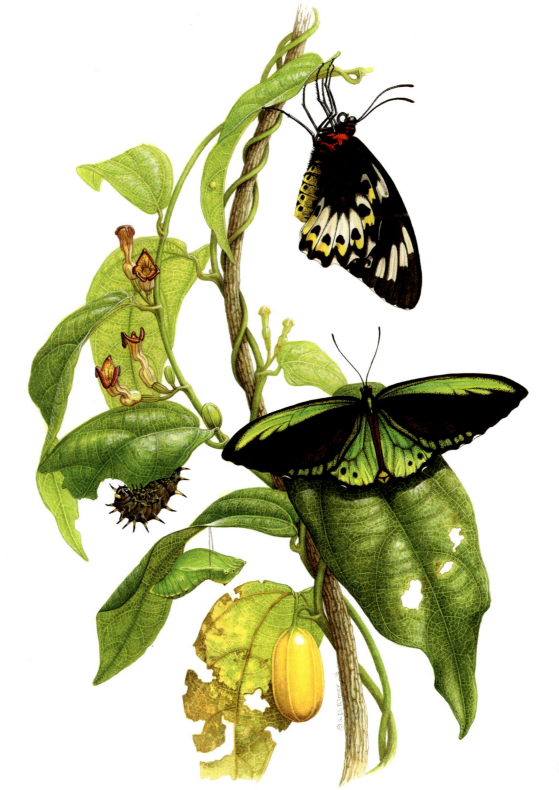

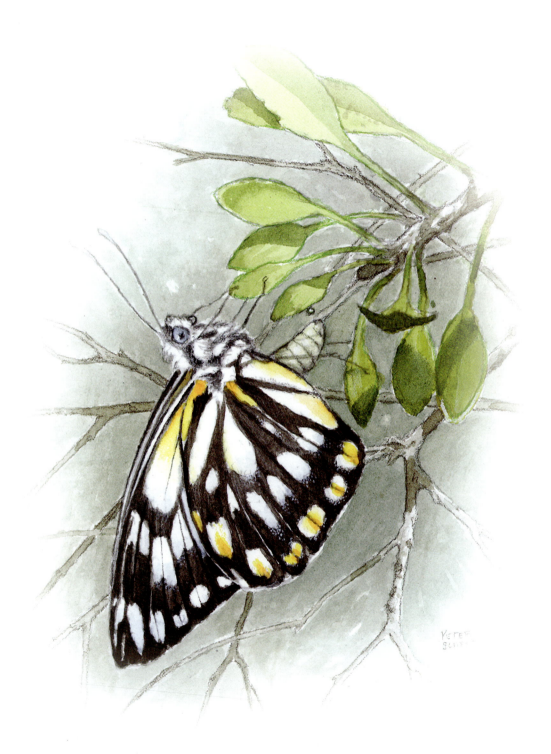

CAPER WHITE
RICHMOND BIRDWING

Each year we set off into the desert for a month or two of sheer delight. In some years when we are travelling through the outback we come across clouds of Caper White butterflies feeding on the nectar of desert flowers and clustering around caper bushes, laying eggs on young leaves. Once the eggs hatch, caterpillars feed on the leaves; many heavily infested bushes are soon stripped, and the caterpillars pupate. After emerging, groups of butterflies drift eastwards; in some years there are millions, and when we return home, a thousand or more kilometres away, we await their arrival. Sure enough after a few weeks they drift in and our backyards are full of them. The move eastwards may be driven by the prevailing winds; we have even seen individuals heading out over the ocean, no doubt to meet a watery end – so different from the desert they came from.

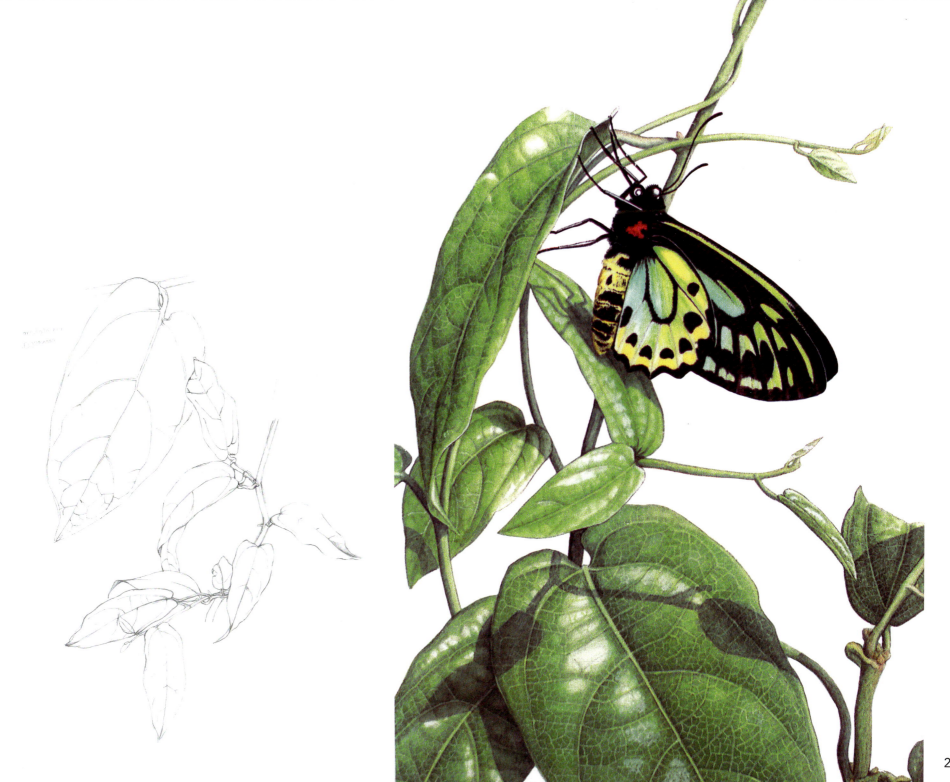

223

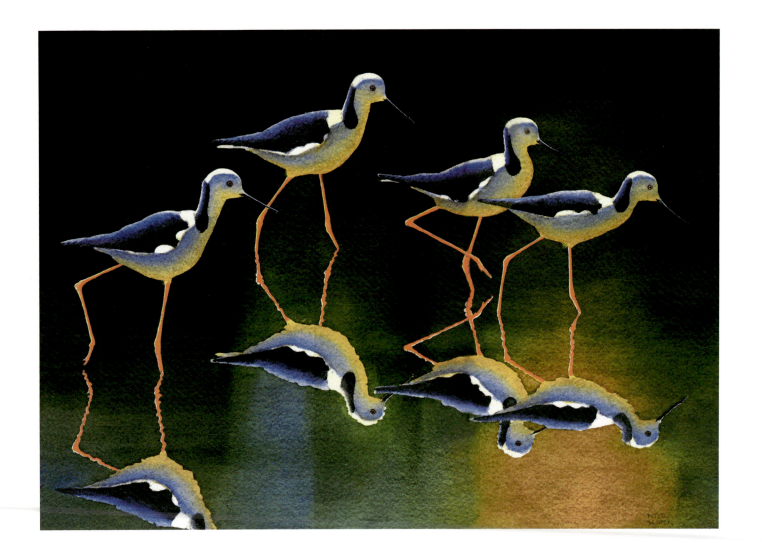